Praise for *The Lon*

"Arrives not as an addition to the minimalist [Chayka] offers sharp critiques of thing-ori~~~ the vision of 'less' as an optimized lifestyle lies ~~~ path to something stranger~ and more profound: a mode of living that strips away protective barriers and heightens the miracle of human presence, and the urgency, today, of what that miracle entails." —Jia Tolentino, *The New Yorker*

"Delving into art, architecture, music and philosophy, [Chayka] wants to learn why the idea of 'less is more' keeps resurfacing...For Chayka, Kondo's method clearly doesn't spark joy. More generative for him are the examples of artists who became known as Minimalists even as they disavowed the term. Experiencing their work sharpens his senses; in place of the dull hum of overstimulation, Chayka gains a heightened existential awareness...The minimalism that Chayka seeks encourages not an escape from the world but a deeper engagement with it." —Jennifer Szalai, *The New York Times*

"Chayka's odyssey through the modern minimalist tradition is worthy of a stand-alone text...Thanks to Chayka, cultural opportunists will not have the last word." —*Los Angeles Review of Books*

"Kyle Chayka's fascinating new book explores not only how one might live in a minimalist fashion, but in fact where the idea comes from and how it's changed and adapted over the ages." —*Town & Country*

"An intriguing deep dive into the many manifestations of minimalism...A superb outing from a gifted young critic that will spark joy for many readers." —*Kirkus Reviews* (starred review)

"Tries to understand the current obsession with minimalism in all its complexity...Chayka takes the reader through history and around the world, giving equal consideration to minimalists like Steve Jobs (who lived in a giant house that remained entirely empty) as he does to Cicero." —Wired.com

"Gets to the bottom of the trend/lifestyle/manifesto and presents it back to us in a new and shiny light." —Literary Hub

"Chayka's insightful book connects a wide array of thought-provoking approaches to the concept of less is more." —*Booklist*

"[A] sharp debut...Chayka is in tune with the spirit of the movement." —*City Paper* (Washington, D.C.)

"[A] wide-ranging synthesis of a fascinating and perplexing impulse... Persuasively argues for the power of works associated with the minimalism movement." —*Slate*

"More than just a story of an abiding cultural preoccupation, *The Longing for Less* peels back the commodified husk of minimalism to reveal something surprising and thoroughly alive." —Jenny Odell, author of *How to Do Nothing*

"Functions both as a corrective to our shallow form of minimalism and as a guide to a deeper form that still has a great deal to teach us." —Brian Phillips, bestselling author of *Impossible Owls*

"[A] lively and sophisticated cultural history of minimalism. Kyle Chayka balances a critical view of the mass-market forces churning the minimalist-goods industry with a tender consideration of the emotions underlying it, showing how the urge for emptiness is part of a timeless, tireless human need to reinvent the spaces we inhabit and maximize our feeling of being alive." —Rachel Corbett, author of *You Must Change Your Life*

"I'm no minimalist, but I am not immune to Kyle Chayka's searching, subtle, and finally quite moving exploration of the beauty of less." —Lucy Sante

"Generous and wide-ranging, a genuine adventure; it's thrilling to ride along with Kyle Chayka as he explores this terrain." —Robin Sloan, author of *Mr. Penumbra's 24-Hour Bookstore*

"Offer[s] nuanced, profound, and then outright dazzling angles on a subject as loved as it is overexposed. With sophistication and subtlety, his new book champions the necessity of critical self-examination amidst our current cultural obsession." —Paola Antonelli, senior curator, Department of Architecture and Design, Museum of Modern Art, New York City

"Awake to the paradoxes in our search for peace and simplicity, *The Longing for Less* quietly observes, with open eyes, heart, and mind, the spirit of iconic places and times when less has been enough." —Kay Larson, author of *Where the Heart Beats*

"Impeccably built and consistently fascinating... tenderly deconstructs the universal ache to build a life that matters." —Kristen Radtke, author of *Imagine Wanting Only This*

The Longing for Less

What's Missing from Minimalism

KYLE CHAYKA

BLOOMSBURY PUBLISHING
NEW YORK · LONDON · OXFORD · NEW DELHI · SYDNEY

For my parents, Marguerite and Paul

BLOOMSBURY PUBLISHING
Bloomsbury Publishing Inc.
1385 Broadway, New York, NY 10018, USA

BLOOMSBURY, BLOOMSBURY PUBLISHING, and the Diana logo
are trademarks of Bloomsbury Publishing Plc

First published in the United States 2020
This paperback edition published 2024

Bloomsbury Publishing Plc does not have any control over, or
responsibility for, any third-party websites referred to or in this book.
All internet addresses given in this book were correct at the time of
going to press. The author and publisher regret any inconvenience
caused if addresses have changed or sites have ceased to exist, but
can accept no responsibility for any such changes.

ISBN: HB: 978-1-63557-210-0; PB: 978-1-63973-419-1;
eBook: 978-1-63557-211-7

Library of Congress Cataloging-in-Publication Data is available

2 4 6 8 10 9 7 5 3 1

Designed by Elizabeth Van Itallie
Typeset by Westchester Publishing Services
Printed and bound in the U.S.A.

To find out more about our authors and books visit www.bloomsbury.com
and sign up for our newsletters.

Bloomsbury books may be purchased for business or promotional use.
For information on bulk purchases please contact Macmillan Corporate
and Premium Sales Department at specialmarkets@macmillan.com.

To Whom

No subject
No image
No taste
No object
No beauty
No message
No talent
No technique (no why)
No idea
No intention
No art
No feeling
No black
No white (no and)

—John Cage, "To Whom" (1953)

Contents

1. Reduction

SONRISA ANDERSEN'S CHILDHOOD home was a mess. Her parents had split when she was eight years old and she'd moved to Colorado Springs with her mother. Then she realized her mother was a hoarder. It might have been grief over the lost marriage that caused it, or maybe it was a habit that had gotten worse as her mother's dependence on drugs and alcohol intensified. On the kitchen table there were piles of clothes stacked all the way to the ceiling, things they would get for free from churches or charities, sometimes not even in the right size, sometimes still dirty. Spare furniture that Andersen's well-meaning grandmother found on the street accumulated. An avalanche of pots and pans, more than could ever be useful, spilled all over the kitchen counters and floor. Anything her mother could get for free or cheap she would bring into the house and leave there.

As a child, Andersen tried to clean things up, but she could do only so much. She became adept at organizing, finding a spot for every-thing. She kept her own space under control, but beyond her bedroom door the mess persisted. The family was poor; with better judgment her mother might have bought only what they needed but instead poverty drove a siege mentality. A sweater, a chair, a baking sheet—you never knew what you might not be able to replace if you threw it out. The prospect of getting rid of stuff was marked with a sense of risk that made it insurmountable.

Andersen knew she needed to leave home in order to change her circumstances. At seventeen she joined the Air Force and moved to New Mexico, then landed another military job back in Colorado. She followed her career to Alaska and then to Ohio, where she now lives with her husband, Shane, and works as an aerospace physiology technician. But the anxiety over her oppressive surroundings at home never left. Clutter was creeping back in, even though this time she thought she was fully in control.

She realized that she and Shane owned two coffee makers instead of one. Little vases from IKEA and other random decorative objects covered every spare surface. Somehow ten spatulas appeared in their one kitchen. There were gadgets ordered online, piles of scrapbooking materials, and souvenirs from the marathons she had run. Credit cards paid for the odd new outfit, television, or smartphone. In the beginning of 2016, when Andersen was thirty years old, one of the couple's two SUVs died completely and was marooned in the driveway. So they leased a third car on top of all their other expenses. There was too much stuff around and too much debt to pay for it. She wasn't sure how to stop from falling into the pattern set by her mother and the threat of more accumulation.

Andersen wanted all the things she had lacked in childhood, the comforts that her colleagues and neighbors enjoyed. She wanted to be like the people in commercials, with their immaculate stage-set living rooms. "You see people around you who had all these things"—the house, the car, the washer-dryer—"and assume that they're happy, and that's what made them happy," she told me. "You just keep getting more stuff, thinking that that's part of your ideal life." Each new purchase brought its small dopamine rush that faded as soon as the thing was out of its box and taking up space.

So she did what any millennial would do and googled for a solution to the stress. The search turned up blogs about "minimalism": a

lifestyle of living with less and being happy with, and more aware of, what you already owned. The minimalist bloggers were men and women who, like her, had had an epiphany that came from a personal crisis of consumerism. Buying more had failed to make them happier. In fact, it was entrapping them, and they needed to find a new relationship to their possessions, usually by throwing most of them out. After going through a minimizing process and jettisoning as much as they possibly could, the bloggers showed off their emptied apartments—open shelves in the kitchen with only a few plates, closets sparsely hung with a few monochrome outfits—and shared the strategies they used to own no more than one hundred objects. The advice gained them audiences of the similarly dissatisfied, and they profited on their minimalism expertise by soliciting donations or selling books. Presiding over them all was Marie Kondo, a Japanese cleaning guru whose books were selling millions of copies off the shelves of every bookstore in the country. The principal commandment of Kondoism was to abandon anything that didn't "spark joy," a phrase that became vernacular.

What the bloggers collectively called "minimalism" amounted to a kind of enlightened simplicity, a moral message combined with a particularly austere visual style. This style was displayed primarily on Instagram and Pinterest (where Andersen made a #minimalism board), two social networks that encouraged the accumulation of aspirational digital artifacts, if not physical ones. Certain hallmarks of minimalist imagery emerged: clean white subway tile, furniture in the style of Scandinavian mid-century modern, and clothing made of organic fabrics from brands that promised you would only ever need to buy one of each piece. Next to the products were monochromatic memes with slogans like "Own less stuff. Find more purpose" and "The more you throw away, the

more you'll find." Minimalism was a brand to identify with as much as a way of coping with mess.

Andersen bought the minimalist books and listened to the podcasts. Under their influence, she removed everything from the walls of her home, cleared off every surface, and installed furniture made of light pinewood so that the rooms glowed in the sun. Without buying new stuff, the couple had enough money to pay off their bills and Shane's student loans. The effect was refreshing mentally and physically; Andersen felt a weight being released that went beyond the absence of clutter. She gained a reputation among her friends for her minimalist identity. Her boss gave her an ornament for Christmas and joked that she wasn't allowed to sell it on eBay to get rid of it, though she planned to anyway. Minimalism required discipline. She spent a full year determining if she should spend $20 on a new glass to-go coffee mug. (She did, and it was worth it.) She felt consumerism's spell over her had been broken. "You don't have to want things," she said. "It's a meditative thing, almost like repeating a mantra."

It wasn't just because of her traumatic childhood, Andersen thought. Something had gone wrong in what was once the American dream of successful materialism.

I met Andersen in 2017 in Cincinnati, where we were both attending a lecture on minimalism held at a local concert venue, with folding chairs lined up on the stale-beer-sticky floor. She had an air of self-possession and confidence that came from the experiences she struggled through, mingled with a certain shyness. There was nothing extraneous in her manner. In that way she was the opposite of the two thirtysomething men we had come to see, a pair of ebullient bloggers named Joshua Fields Millburn and Ryan Nicodemus, who started calling themselves the Minimalists in 2010. Both of the guys had

enjoyed six-figure salaries at big-time corporate jobs in technology marketing, but amid mounting debt and addiction problems they hit the reset button, turning to blogging instead—chronicling about how they got rid of everything and started over.

The Minimalists self-published books and accrued millions of podcast listeners. In 2016 their documentary about minimalist practices across the country was picked up by Netflix. That was the tipping point; most of the fans I talked to in Cincinnati cited the film as their conversion moment to minimalism.

Millburn and Nicodemus, both dressed in all black, were embarked on their "Less Is Now" tour, a nationwide spin through theaters and concert halls where they drew congregations of hundreds to hear the message that "life's most important things actually aren't things at all," as Millburn declaimed from the stage that night. The space was packed with couples and families as well as those who came on their own: women who wanted their husbands to clean up more, retail workers who regretted selling products people didn't need, and writers trying to launch their own minimalist blogs. Before coming together in person these fans met online through themed Facebook groups where they traded cleaning tips, critiqued each other's closet layouts, and sought emotional support. ("How can I stop people from getting upset with me for throwing out things?")

What they all had in common was some version of Andersen's fundamental ennui. They felt that if buying more stuff had become a source of stress instead of comfort and stability, then maybe the opposite would make them happier. So they took out the trash bags.

I had been tracking the rise of this minimalist movement and the style that it produced in my work as a journalist, but its momentum still surprised me. It was a new social attitude that took its name from what

was originally an avant-garde art movement that started in 1960s New York City. How could that have happened? Unlike Pop Art, for example, Minimalist visual art still isn't particularly mainstream, and yet the word was also a viral hashtag.

The trend wasn't just for the wealthy or the cultural elite. There in Cincinnati were suburban commuters, high school students, and retirees alike discussing how they had embraced minimalism. Millburn and Nicodemus told me that they'd found fans as far away as India and Japan. When the lecture ended, the ticket buyers waited in a line snaking through the venue to get the gurus to sign their books, which the Minimalists recommended giving away instead of adding to the pile on the shelf. You can never minimize too much—"less is more," as the popular saying goes.

It's unclear just how less becomes more, however. Minimalism's process of reduction was implicit: You cut down, throw out, make a conscious selection. And then what? Does the empty space left behind provide room for something different to take its place? Or when a minimalist arrives at this state of less-ness, have they attained some new kind of grace, so complete unto itself that it requires nothing else?

Over the following two years, minimalism kept popping up everywhere around me—in hotel designs, fashion brands, and self-help books. "Digital minimalism" became a term for avoiding the overwhelming information deluge of the internet and trying to not check your phone as much. But when I caught up with Andersen more recently, I learned she had left her local minimalism Facebook group and stopped listening to the Minimalists' podcast every week. It wasn't that she didn't believe in minimalism anymore. It had just become an integral part of her life, the basis for her entire approach to the stuff around her. She noticed it was sometimes more trendy than practical:

There were people who liked talking about minimalism more than actually practicing it, she said.

On one hand there was the facade of minimalism: its brand and visual appearance. On the other was the unhappiness at the root of it all, caused by a society that tells you more is always better. Every advertisement for a new product implied that you should dislike what you already had. It took Andersen a long time to understand the lesson: "There was really nothing wrong with our lives at all."

WHEN I BEGAN working on this book, I didn't think of myself as a minimalist like Andersen did. Whenever someone asked me if I was one it gave me pause. I don't think minimalism could possibly be a bad thing. In the twenty-first-century United States, most of us don't need as much as we have. The average American household possesses over three hundred thousand items. Americans buy 40 percent of the world's toys despite being home to 3 percent of the world's children. We each purchase more than sixty new items of clothing a year, on average, only to throw out seventy pounds of textiles per person. The vast majority of Americans—around 80 percent—are in some kind of debt. We're addicted to accumulation.

The minimalist lifestyle seems like a conscientious way of approaching the world now that we've realized the buildup of human materialism, accelerating since the industrial revolution, is literally destroying the planet. Our excess is choking rivers, killing animals, and accruing in floating garbage patches in the middle of the ocean. We should indeed be reconsidering every new thing we buy because if it's not absolutely necessary, it makes life worse in the long run for all of us.

Yet like any label, aspects of this minimalist trend don't fit for me. My gut reaction to Marie Kondo and the Minimalists was that it all

seemed a little too convenient: Just sort through your house or listen to a podcast, and happiness, satisfaction, and peace of mind could all be yours. It was a blanket solution so vague that it could be applied to anyone and anything. You could use the Kondo method for your closet, your Facebook account, or your boyfriend. Minimalism also seemed sometimes to be a form of individualism, an excuse to put yourself first by thinking, *I shouldn't have to deal with this person, place, or thing because it doesn't fit within my worldview.* On an economic level it was a commandment to live safely within your means versus pursuing dreamy aspirations or taking a leap of faith—not a particularly inspiring doctrine. As the architect Pier Vittorio Aureli writes, the "less is more" attitude can be a form of capitalist exploitation, encouraging workers to produce more while getting by with less, creating more profit for their bosses at the cost of their own quality of life.

Minimalism, I came to think, isn't necessarily a voluntary personal choice but an inevitable societal and cultural shift responding to the experience of living through the 2000s. Up through the twentieth century, material accumulation and stability made sense as forms of security. If you owned your home and your land, no one could take it away from you. If you stuck with one company throughout your career, it was insurance against periods of future economic instability, when you hoped your employer would protect you. Little of this feels true today. The percentage of workers who are freelance instead of salaried grows annually. Real estate prices are prohibitive in any place with a strong labor market. Economic inequality is worse than ever in the modern era. To make matters worse, the greatest wealth now comes from the accumulation of invisible capital, not physical stuff: start-up equity, stock shares, and offshore bank accounts opened to avoid taxes. As the French economist Thomas Piketty points out, these

immaterial possessions grow in value much faster than salaries do. That is, if you're lucky enough to have a salary in the first place. Crisis following crisis; flexibility and mobility now feel safer than being static, another reason that owning less looks more and more attractive.

Most of all, the minimalist attitude speaks to the sense that all aspects of life have become relentlessly commodified. Buying unnecessary items on Amazon with credit cards, like Sonrisa Andersen had, is a fast and easy way to exert some feeling of control over our precarious surroundings. Brands sell us cars, televisions, smartphones, and other products (often on loans that inflate their costs) as if they will solve our problems. Through books, podcasts, and designed objects, the idea of minimalism itself has also been commodified and turned into a source of profit.

If I'm a minimalist, then, it's by default. As someone who grew up in and then moved away from the suburbs, I'm ambivalent about the sprawl of physical stuff. In my childhood home in rural Connecticut, clutter was a persistent problem even though the house had three furnished floors and a two-car garage. I remember my parents fighting over where piles of paper, books, and electronic devices accumulated. The spots left a visceral mark in my memory: on top of a stereo speaker in the living room, on the steps going upstairs, and the kitchen counter by the landline phone. At the time I didn't feel like it was anyone's fault in particular; it was like the tide had come and gone, leaving detritus scattered at random all over the place. In retrospect my younger brother and I were probably responsible for a lot of it.

My first association with the term "minimalism" came not from the world of material goods but from art history. That species of Minimalism, which gets its own capital *M*, is different from the ideas and products that are now labeled "minimalist." I first encountered Minimalist art in

high school classes, and then pursued it through self-motivated research in library books. I was drawn to the polished, bright surfaces of mid-century art like Donald Judd's metal sculptures, Dan Flavin's fluorescent lights mounted on gallery walls, and the serene gridded canvases of Agnes Martin. That severe aesthetic could also be found in architecture, with the hard edges and immaculate spaces of Bauhaus modernism, so different from the wood siding and carpets of my child-hood home. Minimalist art presented a new, unexpected way of seeing and being in the world, beyond just living with fewer possessions.

Later, the lifestyle of minimalism became a reality for me. I was in college when the 2008 financial crisis hit. From outside the workforce, I observed the impact on my older classmates, who couldn't find jobs and deferred careers with graduate school and fellowships. I gradu-ated in 2010. At the last minute, I managed to get a paid internship at a visual art magazine in Beijing. I packed two suitcases, left the country, and moved into what was once Communist worker housing. An American friend who also couldn't find a job at home ended up crashing with me there on a bed in the living room. Then I got a job offer in New York City: An art website would pay me $2,000 a month in cash-filled envelopes to be their staff writer. I packed up again. Through my twenties and a series of sublets and crowded multi-bedroom apartments across Brooklyn, my IKEA furniture was mostly disposable, and my possessions were portable. I decorated each new room like it was a hotel I would have to leave in a hurry.

In the apartment where I lived while I wrote this book, I could look around and count the objects that belonged to me. Not the couch, bed, television, console, or dining table, which came from my one room-mate. Just a desk and a bookshelf that held most of the things I cared about: books, papers, a few pieces of art. Unless you're wealthy or

creative enough to afford a lot of space, there are two responses to living in New York: One is overstuffing a tiny space that eventually becomes unbearable and the other is living like a minimalist. Without basements, spare closets, or extra rooms to stash stuff in, you're always Kondo-ing.

But the recession also seemed to usher in a larger minimalist moment. An aesthetic of necessity emerged as the economy came to a standstill. Shopping at thrift stores became cool. So did a certain style of rustic simplicity, the kind epitomized by the lifestyle magazine *Kinfolk*, which was founded around the time of the crash and took root in Portland, Oregon. As the magazine's soft-focus photo shoots demonstrated, perhaps too well, hosting an outdoor picnic with your friends, decked out in DIY peasant shawls, didn't cost very much. Brooklyn was filled with faux-lumberjacks drinking out of mason jars. Conspicuous consumption, the ostentation of the previous decades, wasn't just distasteful, it was unreachable. This faux-blue-collar hipsterism preceded the turn to high-gloss consumer minimalism that happened once the economic recovery kicked in, preparing the ground for its popularity.

It makes sense that millennials embrace minimalism. My generation has never had a healthy relationship with material stability. There are always too few resources at hand or too much competition for what's left, a scenario that's engulfing not just one age group but a wider swath of people every year. Even as the traditional economy falls apart, we're awash in social media noise and new platforms competing for our attention, labor, and cash. Stability is no longer the default.

My purpose in writing this book was to figure out the origins of the thought that less could be better than more—in possessions, in aesthetics, in sensory perception, and in the philosophy with which we approach our lives. Dissatisfaction with materialism and the usual

rewards of society is not new, and by looking at how that dissatisfaction has cycled through previous centuries, how artists and writers and philosophers have already contended with it, I could find what was truly worth keeping. Swerving between austerity and extravagance is stressful; finding the source of our material anxiety might make it more manageable. I wanted to uncover a minimalism of ideas rather than things, not obsess over possessions or the lack thereof but challenge our day-to-day experience of being in the world.

Chronological history is too causal an approach for minimalism. Its ideas don't have one linear path or evolution; it's more of a feeling that repeats in different times and places around the world. It's defined by the sense that the surrounding civilization is excessive—physically or psychologically too much—and has thus lost some kind of original authenticity that must be regained. The material world holds less meaning in these moments, and so accumulating more loses its appeal in favor of giving things up and isolating yourself, whether literally—becoming a hermit or nomad—or through art. No single English-language word quite captures this persistent feeling of being overwhelmed and yet alienated, which is maybe why "minimalism" has become so widespread.

I began thinking of this universal feeling as the longing for less. It's an abstract, almost nostalgic desire, a pull toward a different, simpler world. Not past nor future, neither utopian nor dystopian, this more authentic world is always just beyond our current existence in a place we can never quite reach. Maybe the longing for less is the constant shadow of humanity's self-doubt: What if we were better off without everything we've gained in modern society? If the trappings of civilization leave us so dissatisfied, then maybe their absence is preferable, and we should abandon them in order to seek some deeper truth.

The longing for less is neither an illness nor a cure. Minimalism is just one way of thinking about what makes a good life, though it's a strategy that's particularly relevant when confronting the superhuman scale and pace of our time.

Minimalism's lack of a coherent history is in part due to its nature—it instinctively tends to erase its own background, as if starting anew in each iteration. If its practitioners admitted to being referential or reviving a past tradition, they wouldn't seem so radically minimal after all. Yet no matter where or when you find minimalism emerging, it has certain consistent qualities. Each of this book's four chapters takes on one of these qualities and explores how it manifests. The longing for less is best captured in the texture of the lives of those who pursued it, and what they created that was inspired by it. Each person in this book seeks their own version of the idea, succeeding in some ways and failing in others. By observing the differences and similarities we can chart our own paths through the idea of minimalism.

The first of these common qualities is reduction, the pursuit of simplicity through throwing things out and moving apart, favored by figures from the Stoic philosophers to today's decluttering advocates. The second is emptiness, the austere visual style of Philip Johnson's American modernist architecture and Minimalist art like Donald Judd's, which inspired the current minimalist decorating fads but also have more powerful ideas about the control of space. The third is silence, the desire to buffer our senses from the chaotic world but also the radical possibilities of sound that can be found in the works of composers like Erik Satie, John Cage, and the lesser-known Julius Eastman. The final chapter is about what I call "shadow," the acceptance of ambiguity and the randomness of life or fate that emerges from Buddhist philosophy and Japanese aesthetics, which Westerners have increasingly

adopted over the past two centuries and which form the deepest root of the minimalist trend. The lessons these four aspects of minimalism have to teach us are not the ones we might, at first, expect.

Each of the four chapters is composed of eight smaller sections that take on particular people, ideas, or artifacts, from paintings to symphonies, essays, and buildings. The book's structure is like a grid or a space to wander through, encompassing a range of experiences. Through my research I experimented with sensory deprivation, traveled to see Judd's industrial-scale homes in the Texas desert, plumbed the depths of boredom at the Guggenheim Museum, and visited rock gardens in Kyoto. The way these examples relate to each other comes not only from their similarities but also from the blank spaces between them—the differences in practice or thought that can be seen in each object, artist, or thinker. You can hold on to whichever spark joy.

THE MINIMALIST BLOGGER Joshua Becker, an evangelical Christian and author of *The More of Less*, published in 2016, proposes Jesus as the original minimalist. When he instructed a rich man to "sell everything you own and give it away to the poor," the commandment wasn't about self-sacrifice, according to Becker. It meant that the rich man would be happier without the possessions, so giving them away was a net gain—a kind of minimalist prosperity gospel.

Yet the discipline goes back even further. Contemporary minimalism often gets mentioned alongside the ancient Greek philosophy of Stoicism. The school's founder was something of a minimalist himself, a wealthy Athenian merchant named Zeno of Citium who in the third century B.C.E. decided to forsake his worldly goods for the study of philosophy. (He gave his teachings from a porch, or *stoa*, hence the name.) His philosophy was about "a good flow of life," as Zeno put it, and "living in agreement," an ambivalence to worldly concerns and the vicissitudes of fate. Millennials have their own Stoic commandment: "lol nothing matters."

Most of Zeno's original writings haven't survived, but Stoicism is refracted through his followers. Cicero considered the dissatisfaction of materialism in his *Stoic Paradoxes* of 46 B.C.E. Even for those in possession of mansions, treasure, and power, "the thirst of desire is

never either filled or sated; not only are they tortured by the desire for increasing what they have, but also by fear of losing it." True authority comes from overcoming that thirst. A leader must "first curb his desires, scorn his pleasures, hold his anger, restrain his greed, and avert other spiritual faults; then let him command others." Not that Cicero gave up everything himself. He admitted that he, too, was "influenced somewhat by the error of the age." With this spirit in mind, perhaps, in 2019 a lobbying firm that advocates for Silicon Valley entrepreneurs adopted the philosopher's name and became the Cicero Institute.

Stoicism is especially popular on the internet, where podcasts, blogs, and forums pop up specifically to adapt the practice to more modern problems, like what to do when a romantic interest doesn't text you back. The Stoicism Reddit forum, which has some 149,000 members, debates what constitutes proper modern Stoicism. There's a discussion of how to stop the internet from making you unhappy, a Stoic argument for masturbation as the healthy satisfaction of human urges, and the resolution that tattoos are okay as long as you're getting them for yourself and not to gain social approval. ("Is Keanu Reeves a Stoic?" someone asks. Stoic Keanu probably would have stayed inside the Matrix and made the best of it.)

The Stoic can accept that society has flaws and expectations as long as she can avoid contaminating herself unduly with them. "Our life should observe a happy medium between the ways of a sage and the ways of the world at large," wrote Seneca, who lived until 65 C.E., when he was ordered to kill himself by Emperor Nero. Stoicism has no doctrine but a process of active judgment and self-awareness: It must be chosen moment to moment. You can't just convert in an instant. Even back then Seneca argued for not mistaking the appearance of austerity for commitment to its ideals: "We should not believe

the lack of silver and gold to be proof of the simple life." However, you might need some riches to attain elegant simplicity—as tutor and adviser to Nero, Seneca had plenty of material wealth. "Why this beautiful furniture, this wine older than yourself, these trees that yield nothing but shade?" he asked himself, looking for hypocrisy. Simple answer: He was doing as well as he could, given the circumstances and human fallibility. "Philosophy calls for plain living, but not for penance."

Simplicity didn't mean a lack of pleasure. In fact, the second-century C.E. emperor Marcus Aurelius offered a perfect manifesto for minimalist hedonism in his *Meditations*, a lifelong diary of Stoic aphorisms: "That which is really beautiful has no need of anything."

Despite his slight materialist hypocrisy, Seneca was taken up by early Christians and posthumously converted from Paganism. He would not have been extreme enough for later saints, however. For Saint Francis of Assisi, who established the Franciscan order of friars in the thirteenth century, there was no such thing as too much austerity. He had his followers vow poverty and wear rough gray robes. His hagiographer Thomas of Celano recalled that Francis "detested those in the Order who dressed in three layers of clothing or who wore soft clothes without necessity." Self-abnegation was next to godliness and materialism literally Satanic. "We ought not to have more use and esteem of money and coin than of stones," he wrote in the Franciscan Order's rules. "And the devil seeks to blind those who desire or value it more than stones."

Francis made self-sacrifice into performance art. He had a mania for giving clothing away to the poor and going naked. A monastery built a special cell for him to stay in during a visit but it was too well-constructed, so he requested that it be smudged with dirt and leaves

before he slept there—only then could he be comfortably uncomfortable. Rocks and pieces of wood were his pillows. To prove their piety his followers kept starving themselves to the point that Francis had to eat with them so that they didn't die. Pursuing material satisfaction was a sign that a person had already fallen from grace, according to Francis: "When the soul finds no delight, what is left except for the flesh to look for some?"

The United States has its own secular saint of asceticism in Henry David Thoreau, who famously retreated into the woods from 1845 to 1847 in order to find the joy of simplicity. More accurately, he moved to land owned by his friend Ralph Waldo Emerson on Walden Pond, a small body of water walkable of an evening from the town center of Concord, Massachusetts, where he grew up and where his mother's cooking was still freely available whenever he felt like going back. As far as an escape from society, it seems more like a child running away from home and making it to the nearest street corner.

In the rustic-chic cabin he built for himself Thoreau sought "to front only the essential facts of life," as he wrote in *Walden*, "to live deep and suck out all the marrow of life, to live so sturdily and Spartan-like as to put to rout all that was not life." Here, again, the good life lies in the purified remainder, not the excess that had to be thrown out. Only there could the truth be found: "Most of the luxuries, and many of the so-called comforts of life, are not only not indispensable, but positive hindrances to the elevation of mankind."

Thoreau pushes the point that anyone could carry out his experiment, though few people had the benefit of being a Harvard graduate and published writer who could turn his rusticating hobbies into profitable texts. As Kathryn Schulz wrote in a scathing *New Yorker* takedown, Thoreau was "narcissistic, fanatical about self-control, adamant

that he required nothing beyond himself to understand and thrive in the world."

Thoreau also sowed the seeds of another repeated misunderstanding, the belief that this enlightened simplicity had already been found in places and times that were exotic to him. "With respect to luxuries and comforts, the wisest have ever lived a more simple and meagre life than the poor," Thoreau wrote. "The ancient philosophers, Chinese, Hindoo, Persian, and Greek, were a class than which none has been poorer in outward riches, none so rich in inward." Never mind Seneca's wine cellar; most of Thoreau's "ancient philosophers" likely kept servants or slaves, a practice he detested in his own time. Still, there remains this sense that true austerity has to be imported from somewhere else.

What the Stoics, Francis, and Thoreau have in common is a strategy of avoidance, especially in moments when society feels chaotic or catastrophic. It's a coping mechanism for those who want to fix or improve the status quo instead of overturning it. Its orientation is toward survival. The minimalist is committed to the protective cultivation of the self in difficult situations—recall Sonrisa Andersen cleaning her room. Yet the withdrawal is paradoxical. The minimalist is ultimately a pragmatist who has to reconcile the desire for a better, cleaner world with the limits of what one person can influence. It's often an internal, individualized process rather than an external one: Your bedroom might be cleaner, but the world stays bad.

Among Thoreau's other accomplishments—including popularizing abolitionism, vegetarianism, and environmental conservation—he might have also invented the tiny house that's now the star of coffee-table books and reality TV shows. His Walden cabin was only ten feet by fifteen, but he observed an even smaller disused train car that he

fantasized about turning into a claustrophobic home by punching air holes in it: "Many a man is harassed to death to pay the rent of a larger and more luxurious box who would not have frozen to death in such a box as this," he wrote.

Minimalism is thus a kind of last resort. When we can't control our material security or life path, the only possibility left is to lower our expectations to the point where they're easier to achieve, which could mean living in a train car, or a camper van.

THE UNITED STATES is particularly vulnerable to the charms of mini-malism. Something about our belief in the power of self-definition and starting over suggests to us that if we only sweep our floors we will magically become new people, unburdened by the past. Maybe it started with the iconoclastic act of throwing tea off the boat in Boston Harbor, or it's the misperception that the country was simply blank space before the Pilgrims came from England and the pioneers headed west to occupy Native American lands. We like to think that we can do without, rough it to prove that we're not so soft or bound to the past. In fact, we've gone through a few nationwide cleaning fugues before Kondo.

In the 1920s, the American philosopher Richard Gregg traveled to India to study with Gandhi, then formulated a theory of nonviolent resistance that decades later inspired Martin Luther King Jr. Gregg followed that up with an essay in 1936 called "The Value of Voluntary Simplicity" in which he critiqued the "vast quantities of paper and ink devoted to advertisements" and the way that industrialized countries seemed to depend on an ever-increasing demand for material goods, which only new kinds of mass-manufacturing could satisfy. "We think that our machinery and technology will save us time and give us more leisure, but really they make life more crowded and hurried," he wrote.

"It is time to call a halt on endless gadgeteering." Rather than smart-phones, Gregg was critiquing telephones and Henry Ford's motorcars. The greed of traders in the newly ascendant stock market had also helped cause the Great Depression.

The solution to this hurried life was Gregg's "voluntary simplicity": a "singleness of purpose, sincerity and honesty within, as well as avoid-ance of exterior clutter, of many possessions irrelevant to the chief purpose of life." Voluntary simplicity emphasized "psychic goods" instead of owning physical things: art appreciation, friendship, and love, for example. We had already achieved material abundance, Gregg thought, so why continue the race to accrue even more? Possessing so much stuff as a consequence of wealth causes nervous strain because we're forced to make so many different decisions every day—a conclusion that now seems prophetic for the twenty-first century. (George Carlin mocked the problem in a 1986 stand-up segment: "That's the whole meaning of life, isn't it—just trying to find a place to put your stuff.") Choosing simplicity instead could provide a kind of "psychological hygiene."

Gregg saw voluntary simplicity as a new aesthetic system, in line with what was happening in European modernist architecture at the time. He also cited the experience of visiting a Japanese country inn that sought an overall harmony through soft colors and textures, as opposed to a Western excess of furniture and interior decoration. It taught him, "There can be beauty in complexity but complexity is not the essence of beauty." Like Thoreau a century before him, Gregg argued that the simplicity he advocated could be found in non-Western sources—the Indian Brahman class already lived in enlightened austerity, he wrote, as did the "leaders of China," which might have come as a surprise to Chinese peasants.

Gregg thought that simplicity might be a way to solve poverty, because if the privileged decided to live with less as a choice, then the

poor would feel better about their own "enforced simplicity," ridding them of their sense of inferiority. This is a superficial solution to a much deeper structural problem. It wouldn't do anything for access to healthcare or legal protection, and yet we hear the same narrative today: If only the poor would earn more and spend less money, then they wouldn't be so poor.

The essay was influential but it took a while to become mainstream. Four decades later, in 1977, Duane Elgin, a trend forecaster and public intellectual, who might now be called a "futurist," revived the concept of voluntary simplicity in a report of the same name written with Arnold Mitchell. He later turned the report into a bestselling book called *Voluntary Simplicity: Toward a Way of Life That Is Outwardly Simple, Inwardly Rich.* It was the '70s equivalent of Marie Kondo—the *Wall Street Journal* called it the "bible" of the simplicity movement and it has been reissued multiple times, most recently in 2010.

Elgin had worked with a government commission on population growth looking ahead to the year 2000 and then for the Stanford Research Institute. Over the years, he observed a trend of Americans "returning to the simple life," which the media had turned into a new archetype. Moving to the country, baking your own bread, and establishing cooperative businesses constituted a new social philosophy that mingled with the techno-utopianism of Stewart Brand's *Whole Earth Catalog* circa 1968. Elgin rebranded Gregg's voluntary simplicity with the acronym VS, which sounds more like a technological device than an idea with centuries of history—once again showing how minimalism erases its own past.

Elgin's version of VS was driven by a sense of disconnection: Economic and political structures had grown beyond human scale, so people wanted to separate themselves from them. He linked this attitude to a kind of nationalism that he saw as positive, writing that the

desire for simplicity is "reminiscent of the stubborn independence out of which was born the American Revolution." Getting rid of stuff wasn't only good; it was patriotic.

The "sense of urgency" to simplify that Elgin documented was intensified by a familiar kind of global havoc happening at the time: the threat of chronic energy shortage, the growth of terrorism, the possibility that even before we run out of resources "we may poison ourselves to death with environmental contaminants," and "a growing social malaise and purposelessness." Though Elgin assigns a problematic amount of blame to the "growing demands" of "less-developed nations," we're still concerned with the same issues now, decades later.

VS chimed with Chuck Burton, a man now in his late sixties, who grew up in the Bay Area in what he described to me as upper-middle-class luxury. Burton avoided the draft by going to college, where he made a habit of dropping LSD, and in 1971 he undertook a sojourn in Europe, backpacking and couch-surfing before there was an app for that. Back home he took temp jobs and lived in a group house. That's when he encountered Elgin's work. The philosophy "seemed about right," he said. Burton married a woman who also valued frugality and travel. When they had a daughter, they decided to settle down and bought a car and an 850-square-foot house in small-town Oregon. (Burton said his daughter is now "irredeemably materialistic," despite, or perhaps because of, her upbringing.) He still follows VS, travels four months out of the year, and prioritizes reading, hiking, and seeing his grandchildren. "Big houses and big cars are nothing but black holes," he said. "Almost everything I love is free."

Elgin predicted there could be as many as ninety million VS adherents by the year 2000, up from the ten million that he identified in

1977. While the label might not have survived, the ideas feed into today's popular minimalism. Elgin even saw how minimalism could create a greater emphasis on individual taste: "Material simplicity will thus likely be manifest in consumption styles that are less ascetic... and more aesthetic," Elgin wrote—in other words, not Spartan but stylized. He predicted the social media era's obsession with curated authenticity, the kind that we see displayed on Instagram accounts: "Each person will consider whether his or her level and pattern of consumption fits, with grace and integrity, into the practical art of daily living."

If we don't establish our identities with the *volume* of things we consume, then we feel more attuned to the *way* we consume them and the careful decisions we make between one thing and another. It's a species of the narcissism of small differences. We take pride in the small details that we have actually chosen from our limited options, which might make us feel better about not being able to change our circumstances as a whole.

Like Gregg and the Great Depression, Elgin's theories fit the mood of the 1970s, after the social upheaval of the late '60s had ended. Psychedelics didn't change much, the old social order had reasserted itself, and the Vietnam War had come to an unjustifiable end, ejecting scarred veterans. In the 1990s, another simplification fad emerged, spawning a clutch of books, including Janet Luhrs's bestselling *The Simple Living Guide* in 1997. The *New York Times* reported that recession-induced corporate downsizing was one motivation of those "choosing to buy and earn less." In each of these cases, minimalism always seems to follow crisis, as it has in the 2010s.

What Gregg and Elgin critiqued—and what minimalist bloggers struggle with, though they don't mention it by name—is the state of

capitalism itself. Consumerism causes a kind of alienation, in the Marxist sense: When workers are separated from the products of their labor and compensated by an hourly wage, they can't find satisfaction in their jobs or the remainder of family life. Thus they turn to acquiring capital as the only form of self-fulfillment. We work only to accumulate stuff and in turn the accumulated stuff dominates us, further distancing us from non-commodified things like relationships, joy, and community. Labor "is therefore not the satisfaction of a need, but only a means for satisfying needs external to it," Karl Marx wrote in 1844.

"The less you are, the less you express your own life, the more you have," Marx argued, "the greater is your alienated life, the greater is the store of your estranged being." Stuff is therefore the enemy of happiness, and not just because it's crowding your apartment, but because it's part of this larger alienating system.

FOR SOME OF its devotees, minimalism is therapy. The spasm of getting rid of everything is like an exorcism of the past clearing the way for a new future of pristine simplicity. It represents a decisive break. No longer will we depend on the accumulation of stuff to bring us happiness; we will instead be content with the things we have consciously decided to keep, the things that represent our ideal selves. By owning fewer things, the thinking goes, we might be able to recover from some of the alienation that Marx diagnosed—constructing new identities through selective curation instead of succumbing to rampant consumerism.

At least, that's the model popularized by Marie Kondo's books, social media accounts, and the instantly famous Netflix series that launched at the beginning of 2019. Kondo's books were a surprise mainstream hit in the United States—she's not someone you'd predict to sell six million copies. A quiet, young Japanese woman whose English is usually supplemented by a translator, she has been preoccupied with the clutter in her house since she was a child. She started cleaning professionally when she was nineteen and immediately accumulated a waitlist of clients. Then, she attended a publishing course titled "How to Write Bestsellers that Will Be Loved for Ten Years," during which a Japanese publisher spotted her cleaning aptitude and natural charisma. With his help, Kondo blew past the course's goal. The book was published in

Japan in 2011 and sold well, but it was supercharged by the aftermath of the tsunami that struck that year—another national trauma that made readers reconsider their relationship with their possessions.

The English-language edition of *The Life-Changing Magic of Tidying Up* was published in 2014; the start of the American boom is often traced to a journalist who published an account of her own Kondo-clasm in the *New York Times*. I bought Kondo's debut used, the victim of someone's cleaning spree. The "KonMari Method" that it describes is curiously rigid, with a ritualistic appeal lent by the process of handling each item in turn and deciding if it stays or goes.

If an object is thrown out, it must first be thanked for its service. The ritual relates to ancient Japanese Shinto, an animist religion holding the belief that all objects have spirits. Kondo might have absorbed it while working as a Shinto shrine assistant. Only by following Kondo's disciplined tenets can the reader be fully successful. Despite her claims that everyone should find their own version of tidiness, she critiques those who follow "erroneous conventional approaches" to cleaning. One must begin with clothes, then proceed to books, papers, and household miscellany. Sentimental items like photographs or memorabilia are last, because only by the end will you have built up the appropriate sensitivity to joy being sparked to evaluate such potent objects. You shouldn't listen to music while cleaning and the best time to do it is the morning, since the fresh air "keeps your mind clear." Nostalgia must either be banished or curated to death: "In the end, you are going to read very few of your books again," she commands, so throw most of them out. Her argument that a household really only needs thirty books incited a brief fury among literary audiences.

Kondo promises the illusion of choice. You decide what stays in your house but she tells you exactly how it should be folded, stored,

and displayed—in other words, how you should relate to it. When you pull everything out of its nooks and crannies, you realize just how much stuff you own and how much of it you don't really need. It's like learning what actually goes into junk food: Being forced to think about what you include in your life is enough to instill the habit of cleanliness forever. Kondo boasts that none of her clients has ever relapsed. "A dramatic reorganization of the home causes correspondingly dramatic changes in lifestyle and perspective," she writes. Readers trade the orthodoxy of consumerism for the orthodoxy of tidiness. KonMari might seem vaguely anti-capitalist, but then there's the fact that you have to buy a suite of Kondo books to practice it. She has been fully transformed into a commercial brand: Her company now sells luxury Kondo boxes to organize your stuff in and offers expensive certification classes for would-be Kondo acolytes.

Minimalism was already being commodified when Kondo emerged, however. She was only the crest of a larger 2010s wave of writers adopting the idea, a context that often goes unnoticed given her omnipresence. Her English-language predecessors came from the online lifestyle-blogger community, with blogs like Joshua Becker's *Becoming Minimalist*, begun in 2008; Courtney Carver's *Be More With Less*, in 2010; and *The Minimalists*, who had already self-published their book *Minimalism: Live a Meaningful Life* in 2011.

The literature of the minimalist lifestyle is an exercise in banality. It's saccharine and predigested, presented as self-help as much as a practical how-to guide. Each book contains an easy structure of epiphany and aftermath, recounting the crisis that leads its author to minimalism, the minimalist metamorphosis, and then the positive ways the author's life changed. The books are often broken up into subheadings, and important phrases are bolded like a high school textbook.

Each one offers more or less the same vision as the others: "I don't need to own all this stuff," Becker writes. Minimalism's rewards are said to be more money, more generosity, more freedom, less stress, less distraction, less environmental impact, higher-quality belongings, and more contentment, as Becker reels off in a series of bullet points. The books' sameness of content is matched by a shared design of visual serenity. Their covers are all soft colors and soothing typefaces, suitable for Instagramming—even if you don't read them, they can still be inspiring.

Other publishers tried to jump on the profitable trend of clean, quiet books about quiet cleaning. The closest to Kondo might be Fumio Sasaki's *Goodbye, Things: The New Japanese Minimalism*, which was published in English in 2017. Another import from Japan but published by W. W. Norton instead of Kondo's Crown, the book's marketing copy separates Sasaki from Kondo by stating "he's just a regular guy." A thirty-five-year-old self-identified "loser" with a job in publishing (actually a co-editor-in-chief), he decides that all of his books, DVDs, vintage cameras, antique lamps, and spare clothes have to go because they weren't making him happy. Before and after photos printed in the beginning of the book show his apartment reduced to an oppressively empty space holding only a single low table and a futon that folds into a makeshift couch.

Sasaki felt he had failed at his creative aspirations, like music and cinephilia, and so claimed the process of getting rid of them as an artistic act in itself. The author sees living with less as an Edenic state of purity and authenticity that has been lost to history, particularly in his own country: "We're all born into this world as minimalists, but we Japanese used to lead minimalist lives as well." Sasaki suggests "digital detox" along with cleaning, practicing Zen meditation and yoga instead of texting.

For all of the literature's anti-accumulation messaging, the trend has produced piles of minimalist kitsch that cluttered up the stands next to bookstore cash registers. Kondo's books were republished in illustrated and comic book editions. A pocket-sized *Little Book of Tidiness* curated minimalist dictums and quotes from, among many others, Marie Kondo herself. "What are you trying to distract yourself from by buying?" it asks. *The Little Book of Hygge* blew up the trendy Danish word for coziness, which became synonymous with comfortable minimalist style: plush neutral-colored sofas, cashmere cardigans, candles. Another book took on *ikigai*, a Japanese method of finding purpose in life. Beth Kempton, a "Japanologist and life coach," offered *Wabi Sabi*, which riffed on the Japanese phrase that means something like "perfectly imperfect." Kempton called for "soulful simplicity" and "an intuitive response to beauty that reflects the true nature of things as they are."

The trend peaked with Kondo's Netflix show, *Tidying Up with Marie Kondo*. Available on the first day of 2019, it capitalized on the season's spirit of self-reinvention: new year, new, cleaner you. Kondo had moved to the United States, she explained, and would help families across California confront the messiness of their homes, lives, and hearts through her signature method. The television format ignited Kondo mania anew—the internet was suddenly full of memes and Instagram posts of packed garbage bags and neatly ordered drawers tagged #sparkjoy: Kondo's viewers wanted her to be proud of their efforts. Thrift stores experienced a renaissance of donations.

The show's goal was "inspiring the world to choose joy," as Kondo explained in the voice-over. Who wouldn't want that? The confessional HGTV-reality-show format was Freudian: Kondo drew out repressed feelings in the form of hidden mountains of clothes, papers, and books.

The excess stuff symbolized familial tension, a couple's fight over dish washing, and a woman's grief for her late husband.

Under Kondo's watchful eye, clients picked through the piles, handling each object and ejecting those that didn't spark any joy after gently thanking them. As the objects disappear the psychological burden also dissipates: The clients are happy once more. "All this life that we lived and the dreams that he had, and now they're in a pile on the floor," the bereaved woman cried while sorting through her late husband's possessions. But after the ritual: "I can't believe there's room on the carpet!" Finally, she could create her own craft studio. Feelings, encoded in things, are banished in favor of empty space.

The KonMari Method, and minimalist self-help as a whole, works because it's a simple, almost one-step procedure, as memorable as a brand slogan. It's a shock treatment demonstrating that you don't need to depend on possessions for an identity; you still exist even when they're gone. But as Kondo conceives it, it's also a one-size-fits-all process that has a way of homogenizing homes and erasing traces of personality or quirkiness, like the sprawling collection of Christmas decorations that one woman on the Netflix show was forced to decimate over the course of an episode. The overflow of nutcrackers and tinsel was a clear problem (as was her husband's piles of baseball cards), but with their absence the home was sanitized. Minimalist cleanliness is the state of acceptable normalcy that everyone must adhere to, no matter how boring it looks or how oppressive it feels.

THE SOFT, SERENE covers of self-help books are just one example of how, like a spoonful of sugar, minimalism's visual appeal makes its doctrine of sacrifice easier to swallow. Its aesthetic of fashionable austerity is like a brand logo. It is identifiable anywhere and serves to remind us of the air of moral purity that simplicity is associated with, by Elgin and others, even if the minimalist product or space to be consumed has no moral content whatsoever. The word is applied indiscriminately, describing only a superficial style.

As I write this, I'm sitting in the lobby of a new hotel that used to be an enormous church. Now under the barrel-vaulted ceiling is a café counter opening onto a vaguely bohemian hangout full of slow break-fast meetings and officeless freelancers stationed with their laptops. The old stained-glass windows have been replaced with clear panels and the pews with low, plush blue-velvet couches and black hexagonal side tables arranged in repeating configurations as if it were the chill-out room of a disco.

Online and in print, journalists have described the style of this hotel as minimalist, and I'm sure many visitors would agree. It has a certain aggressive cleanliness. The historical remains of the church have been erased by painting the walls pale blue and the ceilings white. The space has been divided by glass walls and illuminated by orbs mounted

on squares of brass. The ceiling is high and airy, left open above a mezzanine, the expanse broken only by a hanging geometric sculpture made out of what used to be organ pipes. The design draws attention to scale and emptiness, the volume more than the meaning of the architecture. The building's religious legacy is only hinted at, as if an amusing joke. Its interior has been covered with the same deceptively simple design that can be found in coffee shops, co-working spaces, retail boutiques, and rooms on Airbnb. In order to succeed, all of these types of places need to make multiple groups of people feel comfortable at the same time. Minimalism is a perfect fit because it allows for just enough character to make a space interesting but not too much. The rest gets smoothed over into blankness.

The hotel is a zone of commerce instead of organic community, a place where customers trade the price of a cappuccino or a perfectly formed croissant for access to a luxurious, high-design space for an hour or two. It addresses itself to a particular type of occupant: the relaxed creative driven by the pursuit of rarified taste above all else—an aspirational identity that fits better for some than others. The room has been laboriously and expensively decorated to emit a sense of informal effortlessness tuned to current fashion, neither old nor young, stuffy nor sloppy, only just right. It is "impeccable without having reference to any authority that could be perceived as inhibiting," as George W. S. Trow described the interior of a stylish restaurant in the *New Yorker* in 1978. (Trow was referring to brown-velvet walls adorned with English hunting prints, which wouldn't pass muster as elegant today—taste always moves on, as it will with minimalism in turn.)

The hotel design presents me with a cultural detective story. How did an unlikely avant-garde phenomenon become the generic luxury style of the 2010s, both an aesthetic commodity and an ascetic

philosophy at the same time? The trend is undeniable: Google's index of published books shows a fivefold increase in the use of "minimalism" between 1960 and 2008, moving from near-zero to mainstream. Google searches for the term also hit the tip of a massive spike at the beginning of January 2017, the digital archeological mark of the cleaning binge.

To witness the minimalist aesthetic fad during the years of its high-water mark between 2016 and 2018 you had only to look around. Cuyana, a women's fashion basics brand, opened a location in New York City's SoHo and emblazoned its slogan on the glass storefront, which glowed day and night to hypnotized pedestrians: "Fewer, better." A lighting brand called Schoolhouse commanded, "Want better, not more," in its ads. An August 2016 editor's letter in the glossy *T Magazine* recommended a terse manifesto: "Less, but Better." "Fewer things of higher quality...with less of the middling stuff that takes up space in our closets, our living rooms and our psyches," then-editor-in-chief Deborah Needleman wrote. The headline's uncited source is the German industrial designer Dieter Rams, who first included "less but better" in his 1970s Ten Principles for Good Design. For Rams it was a mark of efficiency but for Needleman it's luxury.

The moment that I knew minimalism was truly inescapable was while catching a train in New York's Penn Station. A woman walked toward me wearing a black-and-white-striped shirt with MINIMALISM written on the chest in glittering letters like a Louis Vuitton or Supreme logo would be, as if the word meant nothing at all, which maybe it didn't. For a while I figured I had hallucinated the shirt, but then I discovered online that it was sold by the Gap.

When a word or style spreads everywhere, it tends to lose its original meaning. There are more than thirteen million posts tagged with

#minimalism on Instagram and around ten new images appear every minute. Millions more are uploaded on Pinterest, where users collect inspiration for redecorating their homes or rethinking their wardrobes. Shots of the blue sky pockmarked with clouds are categorized as minimalist, as are line-drawing tattoos, wrinkled bedsheets, folded clothing, Chemex coffee makers, spiral staircases, monochrome athleisure outfits, rustic cabins in the snow, and demure selfies.

An archive of material suggests that minimalism entails blocks of solid color, organic textures, desaturated hues, and a lack of patterns. Minimalist imagery has only a few discrete subjects or focal points, often centered. The style seems adapted for the internet and social media, where every image must either compete with or match the vacuum of white website backgrounds. It looks good on the screens that contain so much of our visual experience because the abundance of blank space makes otherwise subtle qualities stand out.

The epitome of this aesthetic online might be the Instagram account of the minimalist architect John Pawson, who takes snapshots that resemble his harshly empty buildings: patches of light falling onto bare white walls, a single tree in a forest, an abstract pattern of sewer grates. Each image is studiously ordered and yet just off-balance enough to avoid boredom. It doesn't matter what the subject is, only that it exudes this inoffensiveness. Scrolling through his feed feels like sitting through an overly polite dinner party. Humans don't usually feature in Pawson's photographs—they're too messy, too uncontrollable.

"Minimal living has always offered a sense of liberation, a chance to be in touch with the essence of existence, rather than distracted by the trivial," Pawson wrote in his 1996 book, *Minimum* (it has more images than words). "Simplicity has a moral dimension, implying selflessness

and unworldliness." The word "implying" here does a lot of work when Pawson uses the morally pure style of simplicity to design boutique hotels and million-dollar apartments. The superficial "liberation" and directness of the aesthetic might be reasons why Kanye West and Kim Kardashian chose to decorate their mansion in Hidden Hills, California, in an extremely minimalist mode, a collaboration between West and the designer Axel Vervoordt. Perhaps the epitome of commercialized minimalism, one gossip headline asked, "Why Is Kim Kardashian and Kanye West's Home So Empty?" All the walls are white or beige. All the furniture is geometric. The square footage isn't used or decorated but left bare, like a rendering more than a home. They have so much space that they don't even have to do anything with it at all.

The veneer of minimalist style becomes like an organic food label, expensive green juices, or complex skin treatments being sold as a "no-makeup" look. It's another class-dependent way of feeling better about yourself by buying a product, as Spartan as the product might be. It takes a lot of money to look this simple.

IN A FAMOUS photograph from 1982, one that seems destined for future historians to analyze as a representation of the late-twentieth century, Steve Jobs sits on the floor of his living room. Jobs was in his late twenties at the time and Apple was making a billion dollars a year in revenue. He had just bought a large house in Los Gatos, California, close to both the Apple office and his parents' home, but he kept it totally empty. In Diana Walker's photo he is seen cross-legged on a single square of carpet, holding a mug, wearing a simple dark sweater and jeans—his prototypical uniform. A tall lamp by his side casts a perfect circle of light; even in the darkness you can see there's almost nothing else occupying the room's bare floorboards. "This was a very typical time," Jobs later remembered. "All you needed was a cup of tea, a light, and your stereo, you know, and that's what I had."

Jobs might be the most famous proponent of minimalism as a life hack. His fashion choices have inspired countless blog posts and copycats, maybe in the hope that a black turtleneck will instill entrepreneurial genius. Yet even before his success Jobs had a reputation for asceticism. He followed restrictive diets, roamed barefoot through India in the '70s, and took up Zen meditation back in California. In the 1982 photo he's quietly confident, with a calm, self-satisfied smile on his face—a demonstration that he's perfectly content with what he has,

even though he could afford far more stuff. Not for him, the usual displays of wealth or status. Maybe artists or architects had already adopted aspirational simplicity at the time, but as an engineer and businessman Jobs brought the style to wider cultural exposure.

Yet the image of simplicity is deceiving. The house Jobs bought was huge for a young, single man with no use for that excess space. *Wired* magazine later discovered that the stereo setup resting in the corner would cost some $8,200. The lone lamp that illuminates the scene was made by Tiffany. It's a valuable antique, not a utilitarian tool. Minimalism often creates this kind of illusion.

In his 1896 essay "The Tall Office Building Artistically Considered," the American architect Louis Sullivan introduced his famous dictum that "form ever follows function," kicking off the following century of architecture and design. Sullivan meant that the external appearance of an object or building should reflect the way that it works and how it's constructed. Though the two are often conflated, there's a big difference between Sullivan's efficient functionalism and the self-conscious appearance of minimalism, as in Jobs's house or the ultimate design of Apple's iPhone. The empty living room wasn't particularly usable. Instead of "form follows function," Jobs echoes that SoHo storefront slogan, "Fewer, better" things—possess the best things and only the best things, if you can afford them. It was better to go without a couch than buy one that wasn't perfect. That commitment to taste might be rarified, but it probably didn't endear Jobs to his family, who might have preferred a place to sit.

The need for simplicity, taken to an extreme, can wipe function away entirely. In the newest Apple headquarters, a perfect circle that Jobs designed with the architect Norman Foster, many of the internal walls are glass. The design might look more immaterial, but employees kept

bumping into the glass and hurting themselves until they appended sticky notes to the transparent barriers, ruining the style but preventing injury.

Apple devices have gradually simplified in appearance over time under designer Jony Ive, who joined the company in 1992, making them synonymous with minimalism. The 1984 Macintosh 128K was white and boxy with an inset nine-inch screen and fans with visible air slots like gills—inelegant, but its shape revealed the structure of what made it work, form giving way to function. It would count as a success for Sullivan. The 1998 iMac was rounded into a self-contained volume with a transparent window of colored plastic, more organism than machine. By 2002, the computer had evolved into a thin flat-screen mounted on an arm connected to a rounded base like a vestigial lump. Then, into the 2010s, the screen flattened even more and the base vanished until all that was left were two intersecting lines, one with a right angle for the base and another, straight, for the screen.

The chunky first iPod, with its rotating wheel interface, similarly evolved slowly into the iPhone and its subsequent iterations, each thinner, lighter, and smoother than the last, with fewer breaks in the phone's immaculate case. It sometimes seems that our machines are becoming infinitely thin, infinitely wide screens that we will eventually control by thought alone, because touch would be too dirty, too analog.

Does this all really constitute simplicity? Dieter Rams, one of Ive's inspirations, had another saying: "Good design is as little design as possible," meaning that the designer ought to stay out of the way of their materials and avoid needless complexity. In one way, Apple follows the rule: The devices have only a few visual qualities. But it's also an illusion. The company has to manufacture its own batteries to be as flat as possible and removes ports—see headphone jacks—any chance

it gets. The iPhone's function depends on an enormous, complex, ugly superstructure of satellites and undersea cables that certainly aren't designed in pristine whiteness. Minimalist design encourages us to forget everything a product relies on and imagine, in this example, that the internet consists of carefully shaped glass and steel alone.

The contrast between simple form and complex consequences brings to mind what the British writer Daisy Hildyard called "the second body" in her 2017 book of the same name. The phrase describes the alienated presence that we feel when we are aware of both our individual physical bodies and our collective causation of environmental damage and climate change. While we calmly walk down the sidewalk, watch a movie, or go grocery shopping, we are also the source of pollution drifting across the Pacific or a tsunami in Indonesia. The second body is the source of an unplaceable anxiety: The problems are undeniably our fault, even though it feels like we can't do anything about them because of the sheer difference in scale.

In the same way, we might be able to hold the iPhone in our hands, but we should also be aware that the network of its consequences is vast: server farms absorbing massive amounts of electricity, Chinese factories where workers die by suicide, devastated mud pit mines that produce tin. It's easy to feel like a minimalist when you can order food, summon a car, or rent a room using a single brick of steel and silicon. But in reality it's the opposite. We're taking advantage of a maximalist assemblage. Just because something looks simple doesn't mean it is; the aesthetics of simplicity cloak artifice or even unsustainable excess.

This slickness is part of minimalism's marketing pitch. According to one survey in a magazine called *Minimalissimo*, you can now buy minimalist coffee tables, water carafes, headphones, sneakers, wristwatches, speakers, scissors, and bookends, each in the same

monochromatic, severe style familiar from Instagram. There are guides to minimalist makeup kits and beauty routines—simplicity makes even the artifice of cosmetics feel more authentic. Most of these products retail for hundreds if not thousands of dollars. What they all offer is a kind of mythical just-rightness, the promise that if you just consume this one perfect thing, then you won't need to buy anything else in the future. At least until the old thing is upgraded and some new level of possible perfection is found.

The profusion of minimalist-branded goods chases after what Charles and Ray Eames, maybe the most famous designers of American modernism, called for when they said, "We want to make the best for the most for the least." The Eameses prized a sense of "way-it-should-be-ness," as they put it, reaching back to Sullivan's "form follows function"—the casual efficiency of something that does what it's supposed to do.

But minimalist marketing usually ends up in one of two ways that both fail at that ideal. The first is simplicity as pricey luxury, like a thousand-dollar iPhone or the iconic Eames Lounge Chair. The chair, made of three segments of bent plywood upholstered with puffs of leather pillows like piped icing, has become a shibboleth of good taste, a cliché fixture in photo shoots. At upward of $4,000 for the real thing, it's not really "for the least" price or "for the most" people. The second is IKEA territory, where every college graduate buys the same geometric side table in shoddy materials that might mimic modernist style but gets ditched whenever they can afford something better. It promises permanence but ends up ephemeral.

Today's minimalist object or space pursues, though usually falls short of, what the architect Christopher Alexander called the "quality without a name" in 1979. This nebulous, nigh-mystical concept is a

kind of Eamesian just-rightness that arises organically from series of patterns and activities set by nature that are allowed to generate structures of their own. "It is the search for those moments and situations when we are most alive," Alexander wrote. It is a "self-maintaining fire," "the root criterion of life and spirit in a man." Later, Alexander decided that the word for what he was seeking was "wholeness."

Looking past the verbosity, it's not just about form following function but an intimacy of cause and effect, design and purpose: everything at a human scale, integrated into one graspable system. According to Alexander, the quality "will happen of its own accord, if we will only let it." There was nothing so organic about Steve Jobs's living room. It was empty and uncomfortable in its monkishness, austere to the point of showing off, as Jobs well knew during the photo shoot.

I think the quality-without-a-name, or the spirit of minimalism, can more easily be found in the main area of the Eameses' 1949 Case Study House No. 8 in Los Angeles, where the couple lived for most of their lives and that is now preserved as a museum. The structure is a pair of rectangular boxes covered in colorful geometric panels, interspersed with wide panes of glass like a painting by Piet Mondrian. The living room is double height, with plenty of light and empty space. It was designed as a "large unbroken area for pure enjoyment of space in which objects can be placed and taken away—driftwood, sculpture, mobiles, plants, constructions, etc." Charles Eames described its pre-execution plan in 1945.

Where Jobs's décor is both sparse and elitist the Eameses' is crowded and haphazardly curated. Nothing matches but everything goes together. There are hanging rice-paper lanterns of different shapes and sizes, trinkets like tribal dolls and bird sculptures, and primary-colored paintings that are mounted on the ceiling. One of their

leather lounge chairs is there, too. It's an eclectic symphony of sights and reference points, a perfect imperfection where plenty of humanity is allowed. Just because it's crowded doesn't mean it can't be minimalist. Charles Eames described their house as "unselfconscious," which certainly can't be said of an Apple store. As for Jobs, the perfect perfectionist, he kept moving houses. Late in his life he had an entire historic mansion demolished in order to build a new smaller home in its place.

My goal with this book is to seek a bypass around the superficial minimalist style, the careful blankness of the cavalcade of design products. I want to find the fundamental, essential quality that imbues the Eames house with life: the appreciation of things for and in themselves, and the removal of barriers between the self and the world. Such is my working definition of a deeper minimalism.

THE PRACTITIONERS OF minimalism who most interest me work hard against orthodoxy, against setting or following strict rules in favor of charting their own path, however meandering it may be. They don't purport to know how others should live or the best way to organize a closet. The people in this book are more often messy and fraught, constantly fighting the expected narrative. Instead of promoting simple answers, these minimalists confront new, existential questions of how to live in the modern world. They do this through the visual art, music, and philosophy that they made, embodying both the ideals and contradictions of minimalism without requiring an easy resolution.

I discovered that the principles of minimalism could be found in the entire life stories of my subjects in the ways that they sought their own identities through study, travel, writing, and homemaking. This biographical approach paid off with my first subject, whom I was reminded of in a particularly tense cultural moment. It was in October 2016, shortly before the most divisive American election of my lifetime, when half the country thought everything was going wrong and the other right. That month the Guggenheim Museum in Manhattan opened a retrospective exhibition of the late painter Agnes Martin. She is one of the artists most associated with Minimalism in the art-historical sense, and the movement's most famous woman, though she didn't want much to do with either of those labels.

Martin's mature paintings, which she began making in the early 1960s and continued straight through to her death in 2004 at the age of ninety-two, exemplify the visual associations of Minimalism. They're consistently sized, most of them six-foot squares of canvas, and as simple and gentle as any artwork ever made, yet with an inner strength. Each canvas is covered with repeating patterns in soft, pale colors; some are grids drawn with a ruler in pencil, others vertical or horizontal stripes of paint. The effect is quietly meditative; the paintings shimmer and waver even when you stand still in front of them, creating deep spaces out of flat images. Their simple construction becomes hazy and unstable, like a city skyline or mountain ridge seen from a distance. The landscape metaphors fit since Martin thought of her lines as horizons. The imperfect, handmade quality was important to her—she actually saw herself as an Abstract Expressionist rather than a Minimalist.

At the Guggenheim, dozens of canvases rose up the incline of the museum's circular spiral ramp, creating an allover monochrome with Frank Lloyd Wright's clean white walls and reflective terrazzo floor. The spiral also presented a chronology of Martin's life, over the course of which she progressed from figurative painting through mid-century Abstract Expressionism into an unprecedented phase that took as much from Zen philosophy as it did Western art history. Martin wanted her paintings to express universal, even utopian, values like hope, innocence, and love. They might look abstract, but they're engaged with communion and connection, the ultimate human concerns.

Maybe it was for that reason the Guggenheim retrospective became a sanctuary over the course of that endless winter, a season of banality and ache, filled with the constant static of TV news against the snow and the cold. Trudging to the museum on the Upper East Side was a pilgrimage to find some peace, as the media, New York media especially, tried to figure out what had happened in the November

election, why the candidate so many expected to win didn't. President Trump, an infamous local with a tendency toward Gilded Age–style opulence, was somehow the creation of a city that also prided itself on openness and access to high culture for all.

I noticed friends posting snapshots of the Martin exhibition on Instagram as if in rebellion, claiming a document of the oasis for themselves. Martin's style was well-adapted to the social network, echoing its format of square images against blank white backdrops. People also posted surprisingly cheerful selfies after they left the museum, paying testament to the show's salutary effects: Martin was medicine for the difficult time. I felt it myself when I saw the show just before it closed in January 2017. Immersing myself in the canvases was like a visual spa treatment.

Still, commercialized minimalism intruded. The Martin retrospective was sponsored by the Swedish clothing brand COS, owned by the fast-fashion retailer H&M, which produced a series of monochrome shirt jackets and pants with grid patterns that were sold glibly on a rack in the gift shop: high art, ready to wear. They were marketed as inspired by the artist's personal fashion choices, a functionalist range of heavy shirts and studio jackets splattered with paint, documented in vintage black-and-white photographs. The artist's legend comes partly from these images of a lone woman obsessed with her work, her craggy profile and thousand-mile stare speaking to an intentional distance from the rest of the world.

Martin is an unlikely lifestyle icon. She appears in blog posts and mood boards, inspiring everything from a line of luxury denim work coats made in San Francisco to DIY craft projects—make-your-own Martin with a pre-prepared canvas and acrylic paint. For a while I saw faux-Martin paintings decorating J.Crew outlets. Yet the artist's wandering path presages many of our twenty-first-century anxieties

about connection and disconnection, order and disorder, whether the true self can be found in society or must be discovered in solitude.

The artist was a reticent person, not amenable to speaking much to critics or curators, nor fond of strict boundaries, except those she put around herself. Her early childhood was spent in the empty, quiet Canadian province of Saskatchewan, a rural frontier of fallow wheat fields in the winter, flatness only punctuated by the vertical axes of grain silos. Her mother was stern and grandfather aloof; her father died in slightly mysterious circumstances when she was young. From Saskatchewan Martin moved to the state of Washington, seeking a better education in the United States, then spent time in New Mexico, where she began to study art in earnest, and then settled in New York City in 1957.

For the sake of narrative it's always tempting to link a biographical cause to an artist's work, like a stem to a flower. You could imagine the Saskatchewan fields and Southwestern deserts caused the Minimalist paintings or that Martin's internal peace led her to create canvases that are often called "serene." In fact she was anything but serene. A complex and self-contradictory figure, she didn't feel she made any art worth saving until she was in her forties.

The epiphany struck when she was ensconced in a reclusive artistic community on Coenties Slip at the waterfront edge of Manhattan, removed from the SoHo neighborhood that was becoming popular with artists at the time. Ellsworth Kelly, Robert Rauschenberg, and Lenore Tawney made homes and studios at Coenties while the older Martin was something of a den mother, baking muffins on her cast-iron stove. Martin occupied a long, open loft, rough-hewn but with views of the river. At Coenties she began making her grid paintings, a departure from the egotistical energy of the established Abstract Expressionists, the dominant, usually masculine wave that included Jackson Pollock

and Willem de Kooning. When she needed a break from painting she liked walking across the Brooklyn Bridge, the only spot in the city where the horizon opened as wide as it did in Saskatchewan.

New York was always an uneasy fit, however. Martin needed excesses of time and space. She forsook all attachments, from pets to long-term partners. She also struggled with schizophrenia, suffering from psychotic breaks that left her at times catatonic in her loft. What might have appeared from the outside as monkish asceticism was also a coping strategy for this mental illness, which was inseparable from her art. Martin said the plans for her paintings came from visions that originated somewhere outside of herself. The same voices gave her proscriptions like hewing to severe diets and not owning property.

In 1967, when her beloved loft was set for demolition, a relationship with the Greek artist Chryssa had crumbled, and a grant gave her enough money to buy a heavy-duty van, Martin decamped from the city completely. She drove around the United States hiking and camping until she was struck with a vision of an adobe house that she figured must be back in New Mexico, so she settled again in the desert village of Cuba, surrounded by nothing.

During that period she stopped making art for a full six years. The first new work came in 1973 with a series of square screenprints, hazy grids and horizontals in the finest of lines, transcendental in their smallness, called *On a Clear Day*. In 1977 she moved to another village called Galisteo. There she set the template for the rest of her long life, building a permanent adobe home and studio for herself, traveling sometimes and hosting scattered visitors, pilgrims to her hermitage. Yet her life wasn't so strict as it seemed. She listened to loud Beethoven, drove a white Mercedes at high speed, and was known around town to stay up late drinking and dancing once in a while.

The root of Martin's art was what she called "inspiration," a word she pronounced in interviews with the weight of a prayer, almost sighing it skyward in her tremulous voice. She referred to it constantly in her writing, which took the form of prose poems more than essays or statements. Martin's literary oeuvre is vague but prophetic, a series of puzzles in which the words don't quite line up. There's a sense, as with all spiritual texts, that the meaning is somewhere beyond the words, in a place language can only hint at. Inspiration means "that which takes us by surprise—moments of happiness," she wrote. It is "really just the guide to the next thing." "Beauty is pervasive / inspiration is pervasive." "Although we are in the dark we are not without guidance. / Our guidance is called inspiration." The goal was to find this inspiration and follow it.

An almost unbearably affecting documentary shot in 2002 shows an elderly Martin still in her studio, laboriously dipping a paintbrush in a bowl of blue and drawing it down the penciled outline of a single hazy stripe. She gasps with effort and stops halfway through to sit down, catching her breath before returning to finish it. What makes the scene so powerful is Martin's utter belief: Everything in her worldview can be, and has been, contained in this single line, repeated endlessly. It looks like nothing and yet means everything. Martin wasn't concerned with reaching an enlightened state but the process of seeking it, fighting not to lose her glimpses of it. "I hope I have made it clear that the work is *about* perfection as we are aware of it in our minds but that the paintings are very far from being perfect...even as we ourselves are," she wrote.

Instead of a direct cause-and-effect relationship between childhood and canvas, the keys to interpreting an artist or designer's work on a deeper level can often be found in their daily habits and the

people and objects they intentionally surrounded themselves with. It's true for Martin and the Eameses as well as the meticulous spaces Philip Johnson and Donald Judd created for themselves, which will be the focus of the next chapter. These lifestyles show how we can incorporate both aesthetics and ideas together into our own ways of confronting the world without resorting to an easy boilerplate lesson, like the superficial version of minimalism. Instead of a single act or image, minimalism is a practice that takes place over time—it makes simple things more complicated, not the other way around.

In the final painting of Martin's Guggenheim retrospective, completed in the early 2000s, two white stripes run through a luminous body of blue-tinged gray built up in wide brushstrokes of thin paint, the marks of the process that made it. The canvas stopped me in my tracks at the top of the museum's ramp. Superficially, it's simple. It looks like it should be easy to make such a thing. Yet it was the result of a lifetime of existential discipline, decades spent struggling with the problem of doing anything at all. In the painting, the rest of her labor was made invisible—the search for inspiration; the struggles with curators and dealers; all the paintings she destroyed throughout her career after deeming them incorrect, slicing the invaluable canvases with scissors or knives.

These stripes were what Martin felt called to paint, expressing her existence in its absolute essential form. It is a simplicity almost impossible to reach. "We are in the midst of reality responding with joy," she wrote. "It is an absolutely satisfying experience but extremely elusive."

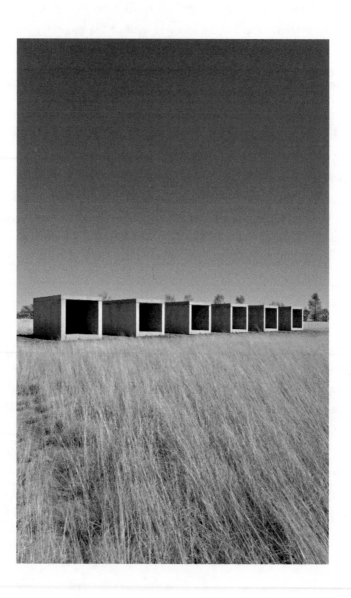

2. Emptiness

THERE'S A PARTICULAR genre of apartment building popping up like geometric fungi all over the world. They're not quite lofts, though they're often marketed by that name. They're too metastasized to be town houses. The shorthand "condo" is fittingly bland since it's a relatively recent coinage and devoid of any one geographic origin. These buildings are basically boxes stacked on top of one another. The structural pattern doesn't seem to matter to developers as much as sheer volume; as many boxes must be packed into the footprint as possible so as to maximize profit through leasing or selling. Their facades are made from no naturally occurring material. Instead of a few regularly spaced rectangular windows they have floor-to-ceiling glass walls that have to be curtained off to keep out excess sunlight during the day and then to preserve any semblance of privacy after dark.

When just such a new building was finished across the street from my old apartment in Brooklyn (a strange brick structure with an angular appendage that housed my bedroom) the glass walls stayed dark for a while, like closed eyes. Then some enterprising real estate agent decided to stage a floor as if someone actually lived there. Every night I passed by and looked in at the Instagram-ready tableau of white bed, white nightstand, white table, white kitchen cabinets and wondered if this radical transparency could possibly be appealing to its future

occupants. The possibility of light and space in a crowded city is nice, but homes are usually meant to keep the rest of the world out, preserving some personal space. Instead, the rudimentary ingredients of a cliché "creative" Brooklyn existence were on view for anyone to see. The monochromatic space hinted at just how generic and ready-made that life could be, as if when you bought the real estate you adopted the role simply by putting yourself on display, as you would against a blank photo backdrop.

This particular brand of aspirational austerity has become synony-mous with minimalism. It's wrapped up in the desire to live with as little as possible, to have nothing holding you back from the world around you. We're drawn toward this visual blankness because it offers a sense of freedom; there's no risk of getting bogged down by material possessions because the space doesn't allow for them. It's a perpetu-ally blank canvas. Yet the apartment also prompts the question of how an extreme style became so popular across cities and countries when it's such a sharp departure from our usual associations with domes-ticity. Despite my discomfort at being a voyeur, I had to admit that the space looked stylish.

The precedent for these glass boxes is a single glass box that rests hidden from the road on the flattened slope of a grass hill in New Canaan, Connecticut, an out-of-the-way suburb of well-compensated commuters. The size of a large apartment, fifty-six feet long by thirty-two feet wide, the rectangle's four walls are all transparent glass, wrapped in a frame of dark steel so that the opaque floor and ceiling seem to float, wavering above the ground like a mirage. You can see the tree line through it. The space inside is undivided by interior walls except for a single brick cylinder, the only area impenetrable by the eye. Inside the glass box, the way a dollhouse living room might be

meticulously staged, are low leather-and-steel chairs, a bench, desk, bed—the only signs of human life—and not much else.

The Glass House, as its creator and owner called it, was the home of the American architect Philip Johnson, who completed it in 1949, though it looks like it could have been designed yesterday. Long before the identical condos, Johnson's house was revolutionary—the first of its kind, as its singular name announced. The Glass House became a vehicle for Johnson to popularize the taste for the new twentieth-century aesthetic he espoused: very empty and very transparent.

Before the Glass House, Johnson was a dilettante architect who hadn't designed much of anything. The scion of a wealthy family of Cleveland industrialists, he attended Harvard Graduate School of Design and built a geometric home in Cambridge. But he was less of an inventor and more of a tastemaker, importing the artifacts and aesthetics of modernism that had emerged in Europe in the early decades of the twentieth century. Johnson spent his inheritance bumming around the continent with Alfred Barr Jr., who was the founding director of the Museum of Modern Art. Barr put Johnson in charge of the museum's architecture department. Over the 1920s the two young men interviewed architects, photographed buildings, and brought their findings back to the relatively uncultured (they felt) pre–World War II United States.

Johnson dubbed the mode of architecture that had been solidifying since the 1910s "International Style," which he displayed in a 1932 MoMA exhibition, installing building models on plinths alongside shots of their interiors. International Style buildings were austere, white, and boxy, constructed with innovative glass-and-steel techniques. Pioneered by the German architects Walter Gropius and Ludwig Mies van der Rohe as well as the Swiss-French architect Le Corbusier, the style had

its center at the Bauhaus, the holistic art, design, and architecture school that Gropius founded in 1919. At the Bauhaus, architecture was the peak of all artistic forms, combining two-dimensional art, sculpture, and industrial design into a *Gesamtkunstwerk*—a total work of art, to use the term the composer Richard Wagner popularized in the nineteenth century. At Gropius's glass-walled Bauhaus building in Dessau from 1926, for example, every detail was part of the same whole, down to its custom-made window latches. The Bauhaus ideal was to create architecture that might house all of humanity, a perfect solution for postindustrial living. The school proposed that mass-manufacturing could be not only efficient but beautiful, too.

Back in Manhattan in 1931 Johnson commissioned Mies to equip Johnson's own apartment with the stark industrial furniture that Mies designed at the Bauhaus, proselytizing for it at parties in the town houses of wealthy art patrons he knew through MoMA. It was hard work, convincing the New York elite to move away from drab, heavy wood and brownstones toward these airy buildings and skeletal chairs. Like any Manhattanite, Johnson wanted an escape from the pressure of the city, but he also needed a calling card for his inchoate architectural practice, something to convince his audience that modernism was indeed the inevitable future. In 1946 the forty-year-old bought six acres of land in New Canaan and started planning a weekend retreat, a "place to hide," as he put it. There he could test his most extreme ideas on the only client with whom he couldn't possibly disagree: himself.

Johnson's talent for curation and salesmanship may have surpassed his skill as an architect. He was always something of a showman, playful in publicity photos, dressed in casually stylish loose slacks and buttoned-up shirts. He framed his glinting eyes behind thick-rimmed, round black glasses. This progressive style and his social standing

ended up hiding his personal alliance to the Nazis, whom he toured with in Europe and fund-raised for—with what he later called "unbelievable stupidity" in 1993. His polished image made his beliefs easier to overlook, though they have become more public after his death. Even Johnson's consequent FBI file confirmed that he "would be termed a handsome man." The file dryly cites his erect build, dark hair, and square chin.

Curation by definition is not an original act. When Johnson set out to design the Glass House he didn't copy but stole, grabbing a design from Mies, who had become his mentor. Mies was the last director of the Bauhaus; he fled Germany and landed in the United States in 1937, four years after the Nazis shut down the school. While teaching at the Illinois Institute of Technology in 1945 Mies designed a kind of glass prism, a transparent structure floating on a series of plinths above a clearing in the woods, for a Chicago nephrologist named Edith Farnsworth. Johnson saw the in-progress plans for the Farnsworth House when he included a model of it in a Mies retrospective at MoMA in 1947. But the older architect hadn't built his yet, so Johnson charged ahead.

Johnson's early drawings from that year show a thick, opaque wall as an axis separating a main living area from a distinct wing containing the kitchen, bathrooms, and a guest bed—the messier parts of the house. The layout is sleek, with six separate sides of glass walls facing outward to the landscape, but it looks finicky and unresolved compared to what came after. Johnson's leap was to remove everything, even more than Mies, and contain the house into a single space.

While it lacked rooms, the inside of the glass rectangle was divided into implied zones, each with its own purpose. A dining table is

positioned in one corner and a single desk at the opposite, facing the window-wall. Instead of a television set, a painting by Poussin is mounted on an easel. The theoretical living room is arrayed on a thick carpet covering the herringbone-brick floor: A set of two low, tufted leather chairs, an ottoman, and a daybed, all designed by Mies, are positioned around a glass coffee table holding only a single ashtray.

The house appears as a hermetic space in which things are dissected and deconstructed, as on a surgeon's table. Most of the surfaces in the Glass House are conspicuously empty, from the long kitchen counter that hides the stovetop—martinis were served more often than food was cooked—to the desk and the side tables. There are no visible bookshelves and there is no storage save a tall cabinet that hides the bed on one of the house's shorter walls.

It's not a space for children, nor anyone who habitually leaves piles of stuff around. The peculiar emptiness of the interior seems somehow pointed, as if any human figure would intrude on its perfect geometry. "Comfort is not one of my interests," Johnson told *Esquire* magazine in 1999. "You can feel comfortable in any environment that's beautiful." Beauty, here, means precision. His advice was to "pick very few objects and place them exactly"—which might be the minimalist decorative formula.

Beyond functioning as a domestic space, the Glass House was a business card and a site for cultural experimentation. Johnson hyped the building, bringing professional colleagues and Yale students to the site while it was still under construction. In the '60s Andy Warhol came to stare out of the walls, and the Velvet Underground performed in the wide grass field at its side. The composer John Cage mounted concerts set to choreography by Merce Cunningham. Marijuana bread was served by David Whitney, Johnson's three-decades-younger boyfriend,

whom he met when Whitney was twenty-one; the two remained part-
ners for the rest of their lives. Even during weekend parties the immac-
ulate order had to be maintained. One of those guests, the painter
Jasper Johns, later observed the couple's "ruthless elegance," noting,
"I don't think clutter was allowed." "Every flower knew its proper posi-
tion in the vase," according to the architect Robert A. M. Stern.

The Glass House takes the Bauhaus concept of elegant
replicability—the attempt to reduce down to a set of architectural rules
that would work for everyone—and turns it into something elitist, an
implicit brag that Johnson could live with less than anyone. It stands
proud among the Connecticut suburb's conservative neocolonial
estates and New England stone walls, making the surrounding homes
seem square, outdated, excessive.

There are two sides to the modernist aesthetic. The first is the
radical emptiness that came when the old definitions of elegance were
thrown out. In 1926 the Bauhaus architect Hannes Meyer proposed
"The New World" with a room, *Co-Op. Interieur*, designed for a single,
perhaps utopian, worker, equipped with only a folding chair, a bed, a
fabric pallet for a mattress, and a gramophone on a stool in the corner.
In the attendant essay, Meyer wrote that we would find comfort in our
souls instead of our consumerism: "Snugness and prestige are not
leitmotifs of the dwelling house: the first resides in the human heart
and not in the Persian carpet, the second in the attitude of the house-
owner and not on the wall of a room!"

But the other side of modernist emptiness is control, the ability to
judge and then exclude anything that you consider distasteful, as in
Johnson's Glass House or that blank, personality-less Brooklyn condo.
From that perspective the style of emptiness is not particularly radical;
it might even be conservative. As far back as 1954, the American critic

Russell Lynes had already marveled at modernism's success as an aspirational aesthetic in his book *The Tastemakers*. Its persistent popularity was because "it appeals to a morality that is deeply imbedded in our history," Lynes wrote. "It seems to be harking back to American puritanism, a morality which stressed the virtues of modesty, clean living, and disdain for what we call vulgar display."

The idea that getting rid of things can be better is encapsulated in the slogan "less is more," which is usually ascribed to Mies. With less stuff we might be more creative, more loving, more communal, more engaged with our surroundings. Yet Johnson was the first to associate modernism's extreme austerity with a particularly American mode of enthusiastic conspicuous consumption: Less could be cool.

LATE IN PHILIP Johnson's life, after a stroke, the Glass House became his hospital room, where he was propped up in bed so he could continue enjoying the view. The surrounding property had gradually become his autobiography, sprinkled with smaller buildings that he completed over the course of his life, including a small library studio, a gallery enclosed in the side of a hill, and the Brick House, a guesthouse with few windows at all. But the architect had always meant the Glass House to be a monument in architectural history, not just a home. In 1986 he donated the property to the National Trust for Historic Preservation in order to turn it into a posthumous museum. In January of 2005 Johnson died at the age of ninety-eight. David Whitney followed just five months after.

I first visited the Glass House shortly after it opened to the public in 2007. Looking at photographs was enough to seduce me, since it was so different from where I lived. I grew up only an hour's drive from New Canaan, but instead of a modernist box my house was the usual suburban development, a two-story, cedar-sided structure with far more walls than windows. The Glass House presented the possibility of creating oneself by deciding on everything that was in a space, which certainly wasn't possible for me as a teenager. Over the past decade I've returned several times, and on each visit I'm struck again

by the peculiar vision of freedom it offers and the contrasting sense that Johnson thought this was the only way to live, that he had created the platonic ideal. The more I thought about it the less I trusted the idea that life could be filled with only perfect beauty.

I returned one morning in late fall on a train from Grand Central to downtown New Canaan, where there's now a Glass House visitor center with a gift shop—the better to promote its legacy. A white van takes visitors through swerving country roads to the property, which reveals little at first, until you proceed past the gate and down the slope. What photos of the house don't convey is how small the structure actually is within the wider site. "House" might be a misnomer; up close it's more like a glass gazebo. The building rests at the edge of a hill that cascades down into a valley so that looking at the Glass House means looking straight through it into the empty air beyond, where the view opens up to the hills. The only barrier between you and the landscape is a long bench at the lip of the valley like a guardrail, preventing visitors from falling off.

The Glass House turns interior and exterior into meaningless terms. The walls don't do the work of obscuring what's inside, nor do they keep anything external out. The interior, with its compositions of low furniture standing guard, is completely exposed so that it might as well not be inside of anything in the first place. Walking across the lawn I felt like I had been caught peeping, an act Johnson passively invited. Before the trees grew in, neighbors used to peer over from the road into the lit fish tank of the house at night, wondering how the architect could possibly live there. The architecture itself is exhibitionist, framing whatever happens within it like the subject of a painting. The architect eventually installed movable curtains, but only enough to create some shade.

Each of the Glass House's sides has a door at its center. When I walked inside through one of them, the polarity flipped. Instead of trying to look into the house I was suddenly looking out from within it as through the viewfinder of a camera, my eyes sweeping over the gentle slope of the lawn. The view that day was cinematic, with long whips of tree branches waving in the wind, releasing gold and crimson leaves that drifted to the ground in slow arcs across the filmstrips of the glass. The landscape created a composition of constant motion, a live-action Jackson Pollock that Johnson referred to as his "very expensive wallpaper."

In his book on the psychology of domestic architecture, *The Poetics of Space*, the French phenomenologist Gaston Bachelard identified windows as the eyes of a house. Dwelling on the image of a lit lamp behind a distant house's glass window at night, he offered the interpretation: "All that glows sees." The Glass House is all eyes, then. The windows allow you to see but also feel yourself being seen, leading to an atmosphere of tense balance established by the carefully placed furniture and bare surfaces. The interior looked museum-like enough when Johnson was alive, but now it is static sculpture. I would have happily sunk down into one of Mies's plush leather chairs in the living room area if I didn't feel like I would get kicked out.

After the instability of two world wars and the rising social impact of industrialization, modernism offered an antiseptic, ahistorical alternative to what came before it—a vision of a safer and cleaner world, with cosmopolitan equality for all who inhabited its architecture. Its message was, in every living room, a Mies Barcelona chair.

Making things simpler and blanker was cast as a form of progress, which hints at why minimalism is so deeply appealing: "The evolution of culture marches with the elimination of ornament from useful objects,"

the Austrian and Czech architect Adolf Loos, author of the essay "Ornament and Crime," wrote. The increasing transparency of glass-and-steel buildings also offered a kind of egalitarian social contract based on needing and consuming less, as well as seeing and being seen. "To live in a glass house is a revolutionary virtue par excellence," wrote Walter Benjamin in 1929. "It is also an intoxication, a moral exhibitionism, that we badly need." In 1933 he continued: "Glass is, in general, the enemy of secrets. It is also the enemy of possession."

Yet Johnson's Glass House was not concerned with revolutionary virtue nor the exposing of secrets. It certainly wasn't against possession—elsewhere on the site the architect buried an art gallery full of priceless work by mid-century painters like Frank Stella in the side of a hill, literally hiding it from view. Instead, Johnson's signature creation was a stylization of Bauhaus principles. The Glass House appears to be functional, with its strict geometry and severe layout, but it was anything but efficient. Without interior air vents, the glass walls fogged and dripped with condensation. The roof leaked, so buckets had to be installed in each of the four corners when it rained. In the winter the floor had to be heated so much that visitors couldn't walk around with bare feet. Without normal walls to enclose its infrastructure, electrical cables and plumbing were installed underneath the house and run to the opaque Brick House across the lawn, where they could be secreted away. The house's transparency had a way of concealing as much as it revealed.

Minimalism can be oppressive. The style can make you feel like you don't belong in a space unless you conform to it, as in upscale cafés or severe hotel lobbies. Being in the Glass House, among the handful of high-design, high-art objects that Johnson deigned to allow, doesn't really feel like freedom but entrapment in someone else's vision. Its

spareness might seem luxurious, but it's also expensive and finicky—a facade of simplicity.

With Johnson's help, Mies made "less is more" famous, but the phrase actually first appeared in English courtesy of the Victorian poet Robert Browning, in an 1855 poem about Andrea del Sarto, an Italian Renaissance painter who was known for his technical brilliance. The saints, Madonnas, and cherubs in del Sarto's religious tableaux were perfect but also passionless, too precise to display real feeling. In the poem, del Sarto monologues to his domineering wife, Lucrezia, who is straying to another lover, and confesses to his own ultimate lack of emotion. Other painters try to match the skill that he seems to display so effortlessly, but they end up achieving "less, so much less." "Well, less is more, Lucrezia: I am judged," del Sarto admits. "There burns a truer light of God in them." The other painters are able to capture the deeper truth that del Sarto misses perhaps because he focuses too much on the cold exactness of each line. "All is silver-grey, / Placid and perfect with my art: the worse!"

Johnson exhibits this negative perfection. His sympathy for fascism is apparent in the strictness of the architecture itself. It's a house built for and by a single person, demonstrating a kind of megalomaniacal possessiveness. The architect has nothing at stake in making a visitor comfortable, only himself.

During the day, the Glass House is expansive and open, the view of the landscape extending like added square footage. But as night falls the horizon and the trees and finally the grass carpet around the house fade away. The transparent walls push in a little more and the furniture feels closer together without its backdrop.

In the evenings, David Whitney would often leave the glass box and walk over to the Brick House to sleep. It was the diametric opposite of

the Glass House, an enclosed chamber of pale pink upholstered in Fortuny fabric like a room-sized makeup case. ("Sex is best in a cocoon," Johnson quipped.) Meanwhile, the architect would stay in his pavilion, switching on the lamp and picking up a book from the single round side table next to the double bed before falling asleep alone in his aquarium. In the morning he woke up to the early dawn cascading in from all sides, the countryside visible once more.

There's such a thing as too much perfection, a space so precisely composed that, despite its emptiness, it can't make room for anything else. That's why a space like the Glass House, or the empty Brooklyn condo, feels like an exercise in narcissism.

One night, when Johnson was staying with an employee who lived nearby, he decided to sleep in the Glass House for the first time. The just-built box loomed in the corner of the field, dark and empty, a man-made, mechanical apparition in the midst of nature. The architect paced across the lawn and opened the door to the unlit interior. But when he switched on the lamp sconces in the corners the electric light bounced off the interior of the glass walls so that instead of the view he had pruned outside all that appeared was his own reflection staring back. Johnson frantically phoned his associate. "You've got to come over immediately," he said. "I turned on the lights and all I see is me, me, me, me, me!"

To solve the problem, he installed lamps outside, too, illuminating the branches of the trees above like a bonfire.

TODAY WE MIGHT describe modernist architecture like Philip Johnson's or Mies van der Rohe's as "minimalist." But the word has only been retrofitted to include such architects in the past few decades. In the context of art history, the two terms were almost completely separate. The label "Minimalist" only took hold in the 1960s. Over that decade a group of artists emerged who made objects using a similar vocabulary to modernist architecture—industrial materials that were geometric and cold—but with a totally different goal in mind. The artists made work that was opposed to being decorative or functional in the first place. Its extreme simplicity made viewers uncomfortable. And they didn't like the word "Minimalism."

"I have a lot of complaints," the caustic New York artist Donald Judd began an essay in 1969. (The essay was titled "Complaints: Part 1," hinting at how many others there were.) Judd was annoyed that art critics kept labeling him a Minimalist. He felt the term was totally irrelevant to his work. To Judd "Minimalism" was just a lazy shortcut, a useless word writers used to oppress artists. Minimalism was just a marketing scheme that made difficult, complex artwork more palatable, dumbing it down. "Very few artists receive attention without publicity as a new group," Judd wrote. "Most ideas of history are simplistic, archaic, and destructive."

Yet Judd is still seen as a Minimalist today, and likely the best known, if art history books are any indication. The glossy metal-box sculptures he began making in the '60s stand in for everything the word now suggests in its combination of intellectual and aesthetic austerity. He never stopped hating the label. A dozen years after the first essay, he was still complaining, as in a 1981 letter to the *Village Voice*: "The first error is that there isn't any such thing as minimalism; the second that traits are given to something that doesn't exist."

A starting point for the dominant strain of Minimalism might be Judd's first solo show in 1963 at the Green Gallery, when he was thirty-five years old. Green Gallery was opened on Fifty-Seventh Street in 1960 by Richard Bellamy, an iconoclastic, improvisational dealer who supported many of the artists who would later be called "Minimalist," like Robert Morris and Dan Flavin. Bellamy aspired to show a different kind of art than the most recognizable style of the decade, a crew of mostly wan second-generation painters following in the footsteps of the "New York School" Abstract Expressionists who first made Manhattan an international artistic hub in the '40s and '50s. The Ab-Ex wave had already crashed, as Judd pronounced in 1964: "Pollock was dead. [Franz] Kline and [James] Brooks had painted their last good paintings in 1956 and 1957. [Philip] Guston's paintings had become soft and gray."

Judd was better known at the time as a critic than an artist. He made his living contributing polemic reviews and surveys to magazines, often getting himself into fights. An outsider to the New York scene, he felt a constant need to prove himself. Born on a farm in Missouri, he landed in New Jersey for high school. After a stint in Korea in the Army Corps of Engineers, he used the G.I. Bill to enroll in classes at the Art Students League in New York and the College of William and Mary in Virginia. The education wasn't rigorous enough for Judd,

so he began studying philosophy at Columbia University in 1948, eventually pursuing a master's in art history under the pioneering scholar Meyer Schapiro. His academic training undergirded his criticism, imbuing it with a certain unshakeable confidence that his statements were always correct—at least in the moment that he wrote them.

Though he was not yet fully confident in his personal artistic practice, Judd led Bellamy up to his studio to see the work he was making, which had evolved over the '50s from abstract geometric prints and paintings into three-dimensional objects made to hang on the wall or rest on the floor. The visit led to Judd's 1963 solo show, which populated the Green Gallery's white walls and narrow wood floor with geometric boxes made of plywood coated in light cadmium red paint. The sculptures were abstract forms, like machines for accomplishing incomprehensible tasks. They were inorganic and yet not quite industrial. Judd had made them by hand with his father, Roy, an executive for Western Union and a skilled woodworker.

The show included forms like ramps, shelves, and racks, but there was no way to interact with the pieces and no clear meaning to be interpreted. The intentional lack of content in the show was an affront to established art-world tastes. In *Art in America*, the critic Hilton Kramer described Judd's debut as "indifferent to formal analysis and metaphor." Other critics called the weirdly mundane pieces "useless objects," "nonart," and "aesthetic furniture."

Judd's work looked like it was supposed to be art but wasn't. Didn't art need to have more intention, more symbolism, some kind of emotional impact instead of all that cool distance? The pieces didn't sell well, but neither did much of the work Bellamy curated, and by 1965 Green Gallery was failing. "I had to close the gallery; couldn't get no bank behind me," he lamented in a characteristically casual letter. Too ahead

of the times—though he did manage to sell one of Judd's sculptures, four metal cubes connected by a square pipe, to Philip Johnson for $300. The artist figured any act of good taste originated with Bellamy rather than the architect, whom Judd dismissed during a gossipy interview with the art critic Lucy Lippard in 1968. (The interview is the surest sign of Judd's identity as a workaday art critic: full of complaints about magazine deadlines, freelance rates, and capricious editors.)

A critical essay Judd began writing in 1964 gave him the opportunity to present his side of the story. "Specific Objects" was published in 1965 in *Arts Yearbook 8*. Contrary to his dislike of movements and easy narratives, Judd used the essay to gather a group of his contemporaries and observe certain themes shared in their work. Many of the approving pronouncements Judd made could just as easily have applied to his own untitled objects.

"Half or more of the best new work in the last few years has been neither painting nor sculpture," he began. (Judd loved deeming things best or worst.) Painting is bad because it's boring and overdone, he argued—Abstract Expressionism had hit a wall—and sculpture is bad because it resembles things that already exist—human figures, animals, landscapes—so it's unoriginal. The most important quality for Judd is a kind of enlightened simplicity, a unity in which all the parts of a work of art form a single coherent whole that depends on nothing but itself, rather than referring to a preexisting object. He calls this quality "specific" or "three-dimensional" in the essay.

Artists who accomplished the feat of specificity for Judd included Frank Stella, Claes Oldenburg, Yayoi Kusama, Anne Truitt, Dan Flavin, and John Chamberlain—some of Judd's friends and others he admired. (The problem with being both a critic and an artist is that you'll probably like work that resembles yours.) Kusama covered mundane

objects like a sofa in phallic fabric protrusions, turning them hallucinatory, unusable, and unprecedented; Chamberlain made abstract sculptures out of crumpled car bodies still covered in coats of glossy paint; and Flavin, one of Judd's closest compatriots, attached mass-produced fluorescent light fixtures to wooden boxes and eventually mounted the fixtures directly on gallery walls. The specific objects "aren't obviously art," Judd admitted, but that didn't matter: "A work needs only to be interesting."

Interesting in this case meant offering a unique, instantaneous aesthetic experience. Frank Stella, a New York painter who became famous for a series of "Black Paintings" with even-sized black stripes running across large canvases in monumental patterns, put it another way: "What you see is what you see."

No one knew what to call or quite how to understand this new art of the '60s. Other critics labeled the ambiguous group "ABC Art," "Cool Art," "Literal Art," and even "Boring Art," turning its seeming vacuity into a fault. "This art has apparently no memory and no expectations," the artist and writer Brian O'Doherty argued. In his 1967 *Artforum* essay "Art and Objecthood" Michael Fried wrote that the group's work "is inexhaustible...because there is nothing there to exhaust." Clement Greenberg, the champion of the Abstract Expressionists, complained that their work was "readable as art, as almost anything is today— including a door, a table, or a blank sheet of paper." He almost realized that that was the point.

The critics forgot that the objecthood of art had already been settled by Marcel Duchamp's earlier "readymade" sculptures, like his bicycle wheel attached to a stool from 1913, called "Bicycle Wheel." Picasso had turned a bicycle seat and handlebars into a bull's head in 1942. The new, boring art might have looked like a radical departure but it,

too, had a certain legacy. A vengeful Judd later called Fried's article "stupid" and "pseudo-philosophical"; Greenberg was likewise "garbled." Whatever the group was doing, Judd posed himself as its defender.

The pestering term "Minimalism" that ultimately stuck came from Richard Wollheim, a British art theorist who published an essay called "Minimal Art" in 1965. He argued that the major characteristic of this group was that their work had "minimal art content," that is, a lack of the usual qualities that traditionally define Western art. All the wooden boxes and lightbulbs and unadorned metal made viewers nervous because it destabilized the old idea of art as one heroic artist sweating in front of a canvas. Instead, the Minimalist artists adopted manufactured materials and incorporated found objects. They planned their pieces on paper, more like architects or designers, and then had the work fabricated entirely outside of their studios, as Judd did after 1964, commissioning the Long Island metal shop Bernstein Brothers.

According to Wollheim, this newfound distance between artist and object was what made Minimalism so aggravating. If art was meant to be ineffable and transcendental, then how could artists simply order it up from a factory without suffering or getting their hands dirty? That Judd could send out a drawing of an aluminum box, as he began to do in the late '60s, have the final product delivered, and then install it in a gallery without modification as his own work was off-putting. Maybe it was even insulting to unprepared viewers, provoking a feeling akin to the naive critique you still hear while wandering museums of modern art: "My kid could do that."

Yet, Wollheim continued, there actually was a form of labor to Minimalism. It was just more curatorial than physical. The choices of material, treatment, and scale were artistic acts, as was the decision to call a piece "finished." The process of simplification or reduction,

choosing which elements to preserve and which elements to leave out, was a form of creative labor for the Minimalists. That effort just might not be immediately visible in the final piece, which could be a chunk of metal leaned against a wall, as in the case of Richard Serra. Dan Flavin's work disguises this labor so well that in 2016 the European Commission decided to tax any Flavin lightbulb pieces being imported not as artworks but as industrial goods, which meant three times higher a fee.

Minimalism demanded that "we should look at single objects for and in themselves," Wollheim wrote. The description isn't so far off from Judd's use of "specific." This focus on the singular is not about abandoning or ignoring art's visual qualities, but intensifying what is there. In some ways it's about excess more than austerity. "A lot of red is maybe better than three colors," as Judd put it in 1965. Less can be more, as long as you have more of the less part.

What we describe as minimalist today—the white t-shirts, mono-chrome apartments, and wireframe furniture—doesn't have much in common with the artists that Judd, Wollheim, and others gathered together in their criticism. Flavin's multicolored light installations were garish and aggressive. Kusama's sculptures were ornate and disturbing. Chamberlain made literal car crashes into art, all jagged edges. It's not stuff you would immediately want in your house.

The artists were revolutionary not because of a shared homoge-nized style but because of a particular leap that they made: The art object did not have to represent anything, document reality, or even communicate the artist's individuality. It was enough to generate a presence, to become part of the world, and the viewer should appre-ciate the work as such. Sensation replaced interpretation. Maybe that's why Minimalism remains difficult for us to accept as art rather than

décor. We think we should be educated or informed by works of art, swept away by powerful feelings, but that wasn't the point.

Every person who encounters a Judd box in a space sees it slightly differently, depending on the time and context. Even though the object isn't unique, the experience or perception of it is—therefore a stand mixer in a gallery can be as compelling as the *Mona Lisa*. The Minimalist objects didn't rely on the "aura," as Walter Benjamin put it, of the preindustrial, unique work of art. This made Minimalism a perfect match for our "age of mechanical reproduction." The same anonymous form could be produced over and over without losing any of its potency, because the meaning of the work of art resided with its viewer rather than its maker.

IF MINIMALISM HAD little to do with architecture at first, Donald Judd helped connect the two and sped along its transformation into interior decorating. A casual viewer might remember Judd from seeing a geometric cube made of aluminum or colored Plexiglas in a cold white gallery space. The aloof, sometimes alienating context doesn't do his work any favors—it just becomes colder and harsher. But the artist was actually leery of galleries himself and went to great lengths to install his work right in the middle of his own sprawling domestic spaces, which provided the blueprint for the kind of bohemian "loft-living" that cities advertise today.

In the 1960s, the lower Manhattan neighborhood of SoHo was pitch-dark at night the blocks of tall factory warehouses making canyons of the cobblestoned streets. The area had been built up over the course of the late nineteenth and early twentieth centuries as New York City played its part in the industrial revolution. A 1919 map records local businesses churning out fur goods and women's wear, cash registers, enamelware, copperplates for printing, leather boots, and billiard tables, among other products. But by the middle of the century manufacturing had faded. Constant fires from the remaining small industry earned the area the nickname of Hell's Hundred Acres. Artists crept in to occupy the factories' expansive upper floors, available for only a few hundred dollars' rent or $30,000 to buy thousands of empty square feet outright.

But they had to keep the lights off at night to avoid suspicion—it was still technically illegal to sleep in the buildings.

In 1968, while living in another loft on Nineteenth Street, Judd found an entire five-story SoHo factory building for sale for $68,000 on the corner at 101 Spring Street. He could just about afford it, with the help of a recent grant. It didn't look like much at first—the interior was so piled with junk that Judd likened it to an installation by the artist Arman, who filled gallery windows with detritus—but the bones were good. Built in 1870 by the architect Nicholas Whyte, the facade was made of painted cast-iron, with thin metal ligaments stretching between expansive windows so that the building seemed to float. It boasted neoclassical flourishes, like pediments on some of the stories, setting it apart from more workaday industrial buildings. In it Judd saw a precursor to the glass-and-steel structures of modernism, which Philip Johnson and Mies van der Rohe were bringing to New York with buildings like the glamorously glass-walled Seagram Building, completed in 1958.

Inside, 101 Spring Street was ruined. Originally a department store, it ended its industrial life as a hardware store with small-scale manufacturers above. The machines had leaked oil and left imprints on the dark wood. After the cleanout Judd noticed that in the building's original state there was no evidence of it having internal walls, so he decided to leave each level open and devote it to a single function: a gallery and meeting place in the ground-floor storefront, where Judd would sometimes host groups of younger artists (including the later neo-expressionist Julian Schnabel) or stack material samples of metal or wood; a kitchen and entertaining area on the next floor; a studio and gallery; a domestic space like a living room; and then bedrooms on the top floor.

Judd's family was growing with his art career. He married the dancer and choreographer Julie Finch and they had a son, Flavin (named after

the artist), and were expecting a daughter, whom they would name Rainer, after the choreographer Yvonne Rainer. The loft on Spring Street became a functioning home as well as a laboratory for the creation and display of Minimalist artwork, both Judd's own and others'. "I spent a great deal of time placing the art and a great deal designing the renovation in accordance," he wrote of the loft in 1989. "Everything from the first was intended to be thoroughly considered and to be permanent." Permanent, but not perfectly functional—Rainer and Flavin have recalled the loft freezing in the winter and baking in the summer, the badly insulated windows making extreme temperatures worse.

There's a specific dream every New Yorker has. I thought it was a myth until I had it, too. In the dream you discover a hitherto hidden space in your apartment: You walk through a door you never realized was there in some cramped corner and all of a sudden you're in a fresh, wide-open room, bright and spotless as if you'd just moved in. It came to mind when I started visiting 101 Spring Street, which is now open to the public under the auspices of the Judd Foundation, which manages his estate.

Judd probably wouldn't have had that dream, because he couldn't possibly have possessed any more space. I returned to 101 Spring Street on weekday afternoons when I could wander it alone, with the permission of the foundation, which is housed in basement offices. The visits were a respite from the city. There are few places in New York—not the street, not the subway, certainly not the Museum of Modern Art—where you can be surrounded by so much uncrowded space. It's luxuriously empty. Each time I visited I watched the light grow rosier through the floor-to-ceiling, wall-to-wall windows as the sun set over the SoHo rooftops.

The space, seventy-five feet long by twenty-five feet wide, isn't nearly as clean or antiseptic as Judd's public reputation for Minimalism

might suggest. There are signs of life everywhere, particularly in the open kitchen, from small wicker chairs for the young Rainer and Flavin to a stovetop espresso maker, Chemex, and mammoth teakettle on the counter, along with Wüsthof knives and a sinister deli-meat slicer. Judd's shelves are stacked with wine, whiskey bottles, and wooden sake cups, the ingredients of an instantaneous party. The floorboards aren't pristine but spotted with green paint, ground deep into the wood from a century and a half of wear. They squeak in spots, the sound a reminder of the building's age and character, which Judd worked hard to preserve. He presaged ideas of adaptive reuse—turning industrial buildings into livable architecture—and reclaiming urban space that have only recently become mainstream.

Nothing in the loft matches, but everything goes together. Judd mixed angular chairs by the Dutch designer Gerrit Rietveld with tables of his own design, long and wide enough to seat a dozen. Interspersed in the living quarters is a museum-quality collection of artwork from the '60s and '70s, including a wall-sized pastel-colored shaped canvas by Frank Stella and a Claes Oldenburg "soft sculpture," a three-dimensional model of theater lights made of plain canvas flopping from the wall—another "specific object" that doesn't look Minimalist at all. The creaking staircase running all the way up the interior side of the building is decorated with tribal masks from the Americas right next to drawings by Dan Flavin. There's an eclecticism that isn't apparent in more recent "minimalist" condos.

Pride of place on the third floor, the studio, goes to two of Judd's metal boxes. One is a chest-high rectangle open on either end so that you can see through to the windows on the shorter side of the building, where two curved chairs look out over the view. The other is a smaller closed box made of galvanized aluminum with a recessed top that creates a shallow pool of empty space. When I encountered the

installation I realized that this was how the work was meant to be seen—not isolated in a gallery like a hospital patient but in the midst of everything else that makes up a life.

In the natural light shining through the windows, constantly shifting with the angle of the sun, Judd's works come alive. The treated metal of the smaller box sparkled, and its colors changed as I walked around it. There was so much to see and find in the work even though it didn't hold any symbolism besides the perception of space itself. I remembered what Miguel de Baca, an associate professor of art history at Lake Forest College, had told me during a conversation about Judd: "Minimalism in the 1960s was very much along the lines of taking LSD." Just because it looks simple doesn't mean its effect is. "It isn't necessary for a work to have a lot of things to look at, to compare, to analyze one by one, to contemplate," Judd wrote in 1964. "The thing as a whole, its quality as a whole, is what is interesting."

Each part of the loft relates to the building overall; you always know where you are. The distribution of art and objects has a way of ordering what might otherwise be unstructured or messy, which was another goal of Judd's work. In another attempt to define what he was looking for in his installations, he wrote, "It's logical to desire the space in all directions to become clear." There's a kind of ecstasy to the clarity of well-ordered space, a feeling that I also get from well-proportioned floorboards or a full parking lot: Life's structurelessness is briefly banished.

As you ascend, the interiors become lighter and airier. On the fifth floor, where the bedroom is, the ceiling is painted white and angled upward as if opening to the sky. This was the loft's most private space, devoted to the family. The two children slept on a raised platform that Judd eventually built in the corner, while Don and Julie had a bed in the center of the floor's open space on a low platform made of walnut,

the first piece of furniture that Judd ever designed. The bed platform was itself a tool for living, embedded with electrical outlets and light switches. Ringed around it are a heavy black telephone for calls with fabricators or dealers; a thin-armed reading lamp; and a flashlight for navigating at night, since the artist couldn't stand ceiling lights. The surface is worn with ring marks on the wood where coffee cups, wine bottles, and water glasses once rested.

The view across the bedroom, where art takes up more space than the bed, inspired a thousand *Dwell* photo shoots. A chaotic Chamberlain sculpture is mounted on the wall, its metal shards arcing out into empty space. Nearby is an early work of Judd's that looks like a vertically oriented skateboard half-pipe. Along the entire length of the building is a Dan Flavin light installation with repeating squares of red and purple fluorescent bulbs that cast a nightclub glow over the room when the piece is turned on. The ease with which Judd lived among such unrepentantly radical art spoke to how well he understood it. Like Philip Johnson, he made the avant-garde look domestic.

I prefer the less-neat, less-curated or controlled version of the top floor, however. In a photo from the '70s, in the early days of the renovation, Julie Finch rests on the bed with newborn Rainer. Or not the bed exactly, but the rough draft of a bed, planks resting on other planks. Piles of books surrounded it; a television is switched on on the floor in front of Finch next to a box fan and two multicolored Rietveld chairs. Long ribbons of sunset light stripe over the blond wood floorboards to cover everything. There seems to be no barrier between any one object and any other, just a continuous flow of life becoming art and vice versa. Leaning over by the row of windows you can look down on the street and see the pedestrians like figurines pacing through the heart of the city.

WRITING ABOUT EMPTINESS is difficult because words document presence. As soon as you point to something in writing, it's there, even if what you point to is empty floor. Language often seems like so much stuff crowding an otherwise blank page: The more words, the less true a text feels. Both Philip Johnson and Donald Judd chafed at the inadequacies of language in regard to their work, though both were also prolific writers. A tragic paradox of writing: You can't do it, but you also can't not. "The word kills art," Johnson proclaimed in a 1955 speech at Barnard College. "The word is an abstraction and art is concrete. The word is old, loaded with accreted meanings from usage. Art is new." Language can't represent something for which there is no precedent or definite presence. Under Minimalism, "metaphor died," as the critic Brian O'Doherty wrote.

Critical writing often labors to create easy narratives, mounting messy reality into a logical framework. Throughout his life Judd criticized writers trying to categorize his art. "Instead of thinking about each person's work, critics invent labels to pad their irrelevant discourse," he wrote in a letter to the *Village Voice* in 1981 (forgetting his own journeyman critic days). But words have an implacable power to define, he also recognized in 1984: "When I hear the same nonsense about Minimalism and impersonality for twenty years, I realize that the clichés have stuck." Judd was a victim of words.

The question is how to evoke the absences of Minimalism in writing without collapsing or codifying them, without closing the possibilities they open, because true Minimalist aesthetics depend on them. Each intentional absence has a way of intensifying the presence of something else or leaving room for a new sensation. Judd's early sculptures, as well as Dan Flavin's light fixtures or Anne Truitt's colored geometric pillars, were shockingly devoid of the usual suggestions of the art object—anthropomorphic forms, meaningful symbolism, or careful brushstrokes of paint—forcing viewers to focus instead on the bare facts of what was there, the planes of metal and wood that composed the objects. In the absence of narrative, material become more important.

Emptiness in particularly extreme cases can be aggressive. If a space looks truly empty or a thing too austerely boring, it can be a signal for the mind to simply turn off, since there seems to be nothing to perceive, the same way the eye passes over a bare garage. Emptiness can even incite frustration or anger if what you think you're supposed to be seeing isn't immediately apparent—part of the discomfort of Minimalism that Wollheim noticed. Such is the reaction of some visitors to *The New York Earth Room*, a work by the American artist Walter De Maria that has been permanently installed in a SoHo loft a few blocks from Judd's home since 1977. De Maria described the piece simply as a "minimal horizontal interior earth sculpture."

You have to know what to look for, even if you're looking for absence. Nestled among current-day SoHo's fashion outlets and out-of-town shoppers milling about is an anonymous doorway. One of the buttons on the buzzer is labeled "Earth Room." Push it—as I did one morning when the sidewalk food carts had only just started billowing smoke onto the street in preparation for the day's customers—and the door will open onto a set of stairs. Up one flight and through a glass door is a

blank white hallway that seems to contain nothing, but as I made my way inside I was struck by a sudden rise in temperature and humidity, as if I had stepped into a damp sauna. Then came the smell, a familiar but surprising scent to encounter in Manhattan: the deep, slightly musky, fertile aroma of wet dirt.

Down the hallway I encountered a door-sized cutout with a low glass barrier blocking the way. The glass holds back a field of loose, healthy-looking soil piled up two feet high extending throughout a 3,600-square-foot all-white space. The dirt seemed to have just appeared there, as in a dream. I imagined it flowing through the space like a tide of water seeking level. On the ends of the loft, rows of windows cast rectangles of sunlight onto the dark surface, creating a slight suggestion of steam rising up.

The dense smell combined with the blankness of the surrounding white space offered the opportunity to free-associate, as if memory and thought could fill the piece's visual void between earth and ceiling. The image that came to me was of the cul-de-sac in my childhood neighborhood. My house was at the end of a long road winding into the hills, so that if I walked down the driveway and wandered down the pavement slope I could hop over the curb and walk straight into the woods, which extended to the horizon. Something of a footpath was marked, but otherwise the woods were as wild as any natural land-scape in the area. Tall trees filtered the sun until it only reached the ground in scattered fragments, spotlighting the soil underfoot. The woods' particular scent came from a combination of slowly mulching autumn leaves; scattered brooks of flowing water, some running clear over pebbles and others muddy; and green shoots of skunk cabbage emerging in the spring. When I was a kid, the sight and smell of dirt symbolized the freedom that came with entering that

seemingly uncivilized space, so close to home and yet so different from the enclosing walls. In the city, De Maria's earth was a reminder that it was still possible to feel that freedom, at least for the length of a reverie.

Behind a high wooden desk at the far end of the hallway past the *Earth Room* sat Bill Dilworth, a painter in his early sixties who has watched over the piece as its caretaker since 1989. He works for the Dia Art Foundation, the organization that commissioned the work four decades ago and continues to support it; they were a formative supporter of Judd's largest projects as well. With an unruly head of hair, thick eyebrows, and an inquisitive cast to his face, Dilworth looks preternaturally youthful, as if the loamy air he is exposed to at work keeps him young. His job is monkish. He waters and turns the dirt weekly so that nothing grows (otherwise it would be full of fungi and plants sprouting from seeds that somehow sneak inside on visitors) and it stays looking as fresh as when De Maria installed it. In fact, it's been the same dirt, held in place by the same plastic sheets, since 1977.

Over the decades Dilworth has become a close observer of how visitors interact with the artwork, and how they react to its Minimalism. Attendance has increased every year, especially since the *Earth Room* was highlighted in *Lonely Planet* as a tourist destination, but some seem to miss it entirely. "A lot of people will walk right by it and not know that's it," he told me. They stand in front of the piece for ten or twenty seconds, gaze at the field of dirt, and wonder what they're missing instead of thinking about what's right in front of them. The reaction has something to do with our expectations of what art should look like, the same expectations that Minimalism pushed against, namely that art should be readily apparent and distinct from the mundane world around it, or that it should offer up a message in the first place.

"People come up and ask me what it means," Dilworth said, sardonically pleased with his strategy: "I really just turn them back to the *Earth Room* so they can look for that answer." The caretaker feels the interpretation isn't up to him, that it would be irresponsible for him to influence how other people see it. The expanse of dirt is whatever you bring to it. There is no answer or solution to the mystery; it just is what it is. Accepting the lack of resolution is core to Minimalism's philosophy, and Dilworth is adept at it.

Walter De Maria moved to New York City from Berkeley in 1960. He had been involved in music as well as art, collaborating with the Minimalist composer La Monte Young in California and forming a band with Lou Reed that was the precursor to the Velvet Underground. But he is best known for his gently monumental sculptures, like the *Earth Room* and *The Lightning Field*, a grid of stainless steel poles—acting as literal lightning rods during storms—installed vertically in a grid over one square kilometer of ground in New Mexico. (The latter was also commissioned by Dia in 1977.) De Maria is often identified with the Land Art movement alongside artists like Robert Smithson and Michael Heizer, who came to prominence in the '70s shortly after the Minimalists, but De Maria's materials and aesthetics are decidedly minimal. Like Judd's "specific objects," *The Lightning Field*'s physical details can only hint at the individualized sensory effect it produces, the place- and space-specific effect that is the artwork. It's so monumental and yet so reticent that it becomes spiritual, a secularized equivalent to the ineffable majesty of a Gothic cathedral. The piece "offers an intensity of experience that for a long time could be articulated only—or most conveniently—within the language of religion," as Geoff Dyer wrote of his pilgrimage to *The Lightning Field*.

The New York Earth Room is meant to be sustained in perpetuity and so its simplicity also contains a note of permanence. You can

come back to it again and again over the course of a lifetime. The facts won't change. It'll still be full of the same dirt, but the piece's meaning can shift as you yourself change. This is true of any static artwork—you can never look at a painting the same way twice—but particularly for Minimalist art, which rewards and reflects whatever kind of attention you direct at it.

"I came to know Walter well, but it took a long time," Dilworth told me. "Walter understood the power of not speaking." He recalled the artist, who died in 2013, as a quiet figure who avoided explanations. De Maria didn't put on any airs associated with famous artists; he dressed more like a bus driver. On the few times a year that he came to visit the *Earth Room*, he would bolt if any visitor betrayed an awareness that he was its creator. This reticence is another form of emptiness, as the artist's silence, like Dilworth's way of turning visitors back to the artwork, leaves space for our own free interpretations of the experience at hand. De Maria was content to let the *Earth Room* speak for itself, to let his viewers fill the absence he left for us with nostalgia, perhaps, or childhood memories, or a sense of home.

OUTSIDE THE AIRPORT of El Paso in West Texas the city disintegrates quickly into an open horizon of scrubby desert with the odd mountain spiking up like a toy dropped on the carpet of the landscape. As I drove farther west, the mountains cropped up more often, and my rental car, a capsule of air-conditioning in the desert heat, entered into a calm, quiet plane where cattle grazed on sallow fields of grass. On that day a herd of white clouds wandered the entirety of the early-summer blue sky. There was very little anywhere except rocks, brush, and spindly trees. The entrance into this high, serene emptiness was the only sign I was nearing the town of Marfa, population 1,747, where Donald Judd began buying property in 1973 in an attempt to escape the commercialized trap that he felt New York City, and SoHo in particular, was becoming.

Judd had good reason to flee. Over the 1960s he had become one of the most prominent artists in New York, the subject of a solo exhibition at the Whitney Museum of American Art in 1968, the museum's first in a series of shows of younger artists. Curators and dealers from around the world knocked constantly at his studio door requesting new work faster than he could have it fabricated to his satisfaction. Upgrading from Richard Bellamy, he showed at the city's best blue-chip gallery, Leo Castelli, alongside Roy Lichtenstein, Bruce Nauman,

and Lee Bontecou. Sales were not a problem. Artists stopped him on the street wanting to chat or argue, perhaps provoked by his latest critical diatribe, though he wrote more diary entries than criticism as his own work matured. The artist might have been famous, but the shyness of his peripatetic childhood still plagued him. He would sometimes venture out to Max's Kansas City, a bohemian bar on Park Avenue South, but otherwise preferred to spend time with his books and sketches.

As big as Judd thought the loft on Spring Street was when he bought it in 1968, he was already filling up its blue floors—partly with cacti, which he obsessed over as a paid-up member of the New York Cactus and Succulent Society, somehow anticipating the 2010s vogue for the plants. It filled up with his own art as well. "At first I thought the building large, but now I think it small; it didn't hold much work after all," Judd wrote.

His pieces were becoming larger in scope. He made series of metal boxes with repeating, subtly changing forms arrayed on the floor or the wall. Each piece needed its own arena of space, a context that it was dependent on. Neither museums nor galleries could give the artist what he wanted, which was complete customization and a permanent installation. The problem with exhibitions is that they end, and then your work goes back into storage. "You run into an awful lot of people who don't know what it's all about or aren't willing to deal with it seriously or even install it seriously," he complained of art museum staff in 1968. "It gets pretty depressing."

Besides, Minimalism—"I prefer if they damn my work rather than use the word Minimal," he told yet another interviewer in 1976—was becoming a wider practice. On the West Coast a different group of artists emerged who used austere materials to create immersive environments rather than just objects, again emphasizing perception over

interpretation; this so-called Light and Space movement included Robert Irwin, Larry Bell, and Mary Corse. Architects and designers were also adopting Minimalism as a symbol of creative living. In 1977, the architect Alan Buchsbaum designed a SoHo loft apartment for the art theorist Rosalind Krauss, who also published a book on Minimalist sculpture that year. Krauss's loft resembled a massive piece of Minimalist art, with tall, geometric white columns evenly spaced throughout its length and a long white kitchen countertop, sparsely occupied by appliances and trinkets, alongside a boxy white island. A lofted area up a spiral staircase held a bright-white bed on a low gray platform. Upon seeing it, "one's own house suddenly seems cluttered, inchoate, banal," the writer Janet Malcolm observed of the space in 1986.

The photo spreads of Krauss's loft from notices in *New York Magazine* and the *New York Times* show off something like a version of 101 Spring Street given a high-gloss, luxury makeover: all of the angular sparseness but none of the improvisational clutter. Strenuously controlled, it's instead the successor to the Glass House. The arrangement seems to close off space. Krauss's blank white walls dominate in the absence of Judd's carefully treated textures and art installations. "The great thing about this space is that you can put into it anything you want," Krauss told *New York Magazine* at the time. Judd disagreed: Space dictated exactly what you could or could not put in it. Everything had to flow together.

Commercial galleries followed the artists to SoHo's cheap real estate; dealers like Paula Cooper (one of the first to move, in 1968), Nancy Hoffman, and Ileana Sonnabend, as well as Castelli, transformed the industrial lofts into retail operations. It was a process of commodification, even branding, for the neighborhood. During a panel

in 1977, an employee of the Guggenheim Museum said, "SoHo has a style all its own. One could even call it a lifestyle." A dealer said he moved because it felt "much more democratic" than uptown—"and cheap rents!" Larger art installations, such as Judd's, required larger gallery spaces, kicking off an arms race that hasn't stopped to this day. The galleries also evolved a new architectural aesthetic to fit the new art: Their rooms were as blank and empty as possible, the better to highlight the specific objects. The galleries earned themselves the nickname of "white cubes"—a phrase redolent of Minimalism itself.

The white cube presented its own Minimalist ideology. "The new god, extensive, homogeneous space, flowed easily into every part of the gallery. All impediments except 'art' were removed," the critic Brian O'Doherty wrote in his 1981 Artforum essay "The Gallery as a Gesture." This architectural blankness reified what was presented in the gallery as high art, even if it didn't appear to be so to the average viewer, who might indeed mistake a Dan Flavin for mundane lighting. Maybe because the art looked less like art than ever, the gallery-goers needed the aggressive reminder: If you're looking at something on a bare cement floor surrounded by white walls, then it's probably supposed to be art. (This situation sometimes backfires, as when in 2016 two teenagers placed a pair of eyeglasses on the floor of a museum in San Francisco beneath a wall label and watched as viewers took rapturous photos of the "sculpture.")

Though the aesthetic cues themselves could hardly be more different, the white cube worked much like a gaudy nineteenth-century frame around a canvas, reinforcing cultural and historical importance. "The white wall's apparent neutrality is an illusion," O'Doherty wrote in his seminal 1976 essay, also in Artforum, "Inside the White Cube," which codified the idea. It stands in for all of the presumptions and

biases of the art industry, subsuming "commerce and esthetics, artist and audience, ethics and expediency. It is in the image of the society that supports it, so it is a perfect surface off which to bounce our paranoias." The white cube also informs the popular minimalism of the twenty-first century. Today, blank interiors simultaneously deny and reinforce consumerism. The empty house frames any object like a piece of avant-garde art, to be valued as such—even if it's an IKEA dresser.

Judd took issue with SoHo's homogenization. "I think it is horrible," he said. "It is one reason I don't spend much time there." Instead he took to road-tripping with a beat-up white Land Rover and camping in Baja California, where he thought he might establish a new studio but quickly butted heads with the Mexican authorities. One government was bad enough; dealing with two at once would be impossible. Judd instead took a map of the American Southwest, drew circles around the towns with the smallest populations, and then noticed that Marfa was about as far from civilization as you could get while still having enough civilization to hire carpenters—it was made famous previously as the set for the 1956 James Dean movie *Giant*. In Marfa he would avoid all the predatory curators and dealers, the art handlers who damaged his sculptures, and museum guards who let people sit on or put cocktails on his boxes. Anyone who wanted to see Judd would have to make the monotonous three-hour drive from El Paso.

After the long single highway into town, past a lone billboard welcoming me, I arrived in Marfa to do research at the Judd Foundation office, where the artist's archives are kept in a polished-white storefront building on the only downtown intersection that has a traffic light. While I worked there, I sat at the monolithic expanse of a Judd-designed desk in a room full of the same desks, with Judd bookshelves

on the walls. Tourists popped in and out of the archive building all day inquiring about tours and buying Judd souvenirs.

It took decades for the artist to transform Marfa from a semiblank canvas into his own artistic laboratory and a shrine to his entire career. In 1973 the town was actually shrinking; the military base that had sustained a boom in the mid-twentieth century had shut down, removing its only economic bright spot. The population dipped below two thousand and the remaining industry was primarily cattle ranching. But the early prosperity had resulted in a collection of quality architecture that Judd began buying up and restoring in his own style, like the SoHo loft. The first structures he acquired by 1974, for $48,000, were two disused airplane hangars on the outskirts of town next to a noisy feed mill. He roofed the two hangars with corrugated metal and surrounded them with a courtyard wall made from local adobe, turning them into his permanent home. He called the compound the Block, a fitting name for its composite of library, studio, gallery, and living spaces.

Judd's libraries are a demonstration of just how cluttered Minimalism can be. There are two separate spaces, for pre- and post-twentieth century. Twelve-foot-tall shelves stretch through the rooms like army battalions. They're packed with over thirteen thousand volumes on everything from Icelandic sagas to Japanese aesthetics, Enlightenment philosophy, and the psychology of sex. While working on a new exhibition Judd would sprawl out, covering long tables with stacks of relevant books pinned down by odds and ends: seashells, rocks, and tools.

The sheer volume of objects would look like a mess if Judd hadn't acquired so much space to put stuff in. The living areas of the Block are filled with collections of Native American rugs, local ceramics, piles of arrowheads, and racks of cassette tapes—mostly Scottish bagpipe

music and Baroque composers. The whole place was a machine for finding inspiration and making art—the objects didn't just cause joy; they were challenging, shocking, and discomfiting as well, reminders of the wider world outside. Though he eventually turned an entire former grocery store into a devoted studio, Judd felt the artistic process happened everywhere: "Mostly my work is done by me carrying a bunch of papers around and sitting around and thinking," Judd said. "So it could be anywhere."

Throughout each space in every building Judd renovated are tables, desks, chairs, and daybeds, so if passing inspiration struck he'd never be hard-pressed to find somewhere to mull it over. Designing his own furniture was a reaction to Marfa's usual local décor, traditional ranch gear: dark, heavy, and ornate. "There was no way to buy anything I wanted to have," Judd said. Instead he commissioned local carpenters to make airy, geometric pieces out of blond wood, the building blocks of the Judd lifestyle.

His chairs aren't that comfortable, but they weren't supposed to be—you don't need to relax if you're eating or writing. Otherwise you might as well be lying in a daybed or walking around, the artist thought. Nor was his furniture supposed to be for everyone: "I'm not promoting a universal design; it's not going to happen and I don't particularly believe in it." Yet it's hard to miss its resemblance to future IKEA products. (In 1976 the company took up the minimalist slogan "simplicity is beautiful.") Today, the Judd Foundation still manufactures and sells his design products, which don't count as art, though both might be made in factories. A Judd-brand chair starts out at a price of $2,100 and a desk $9,000, though Marfa locals have taken to making their own rough-hewn copies, which I noticed outfitting backyards and picnic areas.

By creating his own architecture in Marfa, Judd was also creating himself. Walking through the buildings feels like watching as he thinks

out loud, testing and re-evaluating different ideas. It takes plenty of egotism (and plenty of capital) to remake the space around you because you think you can do it better, but Judd never settled into one perfect mode or composition: Things were always changing.

One afternoon at the Judd Foundation, I was looking through a box of photographs. There were aerial shots of the desert landscape from when the artist was scoping out new land; interior views of desktops and studio tables; and portraits of Judd in blue jeans and a cowboy hat in the midst of cattle. Then I came across a sheet of blurry Polaroids. They were snapshots of the courtyard at the Block, where Judd built a cubic fenced-in garden, the produce of which he gave away to employees and locals. There was a modernist coop for chicken and geese in one corner, with a rooster inhabiting something that looks like a wooden Glass House. Stray kittens spill out of a cardboard box and scamper over an outdoor table to eat from a bowl while a dog looks on balefully. The sky is the desaturated white-yellow of vintage film. Everything looks improvised and slapdash, far from professionally built—both messy and beautiful.

2 - VII

IN THE MIDST of his Marfa project Donald Judd was offered a blank check. The Dia Art Foundation promised to fund almost any work he wanted to make there. Dia's original plan was to establish a permanent museum by allowing a handful of artists to fill the town's abandoned buildings with Minimalist installations. Judd signed a contract for "certain sculptures, the number and nature of which shall be determined in the artist's sole discretion." The only proviso was that the pieces had to be "a unified aesthetic entity of works and space," which was all Judd wanted to make anyway.

This was an opportunity for the artist to distill all of his ideals into massive projects that would stand the test of time in a context completely under his own control. Judd eventually broke off the Dia collaboration in 1987, yet again dissatisfied with his level of autonomy, and turned over the museum project to an entity called the Chinati Foundation (separate from the Judd Foundation), but the two Dia pieces form the apex of his artistic career. Planning began around 1979 for one indoor work and one outdoor. The original site for the indoor work was a former wool store in downtown Marfa, but when Judd decided the sculpture would consist of one hundred separate aluminum boxes he realized the storefront would be too small. Instead he took over two artillery sheds that were built in 1939, aligned end

to end on the decommissioned Fort D. A. Russell, a military compound on the southwestern outskirts of town where the grid gives way to open scrubland and ribbons of highway. Dia promptly bought the entire property.

The resulting work is equal parts architecture and art, which might after all be the same thing. Judd ripped out the crumbling garage doors of the building that housed the machines and replaced them with gridded glass windows so that the desert light passed straight through the width of the buildings. Then he added semicircular corrugated steel roofs—imagine a grain silo cut in half lengthwise—doubling the buildings' heights. Sketches for the box sculptures evolved into floorplans. An initial prototype commissioned from a factory in Connecticut was too dark and dull; the artist looked for aluminum that would shimmer in the sunlight. The installation—formally known as *100 Untitled Works in Mill Aluminum*—wasn't completed until 1986.

The boxes are an evolved form of the ones Judd left in his SoHo loft, multiplied and arranged in a vast grid three rows wide across the sheds' cement floors, a composition echoed by its gridded cement ceiling. The silhouette of each metal box is the same: seventy-two inches long by fifty-one inches wide by forty-one inches high, and oriented so that their longer side faces the shorter side of the building they're in. But each one is different from all of the rest, like industrial snowflakes.

Some of the boxes are self-enclosed and impenetrable, while others are open so that a breeze would pass through them, if much air moved through the enclosed sheds. The pieces are divided in half vertically or horizontally, or in slices so that gradients of shadow form in their inner voids. Others are bisected diagonally with aluminum sheets like ramps. As I paced the long aisles in silence except for the

sounds of my echoing steps, the light bouncing off the metal made it hard to tell what was actually the inside of a form and what was out. Vibrations of the blue sky and the dun desert reflected everywhere.

Each new box configuration created a continuing rhythm, summoning a sense of movement throughout the rooms like the rippling of waves. The sun made the metal seem soft and hazy. At the right angle some boxes disappeared completely, leaving nothing but reflections of the cement floor, the yellowed landscape, and the red-brown brick of the buildings' front and back walls. Looking over the grid that spread out around me I felt like I was surrounded by aliens, as if someday, far into the future, the boxes would all come alive and replace us in a world built for them alone.

According to Minimalist principles, we have to fight the need to anthropomorphize or impose a metaphorical meaning on the installation. The boxes do not symbolize anything. They don't refer to the soldiers now vanished from the Army base, nor do they represent the variations of our bodies, astrological arrangements, or ideal geometric proportions. Rather, the aluminum boxes are just *there*, empty of content except for the sheer fact of their physical presence, obdurate and silent, explaining nothing and with nothing to explain. They are perfect "specific objects," the fulfillment of Judd's 1967 essay. It might sound deathly boring, more math problem than artwork, but wandering through the installation is a constant affirmation of the simple possibility of sensation, all the ways that the human eye can perceive shifts of light and space and the ways that an artist can intentionally shape that perception.

The boxes are "beautiful" to look at, but the word is not exactly appropriate. I also felt an edge of fear in their midst. Instead of being comforting in the manner of a clean apartment or a bare gallery space,

they are instead implacable, aggressive, and intimidating. Their emptiness in all its variety is a suggestion not of absolute control but absolute freedom, an opportunity to confront the world as it stands before you. Minimalism is a reminder of our ultimate autonomy, that the next second is an unforeseeable future in which we might do anything, or anything might happen to us. Feeling comfortable within that freedom is the challenge that Minimalism poses. Instead of perfection, it can inspire an absence of judgment or an acceptance of immediate reality. "Art is no kind of Utopia, because it really exists," Judd said.

Reality, however, is not just about art. I found that I kept getting drawn back to the work's human element, noticing the intrusion of the temporal into the artificial image of a forever present. The industrial aluminum was as polished as a mirror, but the crevices of the boxes collected dead flies and dust; they have to be cleaned once a week by conservators, an endeavor that takes all day. There was also the building itself. Judd could proclaim a kind of ahistorical objectivity all he liked, but the structures were still military in origin.

On a few of the walls, scuffed painted signs in German are visible, the way Maoist slogans still remain on some of the old factories that have been refurbished into contemporary art galleries in Beijing. The signs were meant to be read by German prisoners held in Fort D. A. Russell during World War II: "Unauthorized access is forbidden," they warn. "Better to use your head than lose it." The signs show how a degree of oppression is inherent in the scale and stature of the architecture itself, something the eternal newness of the boxes and Judd's belief in the possibility of a purely aesthetic art bypasses.

I made my pilgrimage to Marfa in 2018 during the height of a particularly controversial moment of the Trump presidency, when public outcry followed reports that border guards (posted only sixty

miles away from where I was) were forcibly separating immigrant children from their parents, a problem that only intensified in the year following. When I was driving east on the highway on the way to Marfa traffic had slowed to a halt as cars passed through a high-roofed structure in the distance. It was an immigration checkpoint, where police and guards with dogs were checking IDs. As a single white man traveling in a spotless rental car I got waved on without a second glance.

The experience stayed with me as I spent time with Judd's work. The aggressive geometry of the artillery sheds and the unfeeling shapes of the boxes put me in mind of the tall barriers that mercenary architecture firms were designing to make Trump's unbelievable border wall proposal real, as well as the chain-link rooms that the separated children were being caged in. I found that even in the installation simplicity could be a mask, an invitation to overlook certain things and focus on others, prioritizing aesthetics above all. In 1990 the art historian Anna Chave deconstructed the ways that Minimalist art holds itself aloof in her essay "Minimalism and the Rhetoric of Power." In its replicability and denial of the human scale or hand, "Judd's work can easily be seen as reproducing some of the values most indelibly associated with the modern technocracy," Chave wrote. "The blank face of Minimalism may come into focus as the face of capital, the face of authority, the face of the father." This inherent blankness is also what made it easier to ignore or downplay the original ideas of Minimalism and instead embrace its style.

Judd's other Dia-commissioned work, a less absolutist project, is located down a barely marked path through the scrub near the artillery sheds. I went one morning equipped with the requisite hat and heavy sunscreen and walked until I hit an enormous hollow box made of

concrete, a rectangular prism of slabs twenty-five centimeters thick, two-and-a-half meters square on a side by five meters long. The sun was glaring down on top of the slab over my head but the interior, left open and empty, was dark and cool. Its scale was geological, like a boulder deposited there by glaciers, but its proportions were precise and the corners sharp. Extending in the distance running north-south was a line almost a kilometer long of more concrete boxes repeating in various configurations—rows, triangles, and grids—shrinking toward the low horizon.

This was *15 Untitled Works in Concrete*, which Judd made from 1980 to 1984. Of course, he didn't make them, exactly. They were cast in place by workers whose fingerprints, like those of the builders of Stonehenge, are long vanished, leaving them authorless except for the artist, whose name will inevitably fade in time as well. Judd initially had trouble fabricating the concrete boxes; the sides didn't quite match up and the seams weren't clean. He had to bring in a specialist from Dallas and eventually fire the company he originally contracted, save one employee who kept overseeing the project. But after the struggle, the boxes are now as much a part of the landscape as the rocks or trees.

You have to interact with the concrete boxes with your body. It's a sweaty process. I walked from one set of boxes to the next, feeling the variations in composition. Another sensory rhythm established itself over time and space. Farther down the line, the boxes increased in number and the arrangements became more geometrically complex, like a series of diagrams beamed out intergalactically to demonstrate human intelligence. The "15" of the title describes the number of discrete sets: The unit is the configuration, not the individual box. Four boxes in one gridded set are open on both of their longer sides,

forming frames for the desert, golden in the morning light. Down the path, a triangle is made by three boxes with one square end open each, the resulting tunnel pointing inward to the center of the triangle like a blocked telescope. A kind of narrative in light and shadow, emptiness and solidity, takes shape, with the logic of a higher order but no clear message except that what is there is there.

The earth still intruded implacably on the art. The running vines that one Chinati tour guide told me were called "stink squash" ran along the ground. Animals had left what seemed like nests in some of the boxes, particularly those with a closed side, which needed sweeping out. Huge moths attached themselves to the interior walls, seeking shade. I stepped over a lot of antelope poop. Without attention from conservators nature will gradually overcome the constructions, but in the desert it will take a while. As climate change intensifies it's more than conceivable that the boxes will outlast the life around them as the sand accumulates; they will survive as ruins.

After the last set of boxes is a small hill with a path upward. By climbing it you can get a view of the entire installation that's impossible while walking through. When I came to the base of the hill, however, there was a family of antelope perched on it. A mother and four calves wandered the ridge of the hill, picking their way through the bushes. The father—I presumed from the aggressive curlicue horns—lay at the base of the hill by the path. He gazed straight at me like he was keeping guard, looking on impassively and imperiously toward Judd's sculptures. I didn't go any closer, since I wasn't sure the animals would actually flee if I did, so I never got to see the whole thing.

The antelope reminded me of an experience Judd recounted in his diary on December 3, 1986, while he was staying at a ranch farther out in the desert. He recalled a moment the previous September when

the landscape was in bloom from rain. He noticed a jackrabbit hop out of the grass then disappear into the blank spot of a mirage caused by the rippling air. "The desert was spare, as usual, but very green and beautiful. I realized that the land and presumably the rabbits, quail, lizards, and bugs didn't know that this was beautiful," he wrote. "The observation is only ours, the same as the lizard's opinion of the bug. The observation has no relevance, no validity, no objectivity, and so the land was not beautiful—who's to say. It simply exists."

This is Minimalism's most powerful and frightening insight. It has nothing to do with the aesthetic cues associated with lowercase-*m* minimalism, the consumer products, interior decoration, the curated items of clothing. Minimalism doesn't need to look good. It tries to make us understand that the sense of artistic beauty humanity has built up over millennia—the varieties of colors, stories recounted, and bodies represented—is also an artificial creation, not as inevitable as we think it is.

Minimalism requires a new definition of beauty, one that centers on the fundamental miracle of our moment-to-moment encounter with reality, our sense of being itself. Any attempt at elegance is extraneous. Judd left another note in his diary that winter: "A definition of art finally occurred to me. Art is everything at once."

THOUGH DONALD JUDD thought the art world was already too crowded in the '70s and '80s, it is far larger and more influential today. Art galleries are now behemoth shopping malls, the commercial white cubes bigger than museum spaces, proliferating across entire neighborhoods. Auction house sales net a billion dollars in a night as collectors compete over artists, though Judd's prices have never reached the heights of Warhol, Jeff Koons, or Damien Hirst, in part because they are so replicable. Art has been commodified at a scale that Judd may have never imagined, and its most successful figures have become mainstream celebrities who collaborate with clothing brands and pop stars.

Judd couldn't get far enough away. Over time he got sick of the bustle and gossip of tiny downtown Marfa and focused his efforts on rebuilding small ranch houses hours into the desert. He participated in local politics, advocating against any borders that infringed on the region's open land. The sense of freedom in his art was reflected in a kind of libertarian socialism, against authority and for cooperation: "If you don't act, someone will decide everything." Judd's vision never stopped expanding. He died at the age of sixty-five in 1994 from a sudden diagnosis of non-Hodgkin's lymphoma in the midst of working on projects around the world, including renovating an old hotel in a Swiss village and planning a series of barnlike galleries in Marfa,

bigger than ever. His architecture became just as important as the art he made. "It is my hope that such of my works of art which I own at the time of my death will be preserved where they are installed," Judd's will read—the two forms, spaces and objects, were inextricable.

When estate lawyers proved themselves ignorant of the art world as well as Judd's wishes, Rainer and Flavin Judd, who were in their twenties at the time, took over the artist's estate and made a controversial decision. They sold a portion of his work that he had kept for himself at auction in order to fund the preservation of what they thought was most important: the loft at 101 Spring Street and Marfa spaces like the Block. Selling a chunk of an artist's work at once risks depressing the market and lowering prices by flooding it with supply. When I met Flavin, a sandy-haired filmmaker who spends most of his time managing the Judd Foundation, in the modernized office in the basement of 101 Spring Street, he explained the logic of the sale. It was an anti-commercialization move, in a way: Only the pieces that were installed in the spaces Judd designed truly represented his vision.

"If we install it, it's kind of a warping of what Don did," Flavin said. "There are plenty of places that are institutionalized, where the original artist's touch or intention is not there, and you can feel it. It just feels different; it feels more corporate or something. That's to be avoided. You're degrading it no matter what you're doing." Without the full context, the light, space, and architecture that the loft or the desert provided, the works weren't as meaningful. I had to agree; Judd's work never looks as good as when it's in his own spaces and part of a total work of art.

Over the decades art itself has become a commercializing force in the wider economy. Richard Florida's Creative Class theory, circa 2002, made it common knowledge that artists are on the front lines

of reviving urban spaces—a process also known as gentrification. SoHo was the classic example. Judd and so many other artists demonstrated how factory loft living could be cool, giving postindustrial space a veneer of cultural capital that later made it possible for developers.

Frank Gehry's famous Guggenheim Museum Bilbao opened in 1997, a structure of arcing steel waves that became one of the largest museums in Spain, though the city was small. In the decade that followed, the museum's instant landmark status, the tourism boom, and the artistic community that sprung up around it led to the coinage of the "Bilbao Effect." It's "a phenomenon whereby cultural investment plus showy architecture is supposed to equal economic uplift for cities down on their luck," according to the *Guardian*.

The tactic has been adopted everywhere from Denver and Athens to Abu Dhabi, Leipzig, and the Japanese island of Naoshima. Each place tries to lure money like bees to flowers by installing an extravagant array of art in equally extravagant surroundings—part art museum, part intentional tourist trap. Marfa has either thrived or suffered under the same theory, depending on your perspective. Kickstarted by Judd, the town is now a hipster oasis. It features in lifestyle photo shoots and literary novels alike. Ben Lerner's 2014 novel *10:04* evoked Marfa as the locus of artist residencies, late-night parties, and accidental ketamine ingestion.

While researching there I stayed at an inn that was operated entirely on Airbnb. It was a series of small apartments filled with plasticky faux-mid-century furniture ringed around a gravel courtyard with trees shedding pink petals onto the sidewalk. The inn had opened not so long ago, and I suspected I was the only occupant until late in my trip when some neighbors arrived and other windows lit up at

night. Elsewhere the few blocks of downtown Marfa were dotted with clothing boutiques selling cowboy hats and leather boots; a sleek new hotel with an upscale restaurant and pop-up bookstore; a single Whole Foods–esque market stocked with vegan sandwiches and Topo Chico mineral water; and, of course, rustic-chic coffee shops like Do Your Thing, where I visited almost daily to get the almond-butter toast. Everything shuts down early during the week, but by Thursday tourists start trickling in, breaking the companionable silence of the café regulars.

The original ranch-town vibes still peek through with goofy food trucks housed in Airstream trailers and plentiful UFO kitsch, but it's getting paved over with contemporary minimalism, denied from Judd. When I drove out into the surrounding blocks of houses it was easy to spot the newest, largest homes, modernist-style boxes with glass window-walls sealed against the elements. There's a wine bar in a beautifully renovated old storefront, designed to split the difference between old-West saloon and Judd architecture. I ate there several times and saw everyone I knew in town doing the same, including Rainer Judd, but it always felt a little strange. Judd hadn't built all this so you could get homemade pasta and a glass of rosé in the desert. The area is compelling in its own right and might have drawn the Coachella crowd eventually, but Judd is one of the only reasons it's a destination. These days, though, you can go to Marfa on vacation and not think about the artist at all. Plenty of people don't.

Money is flowing in. The Bilbao Effect worked. Bartenders, book-sellers, and a fellow freelance journalist all complained to me about rising rent prices in town. When Flavin goes to Marfa, he stays with a friend. "It's very much as if the Hamptons had been plopped down in the middle of the desert," he told me. "No one can afford to live there

except lawyers. Who wants to live in a town full of lawyers? It's the biggest nightmare ever."

Not even the isolation matters if you can afford your own plane. "It becomes this kind of town of absentee owners who have a superficial interest within the town. It's just secondary and aesthetic," Flavin said. Marfa has suffered the same gentrifying fate as SoHo, where the lofts renovated into glossy sameness now rent for tens of thousands of dollars a month and the ground floors of former factories are occupied by luxury fashion brands more often than not. Few actual artists, except for those who bought in in the '60s, can afford it. Nike recently took over the entirety of a 101 Spring Street–sized building and turned it into a playground for sneaker shoppers.

Art becomes retail surprisingly quickly. On the highway half an hour outside of Marfa there's a single building on the side of the empty stretch of road. It looks like a storefront in an outlet mall, though it stands totally alone, a single symmetrical glass box with a door in the front. The two shades on the windows proclaim Prada. There are lines of luxury bags on the all-white display boxes inside—the minimalist interior design that all the brand's stores adopted—but the door is always locked. *Prada Marfa* is actually an installation from 2005 by the Scandinavian artist duo Elmgreen & Dragset. It's now an Instagram trap. With nothing else around but cows cars pull in to the gravel lot or across the road so tourists can hop out to take selfies. The piece mocks the transformation of modernism and then Minimalism into aspirational commodities; it's the end point of the circuit from Philip Johnson's Glass House. But I still overheard visitors referring to it as an actual store that they wanted to go to—"Do you know what time it opens?"

There's a Bilbao Effect for aesthetics, too. Artists rush out into some unclaimed territory, in this case the appreciation of premade

industrial materials and conspicuous emptiness, the single object on a blank wall. As the aesthetic percolates first the early adopters and then more mainstream audiences realize that they like it, too. Soon, brands and businesses are cashing in on the consumers and it becomes hard to remember that a style ever seemed off-putting or challenging to begin with. It's hard to escape popular taste in the long run, no matter how radical you think you are. When popularity takes over it wears away at what made something unique in the first place, like that meaningless MINIMALISM t-shirt from the Gap that I saw in Penn Station. Minimalism's emptiness helped it slide along this path to commodification, even though that same quality was what made it so radical in the '60s. It could be whatever you wanted it to be, so the style was eventually applied as a class signifier. Yet in minimalisn's origins, and in the objects artists like Judd left behind, it is still capable of breaking down the layers of money, taste, and marketing that separate us from pure sensation.

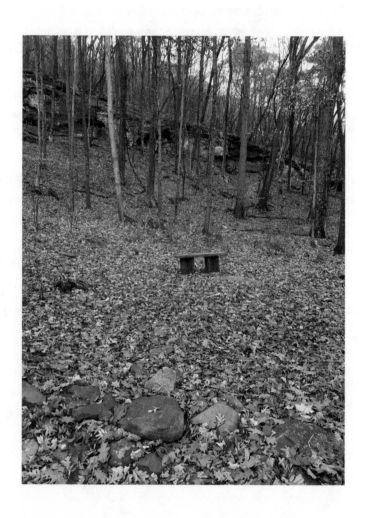

3. Silence

It's EASY ENOUGH to notice the excess stuff surrounding you and decide to throw out old items of clothing or expose the bare floor or empty walls of an apartment. Reducing is a physical solution with tangible results and a clear before-and-after transformation, like a plastic surgery advertisement. A minimalist space is something you can acquire and outfit with a kit, whether it's a $10,000 Judd daybed or a $40 IKEA coffee table.

The rest of the world—the noisy street, the tides of people walking down city sidewalks, the inescapable visual chaos of advertising—is harder to impose order on. Digital space is full of noise, too. The offices or cafés we sit in might be sparse, but we immerse ourselves in our phones or laptops, bombarding our eyes with imagery from Instagram and Facebook; our ears with streaming music or podcasts; our minds with the ceaseless information feeds of media headlines and Twitter. Our heads are victims of the prevailing clutter as much as our spaces.

As I wrote this book, when all I theoretically had to concentrate on was absence and emptiness, I found myself more distracted than ever. I couldn't resist the pull of my iPhone and the latest social media updates or messages from friends. More than news I just craved random stimuli: the latest picture, sound, or text. This craving was simultaneously boring and overwhelming. The constant baseline of

noise created an addiction for more that was fundamentally unsatisfying to feed, much like eating potato chips.

To fight the need for so much stimulation, or at least to readjust my equilibrium, I would turn the Wi-Fi off on my laptop and move my phone into another room so I couldn't grab at it in a moment's weakness. I chose to write in spaces that didn't have internet access and fantasized about a basement bunker where I would be forced to concentrate by the total absence of anything else. This conscious withdrawal from information overload and retreat from the social media platforms that have demanded so much of our energy in the 2010s is often described as "digital minimalism." Digital minimalism means admitting to screen addiction, committing to checking your email less often or deleting your Facebook account.

In the midst of my attention problem I remembered something I had encountered online, probably while procrastinating. Sensory deprivation—a forced plunge into darkness and silence for an hour or two inside a closed chamber—had become trendy for all of us twitchy abusers of the internet. It was the subject of both newspaper lifestyle features and intensive medical studies gauging its salutary effect on the brain. So I searched for a local spa that offered the experience. Up came images of clamshell devices some eight feet long and six feet wide in which the patient floats naked on a shallow pool of water made dense with a thousand pounds of Epsom salts. When the lid shuts, you can't see or hear anything.

I was suddenly desperate for silence. The thought of feeling nothing—an absolute vacation from the outside world—was deeply appealing. Sensory deprivation offered the opposite of overstimulation. Science also seemed to bear out some of its positive effects. The official medical term for floating in a dark pool is "restricted

environmental stimulation technique," or REST, an appropriate acronym. Experiments have shown that an hour or two of REST reduces levels of cortisol, a stress hormone, by twenty-five percent; increases interoception, your awareness of your own body, breath, and heartbeat; and reduces general anxiety.

One study tested floating against watching ninety minutes of *Planet Earth*, another useful soporific. Sensory deprivation turned out to be much better at inducing self-reported feelings of relaxation and serenity than the documentary. It activates the brain's insular cortices, which help produce emotional responses to bodily experiences. Not to mention the whole water thing is incompatible with holding on to your phone. It's like Marie Kondo-ing your mind.

So I booked an appointment at Soulex, a "float spa" that opened in 2017, part of a wave of more than three hundred sensory deprivation facilities across the United States. Soulex was in a storefront on the side of a major thoroughfare among anonymous office buildings in downtown Washington, D.C. Sensory deprivation was the only service it offered, with four pods that might as well have been giant Apple devices, all smooth, white, and curvilinear, each in a separate room. They were created by a Hungarian designer, manufactured in Germany, and cost some $30,000 apiece, which made the $70 price I paid for an initial hour of floating seem almost cheap.

Sensory deprivation was pioneered in the mid-1950s when an American scientist named John C. Lilly invented an early float tank to conduct experiments in human perception, primarily on himself. He took LSD and ketamine; befriended Allen Ginsberg and Timothy Leary; hung out at the New Age institute Esalen; and felt he could personally communicate with dolphins. According to Lilly, sensory deprivation represented emancipation from society and the self. "All the average

person has to do is to get into the tank in the darkness and silence and float around until he realizes he is programming everything that is happening inside his head," he wrote. Isolation paradoxically provided was another way of removing barriers between the individual and the world.

The tanks had a vogue in the 1970s, but unwarranted health scares during the AIDS crisis dispelled much public interest. It was a niche habit, like ayahuasca retreats or Japanese toilets, with a slight air of perversion that hasn't really dissipated. The 1980 movie *Altered States* featured a Lilly-inspired scientist who transcended time and space by taking hallucinogenics while in a float tank. In the end he mutates into a multidimensional blob.

Dariush Vaziri, a trim middle-aged man who built Soulex with his wife, Pedramin, told me that he first encountered float tanks thirty years ago during a reading group in the home of a wealthy CEO. "People usually had these in their homes and strangers would go to try it out," Dariush said. These days, Soulex has a consistent clientele seeking everything from faster physical recovery—it's very popular among athletes—to the more abstract mental health benefits. "We get a lot of people who are in politics here," he explained. "This is just a respite from all this craziness in their lives." The spa gets busiest on Fridays and weekends.

Dariush was serene. I was jealous of his glowing skin, a putative benefit of Epsom salt exposure. His white polo shirt was tucked into fitted chinos and he wore a pair of red-rimmed circular glasses. Despite the scrupulously healthful vibe, I couldn't help but feel like I was participating in something salacious. Dariush led me down the hallway, pointed out a bathroom, and opened the door to my dark-tiled room, with a glassed-in shower in the corner for washing before and after the floating. The white pod loomed in the rest of the space.

He turned on the pod using a touchscreen on the wall and ninety-five-degree water began rushing into it as if it was filling the basin of a giant toilet, except a toilet that was also installed with LED lights slowly shifting color across the rainbow spectrum. A recording of birds chirping emanated from some internal speaker. The sound was particularly surreal because the room was so sterile and unnatural, the only other hint of nature a bedraggled houseplant and one large rock inexplicably placed on the floor. "When the filtered water rises to the lights," Dariush instructed me, "step in, shut the lid, and the hour starts counting down." After a few minutes the lights inside fade to darkness and the sound stops.

Instead of relaxed, I felt slightly terrified. I sometimes suffer from acute claustrophobia. I hate elevators and can't stand it when the subway stops underground for long. I think it's partly boredom that I'm afraid of, the threat of being disconnected after becoming too used to the constant barrage of stimuli. I was not actually looking forward to sealing myself inside a clamshell with no other activity for an hour, no matter how soothing. Maybe it would be too much silence?

Despite my nerves, I did as instructed. I stripped entirely, showered, still feeling awkward, and gingerly dipped a toe into the water. When I immersed myself my body bounced up like the bob on a fishing lure, three-quarters in the water and one-quarter out. Then the lights turned off and I was left alone. Calling it "womb-like" would be an understatement, since I was literally immersed in liquid inside a biomorphic capsule.

The floating experience immediately cancels out a lot of noise, and not just sound waves. I felt my mind cut off from physical sensation since I no longer had to think about where my limbs were moving in space. There was no visual information to process; opening my eyes

was the same as closing them. But the silence was far from complete. I could still hear the low vibration of motors and tires spinning on the pavement outside. Then I noticed squeaks and splashes from the pods that must have been just on the other side of the walls of my chamber. I couldn't stop thinking about how there were other naked people floating in other pods in other rooms, sealed away just like me. We were all in our own separate environments, each divorced from the world, and yet somehow also together. Like the future-forecasting Precogs in *Minority Report* immersed supine in their glowing blue communal hot tub, except totally useless.

I tried to relax, loosened my shoulders after the fear of sinking dissipated, and managed to fall into and out of spells of meditative breathing. In those moments I didn't notice time passing as much, but the lull kept getting interrupted. Maybe I was a little too tall for the pod. Every so often my head or toes would bonk against the fiberglass-egg walls like I was a rubber duck in a tub, breaking the sense that I was hovering in space. I moved into different floating positions, my arms above my head or at my sides, knees bent or legs straight. It reminded me of taking baths as a child.

The best REST came when I could embrace silence: no feeling or thinking. It was like instant meditation, the kind that maybe a trained practitioner could achieve easily but which had felt impossible for me. I simply existed, preoccupied with the sensation of floating, not worrying about any to-do list or looming deadlines. It was like my body was sleeping but my brain was awake. No claustrophobic panic struck. I could open the tank whenever I wanted, but I also wasn't bored—the nothingness was pleasant. When I heard the ambient bird chirps again, at first soft and distant, then jarringly loud, and saw the disco lights turning back on underwater, I was surprised that an hour had gone by so quickly.

After taking a selfie in the illuminated water I showered again and left Soulex feeling a bemused buzz, more like waking up from the perfect nap than chemical intoxication. I was surprised to realize that this state of relaxation was always there, somewhere in my brain. But I needed a machine and an hour of free time removed from the outside world to unlock it.

After the first float session, whenever my environment got too noisy my mind returned to the extreme serenity of the sealed pod, dark and quiet. The feeling was so compelling that I scheduled a few more appointments. I learned to like the feeling of not knowing if my eyes were open or closed. The warm buoyancy, like an embrace from the water, almost brought me to tears. I had strange, immersive dreams the nights after. But I also once got so annoyed with a single strip of light shining from underneath the door that I climbed out dripping and blocked it with a towel.

The artificiality of the situation began to bother me. I was consuming industrialized silence as a luxury, paying an hourly rate for an on-demand product. In the face of too much twenty-first-century stimulation I closed myself into a Stone Age cave in order to deal with it—the ultimate regression.

While Philip Johnson controlled space by ruthlessly imposing order and deciding which objects could stay and which were banished from his Glass House, digital minimalism controls stimuli through a similar process of removal. In the case of sensory deprivation, complete silence is imposed rather than found, turning a stretch of time into something comfortably, as well as expensively, empty.

Silence is now portable. A few years ago, I caved and spent some $300 on a pair of Bose noise-canceling headphones to deal with a loud office. I saw people equipped with the chunky gray devices

everywhere, sitting on commuter trains, in doctors' waiting rooms, and always while flying. No sooner would the wheels leave the runway than my besuited businessman neighbor would don the gear and switch on the green light that meant the machinery was working, erasing the noise around him. I couldn't talk to him even if I wanted to. The brand promised "quiet comfort," which it delivered—the cushions sat over my ears like clouds and the headband felt like it wasn't there at all. Clicking on the electronics is a contemporary ritual, almost an act of prayer: Sound vanishes with a slight whoosh and a sudden vacuum, made by the headphones emitting sound waves equal and opposite to those around you, canceling them out.

Silence can be a kind of nothingness, an erasure of the world in favor of a more manageable blankness, an absense of perception. We use silence to paper over experiences we don't like, creating a blockade between ourselves and sensation. It's a natual response to the excess of information that we confront every day in the form of emails, texts, advertising, and noise. But minimalism can also point the way toward other forms of silence, ones that, instead of erecting a barrier and closing us off, open us up to new ways of listening.

SILENCE HAS A reputation for being generative. It's the natural home of the creative or spiritual mind. Awareness of God is "impossible without silence, recollection, solitude, and a certain withdrawal," wrote the twentieth-century American monk Thomas Merton. The Buddha meditated in a cave. Marcel Proust lined the walls of his bedroom with cork so he could write without disturbance. (Proust would have loved Bose.)

The measures for inducing quiet become extreme. In South Korea, there's a voluntary prison that customers check in to in order to be separated from their phones, jobs, and family life while locked in solitary confinement for twenty hours a day. "This prison gives me a sense of freedom," one young woman explained. It would sound paradoxical except we all know how oppressive digital devices can be. On a magazine assignment, I once enrolled in a $700 retreat in rural Sweden where I was forced to give up all technology and outside communication for a week. It culminated in a joyous epiphany one day that the summer sunset shining on the flowers was *so beautiful* and I was *so alive in the moment,* but all told it wasn't an experience I would choose to repeat (too many mosquitoes), nor was it particularly convenient to drop out of the rest of my life in order to do it.

If we have such an urgent need to block out the world, something must be seriously wrong. The opposite of silence is noise—"unwanted

sound," as the scientific definition runs—and we have more of it than ever before. Noise pollution is rising everywhere, a result of cars, trucks, factories, and airplanes overhead. So much noise exposure causes elevated blood pressure, loss of sleep, increased heart rate, cardiovascular constriction, labored breathing, and changes in brain chemistry, according to a government report. Noise has been shown to directly impact children's ability to learn; one study found that students in a classroom closer to railroad tracks made slower progress than those on the opposite side of the building. To escape we have to create our own silences.

"Silence" was originally a verb describing a persistent state of being. It came from the Latin *silere*, the action of being quiet or still, and has roots in the Gothic *ana-silan*, to remain calm or cease motion, used in the context of the wind or still water. It's tempting to draw a line between this meaning and its modern pronunciation, the sibilance of the initial *s* and the soft ending *c* creating its own susurration that starts and stops with the word, like a breeze that passes through and leaves a contrasting stillness behind, noticeable only after the fact.

Once, silence was a symbol of everything that transcended the scale of mere humanity. Its presence marked things we subjugated ourselves to. There were the vast silences of nature, where no manmade sound could be heard; the silence of prayer or meditation in the quiet of a sacred space; the silence of night, where dangers lurked; and the hushed silence of authority. Silence was inspired by the divine, while royalty demanded it: By 300 c.e. the Byzantine court appointed a class of *silentiarii*, courtiers whose job it was to ensure the appropriate noise levels for the emperor or empress—they were shushers of the imperial classroom. The title survived for centuries as an honorific

given to the worthy or those wealthy enough to purchase it, linking silence and power.

Silence offered a retreat into transcendence, into unknowability, since noise or speech always ties you closer to the mundane world, the way that words on a page pin down the object they describe. In Jewish mysticism, the doctrine of *tsimtsum* proposes that god had to withdraw into silence, in a great inhalation, in order for humanity to flourish into sound and language. "Everyone who knows how to remain silent becomes a divine child, for in silence lies the recollection of his divine origin," the Danish existentialist philosopher Søren Kierkegaard wrote in his journals. The Quakers believe that there is a spark of the divine in everyone, and so they host silent meetings in unadorned rooms, where they face each other in a circle or square. God speaks in a "still, small voice," and so silence makes the voice easier to hear. During the meeting, any Quaker may speak whenever so moved, and then the silence reigns again.

Maybe we manufacture safe silences because we want to avoid confrontation with whatever is beyond us. We're not accustomed to the awe that it can inspire anymore. The new form of silence is devoted to commercial productivity, not transcendent contemplation. You don't meditate in Amtrak's Quiet Car; you fill out spreadsheets. "The fear, even dread, caused by silence has intensified," the French historian Alain Corbin wrote in his 2016 book, *A History of Silence*. "We have almost forgotten what it is."

In 1967, during the emergence of Minimalism, the New York critic Susan Sontag wrote an essay arguing that silence had indeed been turned into a cultural coping mechanism. "In an overpopulated world being connected by global electronic communication and jet travel at a pace too rapid and violent for an organically sound person

to assimilate without shock, people are also suffering from a revulsion at any further proliferation of speech and images," Sontag wrote in "The Aesthetics of Silence." This flood of sensory input, which has only accelerated in the fifty years since the essay was published, prompts the longing for its opposite: "As the prestige of language falls, that of silence rises."

Sontag's evocation of silence isn't about sound specifically. The essay is a deconstruction of artwork—literary, visual, and musical—that tries to move beyond language. Before the modern era, she argued, art was directed outward toward the world. Through art, human consciousness affirmed its own existence with stirring symphonies and grand history paintings depicting social and political accomplishments. But we eventually realized that these material attempts at transcendence had failed. Art had done nothing to halt the violence of the industrial revolution, the rise of exploitative capitalism, and the wars of the twentieth century.

Instead, artists directed themselves inward, confronting this failure by embracing the nonnarrative and inexpressive. Some artists pursued the "ever-receding horizon of silence," as Sontag put it, to the point that they gave up making work altogether, including Marcel Duchamp, the poet Arthur Rimbaud, and the abstruse Austrian philosopher Ludwig Wittgenstein, who in the 1920s took a job as an incredibly overqualified elementary school teacher.

In a flood of relatively meaningless sensation, anything that embraces silence stands out. For the listener, viewer, or reader, the newly austere art that Sontag noticed could actually become hedonistic, because it forces its consumer to focus ever more intently in pursuit of the elusive effects of Minimalism. "There is no talented and rigorous asceticism that...doesn't produce a gain (rather than a loss)

in the capacity for pleasure," Sontag wrote. Minimalism was a mode of experiencing more, not less—not just in art but in life more generally.

"What we cannot speak about we must pass over in silence," Wittgenstein wrote at the end of his single book, the *Tractatus Logico-Philosophicus*, a terse attempt at finding the limits of thought through language. The famous line reminds me of a t-shirt that the musician Frank Ocean, whose work is all about reticence, wore during a 2017 concert that read, WHY BE RACIST, SEXIST, HOMOPHOBIC, OR TRANSPHOBIC WHEN U COULD JUST BE QUIET? The t-shirt, based on a popular 2015 tweet by user @avogaydro and sold by the online store Green Box Shop, went viral and was quickly omnipresent online and off. (Ocean might also agree with another of Wittgenstein's lines: "Ethics and aesthetics are one and the same.")

As the t-shirt suggests, we crave silence because we are disappointed. We are disappointed because man-made noise, language, and art have proved themselves fruitless, if not outright oppressive. In silence, a minimalist aesthetic for the broken twenty-first century, there is an opportunity for a different way of attending to the world.

BEFORE EVERYTHING GOT so noisy, daily silences could be overbearing. There was so much silence that one late nineteenth-century composer took it upon himself to fill it singlehandedly. In order to hear the results, I took the subway to the Upper East Side on a chilly spring evening and walked to the Guggenheim Museum. There, a series of classical pianists were performing an eerie, roughly three-minute-long piece of music for solo piano on loop for seventeen hours straight.

The piece was the French composer Erik Satie's 1893 "Vexations," which Satie had suggested repeating 840 times in a row: "In order to play this motif 840 times, one would have to prepare oneself in advance, and in the utmost silence, through serious immobilities," he noted on the score. There was no time signature, but it was meant to be played "very slowly."

Avant-garde joke or not, the full 840 repetitions weren't performed until 1963 when the American composer John Cage rediscovered "Vexations" and the piece became known as an early predecessor to Minimalist music. But it's also an endurance performance, like a cultural ultramarathon. I walked into the museum's seashell-spiral rotunda and headed downstairs into a hushed basement theater that felt removed from the world, like the deck of a sunken ship. Everything inside was

plush and gray, warm monochrome, from the cushioned chair I sat down in to the thick carpet and the white rounded walls. The room had an air of elevated anticipation, but for what? The radical act we had come here to witness seemed to be boredom itself.

The first pianist took the stage. He settled onto the bench and began to play with a particular warmth and softness, brushing the opening notes of "Vexations." Satie's famous trio of "Gymnopédies" might be sweetly meditative, but "Vexations" is discordant and plunking. It sounds like the contents of a junk drawer spilling slowly out onto a xylophone. It has passages of nostalgic melody interspersed with stabs of pain or discomfort—the soundtrack to going for a walk in the rain with a hangover. But the pianist blurred it together into something mostly pleasing to the ears. When he finished the initial loop of the piece and paused for a moment before beginning again, an attendant behind him drew a single tally mark on an easel pad onstage. There were many, many more to go. The marathon had begun around seven P.M. I wasn't sure how long I would survive.

Satie was more than comfortable with discomfort. He described himself not as a composer but as a "phonometrographer," a scientific measurer of sounds, like a tin can robot, with a lifestyle to match. Too poor to afford Parisian rent, he eventually abandoned the Montmartre of artist studios—Picasso, Matisse, Degas—and the cabarets where he played for a living. He moved to an unfashionable suburb and walked the five kilometers into town every day, dressed in a bowler hat like a staid member of the bourgeoisie.

The normcore outfit was deceptive. The composer joined the extravagantly aestheticized Catholic cult of the Rosicrucians but left it to start his own religion of one. He spent an inheritance on a set of twelve identical gray velvet suits, which he wore every day for a while. In his

memoir he claimed to eat only white foods: "eggs, sugar, shredded bones, the fat of dead animals, veal, salt, coconuts." He collaborated with the poet, artist, and tastemaker Jean Cocteau and befriended Marcel Duchamp and Man Ray, artists who turned absurdity into an artistic strategy. But the composer was one of a kind: "There is no school of Satie. Satieism could never exist. I would oppose it," he wrote. When he died alone in 1925, friends found his tiny, distant apartment crammed with cheap detritus. Previously unseen musical manuscripts were shoved into the pockets of his suits, including the mysterious single page of "Vexations."

"Vexations" has no clear explanation. It might have been a paean to Satie's sole lost love, the painter Suzanne Valadon, or a parody of Wagnerian excess—the loops make it as long as the Romantic composer's *Ring* cycle. The piece was written at an early point in the composer's career, before he became a critical success and society darling, taken up by compatriots like Ravel and Debussy. But "Vexations" also relates to Satie's concept of "furniture music," a genre he invented around 1920, when he debuted it at a play by Max Jacob. Furniture music was an early attempt at creating sound for a postindustrial culture, when silence could be optional.

During the intermissions of the play, Satie and fellow French composer Darius Milhaud performed his new music, but no one was supposed to pay attention to the project. "We urge you to take no notice of it and to behave during the intervals as if it did not exist," the event's handbill read—never mind the paradox of pointing out something that wasn't to be focused on. Even though the performers were stashed away in corners and a balcony box, it didn't work quite the way Satie expected—the audience failed to adequately ignore the music and streamed back to their seats, quietly attentive. "Go on talking!

Walk about! Don't listen!" Satie shouted, gesticulating wildly in a lobby filled with fashionable society who were shocked at his annoyance. The composer "had not counted on the charm of his own music," Milhaud later wrote.

Furniture music would "make a contribution to life in the same way as a private conversation, a painting in a gallery, or the chair in which you may or may not be seated," Satie pledged. He even planned to mount his composition scores on the walls like paintings, underlining their function as decorative ambience—readymade Minimalist drawings. Furniture music was against drama, against progression, almost against its own existence at all. The music would not dominate nor impose itself but simply persist unobtrusively in the background, vanquishing silence: "It would fill up those heavy silences that sometimes fall between friends dining together. It would spare them the trouble of paying attention to their own banal remarks. And at the same time it would neutralize the street noises which so indiscreetly enter into the play of conversation."

"Furniture music is fundamentally industrial," he wrote. The compositions were named after imagined physical objects: "Tapestry of Wrought Iron" (my favorite), "Acoustic Tiles," "Curtain of a Voting Booth." Their score notes give an idea of Satie's desired context for the music, but it's impossible to know just how much he was joking about any part of it. "Tapestry of Wrought Iron" is suggested "for the arrival of the guests (grand reception)—to be played in a vestibule." Not only are you not supposed to notice it, but it's specifically meant to be ignorable for particular occasions fitted to class and culture, like ephemeral wallpaper.

In the 1920s and '30s, affordable radios were just starting to bring music into homes and commercial spaces; Muzak later emerged to

supply sound that was at least interesting enough to catch the attention of listeners before it eventually turned into kitsch, in the sense of soft-jazz elevator soundtracks. But Satie was already imagining music that would blanket everything, organizing the empty space of silence. Furniture music is monotonous, which is fine because Satie loved boredom—he described it as "mysterious and profound." Unlike the later Minimalist visual artists like Donald Judd, who overwhelmed the viewer with stimulus (red! aluminum!) the composer wanted you to be lulled.

At the Guggenheim there was nothing to pay attention to except for the furniture music. It wasn't background but foreground. Onstage the various pianists took turns playing in twelve-minute shifts. At the end of every shift, the next musician came to stand behind the one at the instrument and hovered, ready to put two hands on the keys exactly in time to preserve the endless dreamy loop.

What stood out at first in the parade of "Vexations" were the pianists' different styles. The composition could be played in any number of ways, though its formula stayed the same. Some plinked the keys like a toy piano; others pounded the discordant chords like an angry toddler. I entertained myself by analyzing them, waiting for the next different approach. (Some musicians have undertaken solo recitals of "Vexations" in full. They describe hallucinations and evil thoughts many hours in, but also a feeling of transcendence.)

One good thing about extreme simplicity to the point of boredom is that it makes you focus on whatever is available to you, in this case the single tune. Rather than the notes themselves, the gaps between them increasingly stood out to me as what was important. The pauses and drones gave it a concrete shape. The audience also became its own subject. The rustling of paper programs and shifting bodies and people

arriving and departing provided a relatively exciting, dynamic subject against the constant passive music.

A few hours in, I started to get antsy. I had a sudden urge for some unexpected messiness to break the spell of the sour music, like sneaking out to one of the Guggenheim's circular bathrooms to smoke a cigarette or have sex. But there was an unexpected tension that held me and the other hundred-some audience members in place, a magnetism within the tedium. I realized I was afraid I was going to miss something. But there was nothing to anticipate, no climax or change. It was *Waiting for Godot* without even the specter of Godot. I was worried about being too distracted from the experience that I was there for, but what would I be distracted from? I could tune back in in ten minutes and it would be more or less the same.

At ten P.M. I finally needed a break. I left the theater during the slight interruption of a pianist changeover and climbed upstairs to the museum café, where a few of the off-duty pianists mingled in a corner. The music followed me—it was being piped in live via a speaker system. There was no escape. I bought a mint tea and a cookie, hoping that the sugar would facilitate my brain function.

It didn't work. When I got back to the theater, I sat closer to the stage and concentrated on the faces of the players, but the music sounded awful, like a candy I had eaten too much of. The simplest tune in the world can become grating just the same over hundreds of listens, the way even the most elegant, seamless design gets boring if you see it everywhere. I had a sudden attack of synesthesia, seeing the sounds as towering gray shapes that appeared and faded one by one. Through repetition it became not a melody but a mantra, a chant, a sermon. After a while I realized I wasn't bored but hypnotized. My eyes glazed over.

I zipped my hoodie all the way and flipped up the hood partly because it was cold in the theater but also because I was definitely falling asleep. I felt like I was in a college lecture and had stayed up too late the night before. Realizing sleep was inevitable I moved to a seat in the back and fell into brief, hallucinatory naps, waking up to the interminable music. At midnight I decided to leave. My body was rebelling against me. Per Satie's instructions, it didn't seem to matter how long you listened, just that it could theoretically continue. Behave as if it did not exist, he had commanded. So I did.

Exiting the insulated womb of the theater and walking out of the Guggenheim's glass doors into the cold nighttime air, I felt reborn into the real world. The rush of cars on the avenue along Central Park, honking horns, the rumble of the subway underground—every noise sounded more like music than the piano performances. Despite the hours of repetition Satie's tune faded from my mind almost instantly. I couldn't have hummed it if you paid me. It had fulfilled its function as furniture music only too well.

SATIE'S COMPOSITIONS WERE prophetic. Voluntary sound can be used to cover up unwanted noise or patch over awkward gaps in sound—it just needs to be updated for current tastes, since what registers as unobtrusive is always changing. Now we call it "ambient" instead of furniture music. In the original Latin ambient meant to circle or surround; it defines a sensory atmosphere more acceptable and intentional than noise, but it's not the total absence thereof. When applied to music, ambient suggests something less than artistic in the usual sense, lacking the emotional punch of either a symphony or a pop song. You don't listen directly to ambient sound; you use it as a tool to enhance your focus on other things.

A Spotify playlist called "Ambient Chill" has more than eight hundred thousand followers for tracks that are kitschy and saccharine, mostly soft synth pianos or harps. It's hard to tell who or what is playing, only when it stops and moves to the next song. Lumped into the same category are recordings of whale song, fire crackling, and rattling train wheels, recommended as accompaniments to falling asleep. The audio fills a similar function as minimalist décor: We don't have to think about it, or even pause to judge it.

The ambient genre was invented by the British musician and composer Brian Eno in the 1970s. It has a surprisingly dramatic origin

story, beginning when Eno got hit by a London taxi in 1975. Eno was famous from his days in the decidedly maximalist art rock band Roxy Music, but he left the band in 1973, exhausted from the lifestyle and his conflicts with frontman Bryan Ferry. The taxi accident left him laid up at home in his apartment, where a friend named Judy Nylon came to visit, bringing along the gift of a vinyl record of eighteenth-century harp music. After she left, Eno struggled to slot the record onto the player and started it spinning before lying back down. But when he was already settled again, he realized that the amplifier's volume was set too low, down to the edge of hearing, and only one stereo channel was playing. Given the discomfort of sitting up he couldn't be bothered to remedy the situation, and so he let the record play on, the harp plinking away "almost inaudibly."

It wasn't how the music was supposed to be listened to, nor was it a conscious decision to listen to it that way, but the muted sound sparked an epiphany for Eno: The quiet harp complemented the rest of his holistic experience instead of overwhelming it. He heard the music "as part of the ambience of the environment just as the color of the light and the sound of the rain were parts of that ambience." Music could be just another aesthetic experience among many.

He followed the epiphany with a piece called "Discreet Music," released on an album of the same name in 1975. The music was discreet in the sense of being subtle or hidden. The titular half-hour composition is made up of two harmonized synthesizer melodies—soft rise-and-fall ditties, like a pair of beginners practicing trumpet together—on tape loops that repeat while overlapping each other, splitting into parts and coalescing again, shifting in texture but never in form.

The piece progresses without going anywhere, like the way you feel movement in an elevator without any visual indicators that you're rising

up in a building. But at the end of "Discreet Music" you're right back where you started, in a slightly changed silence. The rest of the album featured "variations" of Pachelbel's Canon in D Major. Eno picked out a few bars of the original and assigned them to different instruments, altered their tempos, or set them against each other in a cascade of clashing sound. He turned Pachelbel's original into a found object, repurposing it the same way Dan Flavin turned a lightbulb into an art installation. "Discreet Music" was a reminder that all art is made from preexisting material, and any change that one makes is a creative act.

Eno didn't formalize the name of this genre until 1978, when he released the album *Music for Airports* and described it specifically as "ambient music." "An ambience is defined as an atmosphere, or a surrounding influence: a tint," Eno wrote. The genre "must be as ignorable as it is interesting." Ignorable suggests an art that doesn't require attention to survive, like a well-behaved dog content waiting to be played with. It requires a certain lack of ego, a willingness to be mundane instead of seeking grandeur. *Music for Airports* comprises four parts split into two overall sections, a symphony on the edge of nonexistence. It's all spacey synth bloops and rushing electronic wind, interspersed with soft swells of digitized voices. The four sections are slightly different in tone—moving from identifiable piano to angelic synth choruses to a meandering electro-organ-trumpet at the end. But there's no arc to this progression, only continuity.

The cover of *Music for Airports* is a cropped map with translucent blue grid lines and branching rivers. It's an anonymous, unidentifiable place—flyover country, like the rectangles of space that scroll by on seat-back airplane screens. "The central idea was about music as a place you go to. Not a narrative, not a sequence that has some sort of teleological direction to it," Eno later told *Pitchfork*. When it was released, listeners were interested if not compelled, which was partly

the point. The veteran rock critic Robert Christgau gave *Music for Airports* a B in the *Village Voice* at the time: not the best background for sex, but a useful conversation piece over dinner with his parents.

You don't listen to the album so much as wait or wade through it. Anytime I get stuck with writing or a day seems to be getting away from me, I have a routine of getting up from my desk, pacing around, then sitting back down and putting it on. Maybe the response is Pavlovian at this point: I associate the airy sound with empty mental space and so the opening synth blooms induce a state of focus. "It's great because there's as little as possible," summarized a writer friend who I recommended the album to. "Everything else is too much." (The genre of New Age music might have taken up Eno's basic palette, but Enya's "Orinoco Flow" wasn't released until 1988, and it sounds stressful in comparison.) Absence is the very structure of ambient music: "Having no silence in music is like having no black or white in a painting," Eno said in an interview about the album.

If ambience started out as music it's now flooded over into other experiences, wherever we blockade or buffer our senses. You can listen to an endless Spotify playlist of unobtrusive, uninteresting sounds or spend hours in silence with headphones or float tanks. This buffering can be so extreme that it verges on a violent removal of sensation. I'm reminded of a hallway of therapists' offices I encountered in Brooklyn. The therapists had all clustered on the second floor of one loft building, maybe for its cheap rent on their one-person spaces. Every door in the long hallway had its own white noise machine running at full blast outside on the floor. I've never heard such an aggressive artificial silence.

The rise of ambience as a lifestyle was predicted in the 1990s by the French philosopher Marc Augé and the Dutch architect Rem Koolhaas, who both (without any reference to Eno's album) used the

airport as a symbol for the negative ambient quality of modern life. In an ambient world, nothing demands your attention, yet nothing is worth devoting your full attention to.

To Augé, the airport was a "non-place," a space of constant motion that lacked the usual defining characteristics of specific geographical places, like embedded historical memory, individual identity, and fixed human relationships. Non-places "are there to be passed through," from train stations to hotel lobbies and malls. While non-places are anonymous they tend to be, at a minimum, comfortable. They contribute to a state in which "people are always, and never, at home," Augé wrote in his 1992 *Non-Places*. Always at home because there's nothing particularly wrong in the moment; never at home because we have no ties to these places, nor they to us. We just float through them after making sure we have the right Wi-Fi password.

Koolhaas saw the airport as a symptom of a world that was increasingly homogenous: Just like every terminal resembled every other, global cities were also becoming the same, he argued in his 1995 essay "The Generic City." Even one-of-a-kind cities like Paris lose their identities in favor of joining the international swirl of capital and labor as personality is sacrificed in favor of mobility and growth potential. The generic city is "equally exciting—or unexciting—everywhere," Koolhaas wrote.

This flattening occurred because of technology: "The Generic City is what is left after large sections of urban life crossed over to cyberspace." Instead of marking the walls with graffiti, we type on our screens. We post photos of things on Instagram instead of creating them for ourselves. We end up in a desiccated malaise: According to Koolhaas, ambience inspires only "weak and distended sensation, few and far between emotions, discreet and mysterious like a large space lit by a bed lamp."

Minimalism is often ambient, too. In its most popular form it is the house style of the non-place and the generic city, turning buildings into bland condos, interiors into empty boxes, and the sensory landscape into a vague wash of white noise. Whether in space or sound, it acts as an on-demand buffer to direct sensation rather than a path to more of it. To escape the ambience—to feel anything—we have to be willing to risk hearing something unpleasant and being taken out of our familiar comfort zones. We need to recapture the awe and the surprise of silence.

ON THE EVENING of August 29, 1952, David Tudor, a young pianist known for performing complicated avant-garde work without breaking a sweat, sat down at a piano in a ramshackle barn theater in the woods of upstate New York, Woodstock's Maverick concert hall. A hushed audience waited before him arranged in rows that extended into an outdoor section where listeners were shrouded by trees. The concert was a benefit, tickets one dollar plus tax, organized by the composer John Cage. The program comprised a list of challenging contemporary composers—not your usual Bach and Mozart, but Morton Feldman, Pierre Boulez, and Henry Cowell. It came time for the second-to-last piece of the night, by Cage himself. Tudor raised the piano lid to expose the keys. There was a momentary hush of expectation, the listeners curious about what would come next. But the pianist played nothing.

Instead, Tudor placed his hands on his lap, as if waiting at a bus stop. But his eyes intently followed the measures inscribed on the score he had propped up, which was a series of empty staves. Every so often he raised a hand to turn to a new blank page. After thirty seconds of silence he closed the lid of the instrument. Then he opened it again. He failed to play anything for another two minutes and twenty-three seconds, repeated the gesture, waited again for one minute and forty

seconds, then closed the piano lid with a final thunk: The performance was over without a note.

He had just played, or not played, Cage's *4'33"*, named for the total duration of its movements. These days the piece is a famous cultural meme, the musical equivalent of the apple falling on Newton's head. It's a cliché of artistic extremism: Making a composition of nothing is either the hardest or easiest—and stupidest—musical gesture ever. It's never been quite clear which. But it shocked the audience at its debut. Was *4'33"* a prank, a betrayal of their highbrow taste as patrons of musical art? Were they being made fun of by this relatively obscure composer and his obstinate pianist?

Cage's piece presented silence as radical and revolutionary. It wasn't supposed to protect or blanket you; it evaded your expectations and then challenged them. Within the context, you couldn't ignore the silence of *4'33"* at all.

Just because Tudor wasn't doing anything didn't mean there wasn't any sound. During the first movement that night the wind kicked up and blew through the trees, rustling the branches heavy with late-summer leaves, Cage later recalled. Then in the second movement a drizzle started and raindrops hit the wooden roof of the barn, adding a percussive element to the experience. By the third, when some of the audience realized there wouldn't be any action after all, the guests started chatting or stirring up commotion as they walked out in protest, creating an aggressive thrum.

In *4'33"* the audience was meant to turn their attention not to David Tudor onstage but the atmosphere around them, the natural sound that flows everywhere: precisely those waving branches and water droplets, and even the bodies shifting anxiously in seats or the sudden rumble of cars being started in the parking lot as others tried

to escape. It didn't matter to Cage if people left or not. It only mattered that Tudor continued sitting, conducting the effects of the piece more than playing it. The difference is subtle but important. It wasn't Tudor's not-playing that made up *4'33"*; it was everything else framed by the context of the concert and the specific stretch of time, a single, specific moment of uncontrolled sound. Cage was reclaiming that awkward silence as music.

Like Donald Judd's refusal of the Abstract Expressionist painters' emotional brushstrokes, Cage denied the individualistic figures of both the pianist and the composer. The environment itself became the musical force. Modern music should only be "organization of sound," Cage argued in a lecture as early as 1937, and the composer simply its organizer. This shift required a different approach from the audience as well as the artist. New music needed a new kind of listening, he realized by the late '50s. After all, if the goal was to tell a story or communicate a feeling, you would use words instead. Music should exist for its own sake, Cage thought.

However absurd it seemed, *4'33"* broke Cage's career open, along with the possibilities of music in general. The quiet event in upstate New York was pivotal in proving that sound didn't have to be composed or controlled to be appreciated as art. Cage was arguing for a flowering, not an elimination. Music was "just an attention to the activity of sounds," nothing more, nothing less.

The quickest way to misinterpret *4'33"* is to assume that it was a one-liner made up in a moment and then executed instantly onstage at Maverick. It was actually the result of a years-long process for Cage, from coming up with the concept for a silent piece to understanding how to integrate it into his musical practice and then finally building up the courage to actually debut it in public, at the very real risk of his reputation (the mother of one of his protégés even warned him to

disavow it in a letter). The performance only happened because Tudor pushed to play the piece.

Cage was on the path to silence from the beginning. His first major innovation, in the late 1930s, was to plant screws and other metal objects or pieces of wood in the workings of pianos, "preparing" them like Duchampian readymades. (One eerie 1947 composition was called "Music for Marcel Duchamp".) They buzzed and clanged instead of ringing out cleanly when the hammers struck the strings. The composer's interference emphasized the inherent materiality of the instrument and the music alike. If a piano didn't have to be perfect, maybe it didn't need to make any sound at all.

A visual inspiration for *4'33"* came from Cage's friend the artist Robert Rauschenberg, whose White Paintings of 1951 were pure white acts of creation-by-negation—Cage described the paintings as "airports for the light, shadows, and particles." (In this same vein, Rauschenberg laboriously erased a drawing by the better-known artist Willem de Kooning in 1953.) A pamphlet that Cage distributed at Rauschenberg's debut of the white paintings presented a negative manifesto: "No idea / No intention / No art / No feeling…" (In full it's the epigraph for this book.)

In 1948, Cage admitted that he was already thinking of a composition of nothing. He wanted to call it "Silent Prayer" and hoped to sell it to the Muzak Corporation. Instead of the sweetly generic sounds that filled commercial spaces, there would instead be a quantity of comparatively freeing quiet. Cage never made that piece, but in a concordance too close to be total coincidence, *4'33"* was almost the same length as a standardized Muzak record, four-and-a-half minutes.

Gita Sarabhai, a wealthy Indian musician who wanted to study Western music, sought out Cage for teaching in the mid-1940s. In return, she instructed him in the principles of Indian composition: The

purpose of music was "to sober and quiet the mind, thus rendering it susceptible to divine influences," an aim Cage took to heart. The composer became increasingly interested in Indian and Asian philosophy, seeking a departure from the hyper-narrative, emotional composers of Western classical music.

During his research Cage also came across the *I Ching*, or *Book of Changes*, an ancient Chinese system in which sixty-four geometric diagrams are used to predict fate. By tossing a set of yarrow stalks or coins one lands on a particular diagram whose associations will determine a future fortune. Cage first took advantage of the technique for his 1951 "Music of Changes." The choppy, discordant, forty-five-minute-long work was created by slotting various rhythms, melodies, and compositional strategies into a chart and ordering them according to *I Ching* coin throws. Each throw determined one musical aspect of one length of time, derived from Cage's predetermined palette of sound. The piece reduced music into pure structure. It often sounds like a piano transcription of glass shattering.

Cage said he composed the lengths of the movements in *4'33"* through the same *I Ching* method, but this time the system of chance was set up so that the coin throws resulted only in duration, not pitch or rhythm. If music is just organization of sounds, then the material choice of no-sound is as valid as the choice of sound. Instead of thinking of *4'33"* as a composition of nothing, it might be more accurate to think of it as an empty one, a box that can be filled.

The piece also emerged from Cage's interest in Zen Buddhism, which he first encountered in Aldous Huxley's 1945 book *The Perennial Philosophy* (Huxley found silence to be one of the themes universal to all religions). Cage studied Zen in earnest in the early 1950s under D. T. Suzuki, a Japanese layman who was one of the

most important figures in bringing the religious philosophy to American audiences. Suzuki's classes were held at Columbia in classrooms crowded with an assortment of New Yorkers auditing alongside only a few formal students. The professor droned in quiet monotone so that students could barely hear him, but it didn't matter. Suzuki quoted the Buddhist Heart Sutra, which applies easily to Cage: "That which is form is emptiness, that which is emptiness is form."

Cage wasn't that great of a Zen practitioner. He never meditated, and didn't want Zen to be "blamed" for his work, he wrote. But in it he found the license to pursue his most extreme ideas, like the 1963 staging of Satie's full "Vexations," for eighteen hours and forty minutes straight. "In Zen they say: If something is boring after two minutes, try it for four. If still boring, try it for eight, sixteen, thirty-two, and so on. Eventually one discovers that it's not boring at all but very interesting," Cage wrote. (Maybe I didn't stay long enough at the Guggenheim concert.)

Cage had another epiphany around 1952, just before the composition of *4'33"*, when he visited an anechoic chamber at Harvard University. In the perfectly insulated room, no sound waves traveled. As Cage adjusted to the vacuum, he discerned two sounds, one high-pitched and one low-pitched tone. He recalled the engineer telling him he was hearing his nervous system running and blood flowing. The anecdote doesn't usually include the fact that it's not actually possible to hear your nervous system and the sounds were more likely tinnitus. Still, the realization that not even a vacuum could be perfectly quiet was enough to follow Cage throughout his life as a personal mantra: "There is no such thing as silence," he wrote.

If *4'33"* is sometimes taken as a joke, then it's partly the composer's fault. He made his career on a kind of Minimalist absurdity that allowed for anything to happen at any time. The most popular avant-gardists

are always savvy marketers as well as iconoclasts. Cage had an easy way of presenting new ideas that might have been an inheritance from his mother and father, a journalist and an inventor, respectively. He talked his way into presenting a concert at the Museum of Modern Art and in 1960 performed a piece called "Water Walk" on the popular television show *I've Got a Secret.* "If you are amused, you may laugh," the host Garry Moore forewarned the audience, treading the line between joke and art. A straight-faced Cage, dressed in a suit, then shot off firecrackers, boiled water, watered flowers in a bathtub, and slammed piano keys, all to a strict timeline provided by a pocket watch—the noire was the piece. Gales of laughter came and went: the composer as stand-up comic.

Cage's performances are easy to make fun of and yet they have a sneaky profundity. The compositions are made for daily life, but not like the unobtrusive background of ambient music that deadens any unique atmosphere. As I've listened again to his body of work, opening YouTube tabs while I write, more than a few times I've had a composition end only to hear something around me—a hand knocking a desk, air vents buzzing, a distant police siren blaring—and perceive it, faster than my own self-awareness, not as unwanted noise but part of a composition that Cage is still invisibly conducting. His music is a kind of conditioning for heightened awareness: These sounds are going on all around you, all the time, but only with the help of art are you able to register them beyond your own conveniently numbed perception. Instead of masking details, Cage's music highlights them.

There's a freedom in allowing chance or happenstance to dictate an artistic experience instead of forcing the audience through a predetermined narrative that is supposed to form the grand masterpiece. The Minimalist work of art leaves room for multiple paths through it,

or for no path. One doesn't even need to listen to, look at, or read it (the way a book left closed on the desk still exerts its influence). It might be missing the point to offer any interpretation of *4'33"* at all, because what it ultimately offers is an emancipatory space through which we must conduct our own experiences: a freedom of silence that has to be engaged with moment to moment. Its best analog in words might be an empty page, devoid of any language, containing pure potential for the reader to decide.

ABSOLUTE SILENCE IS a metaphor rather than a literal possibility, as the anechoic chamber demonstrated. There is no such thing as silence, Cage wrote, because there is always some sound happening, even within the body itself. What matters is how we interpret it. Rather than a lack of sound, *4'33"* was about an absence of judgment. Cage sought a state of acceptance in which any noise could be encountered with equanimity. There's a very Cageian anecdote that illustrates his strategy. The composer once had guests staying over in his New York City loft, but the smoke alarm in the stairway was malfunctioning and beeped all night. No one could sleep except Cage, who had no complaints. He simply analyzed the alarm, understood its dynamics, and integrated it into his dreaming: Noise became music.

The goal was an open silence instead of a closed one. If I could find it anywhere, maybe it would be at the Maverick concert hall, where *4'33"* debuted. On a Sunday in late autumn I decided to make a pilgrimage there, setting out from my parents' house in Connecticut to drive through upstate New York with my girlfriend, Jess. She understood the mission we were on, but it was also a running joke—couldn't you hear the same lack of sound anywhere?

The previous day had seen a few freak snow squalls, but the weather was bright and clear with sun shining through the last bronzed

leaves on the trees. The landscape was the most peaceful part of the drive. Traffic came and went along with staticky pop songs on local radio stations. Maverick is off a side road surprisingly close to downtown Woodstock, though the area wasn't so developed when the arts patron Hervey White bought 105 acres of land in 1905 to build his artists' colony. (The name refers to White himself, since he broke off from another colony to go solo, as well as to a legendary horse he heard rumors of while visiting his sister in Colorado.) Its summer concert program began in 1916 and attracted classical musicians from New York City to set up summer homes in town, making it a cultural destination long before the rock festival in 1969. In the off-season, however, the roads were empty and the only sign of the concert hall was a placard on a gravel road winding into the woods. We followed it into the parking lot and walked out into the chill air toward the still, shuttered barn that enclosed the stage, small and surreal. Its roof was gently angled into a semicircle and moss grew on the eaves; one section was built around a tree that rose over it like an umbrella over sand.

The angular doors that open up the concert hall to the trees were chained shut. We peeked through gaps in the boards of the doors to see that everything inside was wrapped in thick layers of plastic, from the long pew-like rows of seats to music stands and what looked like, but shouldn't have been, the form of a piano onstage. A towering sculpture of Maverick the horse—carved by hand from a single tree trunk in the corner—was slightly menacing.

Jess lined up her ear with one of the gaps, her head against the wood. "I can't hear anything!" she exclaimed, with only a hint of sarcasm. She compared it to having one ear underwater and one not: The silence inside the hall was solid and pervasive. She felt drawn into it.

Cage said he listened to his silent piece throughout his life, just pausing to focus on whatever ambient noise happened to be around him at the moment—the opposite of wearing noise-canceling headphones. I wanted to do a reenactment, so I set a timer on my phone for four minutes and thirty-three seconds and left it on a fence post to count down.

Wandering the paving stones near where the audience would have been sitting, I first noticed a few bird chirps in the trees, long and short calls, a language that was incomprehensible to me. Then came the rest of the unrequested orchestra: a low humming bed of leaf blowers, intermittent blasts of road noise, and the high-pitched whine of airplanes overhead. I was a little disappointed. I thought the concert hall might be deeper in the woods, where the sounds were more mysterious or evocative. But the machines continued to intrude without pattern or rhythm, just noise going in and out, the artifacts of civilization distracting from some possible transcendent experience. It was hard to hear them with anything except annoyance. Instead I focused on the crackle and swish of leaves under my boots as I paced around.

Then the alarm on my phone broke the interlude with its tinny, artificial ring: Time was up. Her piece was over. "Oh, let's keep staying quiet. It's nice," Jess sighed. Her reaction might have spoken more to my habit of constantly analyzing out loud whatever was happening at the moment than Cage's composition itself. It hadn't felt that long. Unlike Tudor's version, there was no focal point for our attention, none of the expectation of a silent musician poised onstage, and so this re-performance felt to me like any walk in the woods, except for the presence of the timer.

In the 1980s, the composer Pauline Oliveros coined the concept of "Deep Listening," inspired in part by *4'33"*. Oliveros pointed out the

difference between hearing and listening: The ear is constantly receiving outside stimuli in the form of soundwaves, but to actually listen is "to give attention to what is perceived both acoustically and psychologically," she wrote. Deep Listening means "learning to expand the perception of sounds to include the whole space-time continuum of sound—encountering the vastness and complexities as much as possible." For Oliveros that meant meditating on the organic sounds of nature and experiencing the resonance of unique spaces like caves, cathedrals, or wells. Such intense listening is meant to inspire compassion and understanding, a kind of acceptance that goes beyond the noisy concerns of the current moment that usually crowd our consciousness.

I was hearing but not listening; I had to be more open-minded. Maverick is on a flat area at the base of a hill, and up the slope into the woods I saw a rock ridge that stuck out like a natural wall. I wandered alone out of the concert hall grounds up toward the ridge, my boots slipping in the bed of leaves and breath coalescing into vapor. Whether it was the cold weather or the volume of photos I was taking for future descriptive reference, my phone suddenly shut down and I was cut off from everything that wasn't immediately in front of me. The absence of technology removed the distraction of documentation, an anxiety that follows us everywhere there's a smartphone. At one spot the ridge formed a kind of shelter with a bench-height ledge protected by an overhang. I sat on the cold stone and tried to pay attention to my surroundings once more.

What I heard was a tiny sound, barely audible. It was a slight rushing and a bright, higher-pitched patter coming from somewhere near the ground. I crouched down and went spelunking deeper under the ridge. A stream or spring whose source I couldn't see was flowing through

the rock and running down a wall covered in bright-green moss, illuminating it like crystal, then dripping in a hundred repeating drops into a pool that ran down and away. As the water fell and splashed it made a sound like a natural xylophone, an orchestra of tiny percussion instruments—triangles, cymbals, timpani—in concert.

The sound played itself. As long as the water kept running it would continue, whether there was anyone there to hear or not. It wasn't expressing anything and it didn't ask for applause. As Cage wrote, "The best purpose is no purpose at all." I hunched over for a few more minutes to give the organic melody the attention it deserved. I felt like I had discovered something hidden, a treasure that I never would have noticed otherwise.

WHEN WE DESCRIBE a forest as silent, we mean that the sounds that are still there—leaves rustling, birds chirping, the snap of branches underfoot—are natural and authentic to the place. There's a companionable silence to two lovers at home in which no words need be exchanged. One can even be silent alone in the midst of a crowded street, as any urban wanderer knows. Silence is a state of receptivity as much as a lack of noise: "Conversation strives toward silence," Walter Benjamin wrote, "and the listener is really the silent partner."

Actual, physical silences—gaps in a conversation, the hush of a room in which a death has been announced, an inhalation of shock—are often sudden or difficult. Total absence of sound is localized and punitive. The pressurized silence of a library is interrupted by a cough, provoking grumbles. A thunderclap breaks the calm of a summer evening; the aftermath is a silence felt as harsh or violent because of the immediate contrast. There is the silence of being ignored or excluded, a child's request to play in a group met with stony disregard.

Silence might be defined as the persistence of a stable state rather than a lack of content. "What we require is silence; but what silence requires is that I go on talking," as John Cage put it. In his "Lecture on Nothing," where that sentence appeared, Cage aligned his text with a system of musical measures, interspersing the words

with stretches of blank space as if they were individual notes. The content of the text loops and recurs, making no clear progress. Cage could talk or not talk—either act just had to occupy the space that he had outlined for the composition of the lecture, which was indeed about nothing. Silence can be repetition; repetition can also be a form of silence.

Around the time that Minimalist art was becoming famous in New York City in the 1960s, a group of West Coast composers were already experimenting with different forms of monotony than those that interested Cage—and, like the visual artists, different from each other as well. This was the seed of "Minimalist music," a term that was first used either in 1968 by the British critic and composer Michael Nyman or the New York City critic and composer Tom Johnson in 1972 (both came after the visual art term, in 1965). In the *Spectator* Nyman described the recipe for "minimal-music" as "simple idea, straightforward structure, intellectual control, theatrical presence, and intensity in presentation," citing a performance by the cellist Charlotte Moorman and the visual artist Nam June Paik. Johnson wrote an article in the *Village Voice* titled "The Minimal Slow-Motion Approach." Basically, "nothing much happened, and what did happen took a very long time," he later recalled. By 1974 Johnson used "minimalist" to describe a specific strain of composition with a small range of contrast: What you hear at the beginning of a piece is pretty much what you'll hear the whole time.

Four white American men became known as the canonical quaternity of Minimalist music: La Monte Young, Terry Riley, Steve Reich, and Philip Glass. Young might have been the first pioneer in the '50s, experimenting with machine-made monotones in epic durations of time—"Time is my medium," he has said. The Dia Art Foundation, which

supported Donald Judd's Marfa experiments, later funded Young and Marian Zazeela's Dream House in New York, a space for semipermanent installations of light and monotone sound. Reich used newly portable commercial tape recorders to capture snatches of speech and loop them. His major breakthrough came when he began playing two copies of the same sound at the same time but slowed one tape with his finger. The offset gap between the two as they fell out of sync and came back together again became Reich's signature; he went on to use this "phasing" technique in epic orchestral works as well. Riley is best known for his 1964 piece *In C*, in which, according to his instructions, "any number of any kind of instruments" play a sequence of fifty-three musical phrases, with each musician free to decide in the moment how many times to repeat each phrase. The piece thus emerges new-made each time it is played, with a Cageian form of serendipity.

Like Minimalist art, their compositions were a shock at first. In 1970 Reich composed a sixteen-minute piece called "Four Organs" (the titles of Minimalist music often reflect their formulaic structure, as if they were physical sculptures). It was a geometric dissection of a dominant eleventh chord—each organ plays various parts of the chord in tandem at longer and longer intervals to the constant frenetic beat of a maraca. The repetition becomes transcendental, almost spatial, if you let it, but the piece makes no concession to listenability. During a 1973 performance at Carnegie Hall the audience revolted, applauding prematurely in order to cut it off and then shouting threats. One woman marched up and banged her shoe on the stage to get the organists to stop their noisemaking—a version of Stravinsky's *Rite of Spring* riot. "At least there was some excitement in the concert hall," Harold Schonberg, the music critic for the *New York Times*, wrote at the time. Otherwise,

"there is really nothing much to like, nothing much to dislike" about Minimalist music.

Glass, the most commercially successful of the composers, is recognizable from his looping, evolving arpeggios that churn like the brackets on the wheels of a steam locomotive: always the same but always moving forward. He is the author of many symphonies and operas but also a prolific, popular composer for films like *Koyaanisqatsi*, *Mishima*, *The Truman Show*, and *The Hours*. His musical vocabulary has become synonymous with art house films, particularly scenes of looming dread or terrible beauty, to the point of cliché. One critic went so far as to describe his work as "pop-middlebrow."

The Minimalist composers drew inspiration from Japanese classical music, Indian raga musicians like Ravi Shankar, the collective organized cacophony of Javanese gamelan, and the repetitive improvisations of John Coltrane, whose performances Reich in particular attended religiously. Coltrane could riff on a single note for fifteen minutes at a time, Reich recalled, and he sometimes practiced endless scales between sets—predecessors to Minimalist performances. These were all nonwhite influences from outside the context that Young, Riley, Reich, and Glass were trained in; they adopted the unconventional techniques and then used them to separate themselves from the traditional academy.

Within a few decades, musical Minimalism as such was integrated into popular culture—unlike Minimalist art, which had to be stripped of its radical potential and anesthetized into a palatable visual style before it could be absorbed by the mainstream. Maybe it was because Minimalist music was more immediately relatable, its hallmark aggressive repetition not so far from the looping noise of industrial machines. The composers were also more amenable to the Minimalist label, at

least for their early work, which helped with marketing. The sound itself was embraced by listeners and musicians alike, meshed into Detroit techno and electronic dance music, which developed its own mode of transcendental repetition. You can hear Minimalism's legacy in a Chainsmokers track as much as in Glass's latest work.

When a gay African American Minimalist composer emerged in the 1970s, however, he couldn't find a home in this ostensibly progressive movement. Julius Eastman was born in 1940 and grew up in Ithaca, New York. A preternatural singer, he studied in Philadelphia and made his way to New York City before joining SUNY Buffalo's Creative Associates, a group of avant-garde classical musicians and composers, in 1968. Creative Associates ended up performing much of Eastman's extant work. Many of his compositions have been lost and were almost forgotten after his early death, but the archive that remains has sparked a recent renaissance of Eastman performances, as well as a rethinking of Minimalism.

Eastman spoke and looked like an ascetic saint. In rare recorded interviews, his voice is mellifluous and upraised, crescendoing into trills as if his words are prayers. At other moments he sighs archly, as if he only deigns to bestow his art on a world that he knows won't appreciate it. He had an attenuated frame that first found use in his childhood as a ballet dancer and a face as thin and drawn as an El Greco devotional, one of those figures that seem to be burning up as you look at them.

My favorite Eastman composition is "Stay on It" from 1973. In it, a flexible ensemble of musicians—cello, piano, flute, violin, oboe, or even electric guitar and drums—endlessly loop a single phrase a few seconds long. The melody is lilting and energetic, familiar like the hook of a pop song and definitely disco-esque. It swings into place and then

just keeps going, the same bars over and over at breakneck speed, never reaching the resolution of a chorus. Taking turns, the musicians start calling out, not quite singing, the titular phrase in a high mono-tone: "Stay on it, stay on it, stay on it." It's both a command and a state-ment of purpose: They are staying on the hook, on the beat, to the point of absurdity. The pop melody and the scrap of language are found objects, like Reich's tape loops, but in a looser and more self-aware mode. Before you get tired of the hook's charm, it all falls apart out of syncopation into clashing sounds like the crash of a marching band tour bus, recognizable fragments of pop bouncing down a cliffside.

"Stay on It" moves into and out of noise, speeding up and slowing, breaking down the melody until there's no atom of it left untouched. The piece is joyous and raucous, qualities that are missing from Minimalism's standard austerity. It's actually fun, and can even be funny. There's grainy black-and-white footage online of a 1974 performance of the piece in Glasgow during a Creative Associates tour. The aligned musicians jam on their instruments like they're onstage at Woodstock. In the end, the hook dissolves except for the shake of two tambourines that eventually rattle into silence. When it's over, the audience applauds. Then they start yelling and cheering, giving a standing ovation and stomping the floorboards, realizing, perhaps, that they just witnessed a new musical form.

Minimalism can often lead to a stultifying sameness as everything becomes as simple as possible—the elegant, ambient, blank style that I've described. It whitewashes both literally and metaphorically, at times privileging the Westernized, sanitized versions of external influences while deemphasizing their origins. Minimalism's sources get rebranded as high-minded art made by solo geniuses instead of

the products of a globalized culture, even if the artists themselves readily acknowledged their debts.

It takes someone like Eastman to show that minimalism isn't as neutral as it looks. He used it as a tool to express difference, both personal and artistic, rather than similarity. His work shows that simplicity doesn't have to be an end point—it can lead to new beginnings.

JULIUS EASTMAN NEVER quite fit in. He was brilliant and combative in a field that demanded genteel collaboration among a small group of working classical composers. One incident underlined Eastman's rebelliousness. In 1975 at a festival in Buffalo he performed John Cage's "Song Books," which consisted of a series of instructions to be interpreted (within reason) by the performers. Rather than confining himself to auditory challenges, Eastman used the piece to confront identity. Aligning a pair of male and female participants onstage, he gave a semi-satirical lecture on sexuality and began undressing the man appreciatively, encouraging his audience to "experiment" in their own ways at home.

The overt references to homosexuality provoked Cage, who sat in the audience. The older composer wasn't very public about his sexuality—another form of silence. He was first married to the artist Xenia Andreyevna Kashevaroff but eventually left her, after a fitful open arrangement, for the male choreographer Merce Cunningham, who became his lifelong creative partner. Interpreting Eastman's performance as a personal affront, Cage was furious. "The ego of Julius Eastman is closed in on the subject of homosexuality," he said in a lecture at the festival. "And we know this because he has no other idea to express."

Eastman hit up against Cage's limits, as radical as they were. But rather than violating Minimalism's principles, he was pushing it into

new territory: If the idea is about returning to fundamentals, then it can also mean unveiling the fundamentals of the individual self. Eastman described his goals: "What I am trying to achieve is to be what I am to the fullest: Black to the fullest, a musician to the fullest, a homosexual to the fullest." This, too, is minimalist.

The conflict with Cage likely helped push Eastman out of the university and back to New York City that same year. There, he found a thriving queer community and an insurgent music and theater scene on the Lower East Side. It was interdisciplinary; painters and dancers hung out in the same spaces as composers, unlike the cloistered academic classical community uptown. Minimalism was in the air downtown, but once again few identified with the term. It was used in a derogatory sense, a way for the uptown crowd to sneer about such simplistic music competing with them for grant funding.

When the composer and musician Mary Jane Leach first got to know Eastman in 1981, he was wearing leather and chains and drinking scotch at ten in the morning during a rehearsal they were both attending. It was that kind of scene. "I never thought of Julius as sticking out; he was just part of the crowd," Leach told me during a phone call from her home in upstate New York. "He had a big personality, but there were a lot of big personalities."

The first piece that Leach heard of Eastman's was the 1981 debut of "The Holy Presence of Joan d'Arc," a churning composition for ten cellos, which I also heard performed during an Eastman festival, That Which Is Fundamental, in New York in 2018. She was struck by its pure energy—the piece immediately launches into a dark, glossy riff that the cellists saw across their instruments in unison, as instantly recognizable as Beethoven's Fifth. Like "Stay on It," the piece descends into dissonance, but it's the dissonance of internal spiritual conflict rather than aesthetic deconstruction.

Eastman's compositions give way to controlled chaos that feels more akin to the actual experience of living in the world: messy instead of serenely patterned. Minimalism often makes a virtue out of transcending the self—think of Agnes Martin's grids, Judd's manufactured boxes, or Cage's Zen randomness—but Eastman recognized that the self was both irrevocable and vital. (With 1981's *Tehillim* and the famous 1988 *Different Trains*, Reich also began using Minimalism to explore his own Jewish heritage.)

Eastman's under-recognized masterpieces are a trio of lengthy works for four pianos composed around 1979. They are pounding, physical compositions in which storms of monotone notes or chords coalesce and dissipate. Some require multiple pianists attacking the keyboard of each instrument, but they never quite become dissonant, only sculpturally massive. He called the pieces "organic," meaning that each successive part contained all the elements of the parts that came before. Two of the three are titled with a racial term that's reprinted in full below because Eastman used it deliberately to explain the essential quality of his work, both philosophical and intentionally provocative.

Unlike the dry, literal descriptive titles of other Minimalists, Eastman's pieces make no attempt to hide their author: "Crazy Nigger," "Evil Nigger," and "Gay Guerrilla." To him, the words weren't at all derogatory. In an introduction to one of his performances Eastman observed the controversy his work incited and explained his ethos. "A nigger for me is that kind of thing which attains himself or herself to the ground of anything," he said, "…that thing which is fundamental, that person or thing that attains to a basicness and eschews that thing which is superficial or elegant." Minimal, in a sense without becoming stylized. "The first niggers were of course field niggers," he hissed with magisterially dry irony. "Without field niggers you wouldn't have such a great and grand economy that we have." The title of "Gay Guerrilla" described what

he hoped he could be. "These names, either I glorify them or they glorify me," he said. "A guerrilla is someone who is in any case sacrificing his life for a point of view. If there is a cause, and if it is a great cause, those who belong to that cause will sacrifice their blood, because without blood there is no cause."

Eastman elevates that which is fundamental, making noise against the vacuum of ignorance or exclusion. He uses Minimalism as a way of getting outside of the norm, without creating a new order to be followed. Failing to find acceptance in the classical music community over the early 1980s and struggling to keep academic jobs while surviving intensifying bouts of addiction, he was in a perilous position. Police ejected Eastman from his apartment, tossing composition manuscripts out the window. He described himself as homeless and lived in Tompkins Square Park; friends encountered him catatonic on the street. Like a martyr he declined offers of help.

A recorded interview (likely Eastman's last) with the New York City radio host and composer David Garland in 1984 gives a sense of how Eastman's austere material circumstances shaped his artistic process. He explained that it took him about forty minutes to write a twenty-minute piece. He wasn't picky or precious about how or where he composed, because in the absence of supporting institutions or mentors, he couldn't afford to be. He scratched the music onto paper in snatches as he walked on the street or in the subway. "I'm in the bar and I might write a phrase for a string quartet," he said. "I write it, then I give it away to someone."

In the interview Eastman painted a self-portrait that was at turns tragic and absurd. "I live like a wandering monk, not in the country, more or less, but in the city." He no longer used a piano to compose because he didn't have access to one; the music was all in his head, and anyway, a piano was just a kind of calculator. He referenced the "illusion of

change" and the philosopher Mencius. He was "studying the Chinese masters, trying to be impartial to this and that. Be impartial to heat and cold, be impartial to love and hate. The Chinese were very elegant and restrained." The interview spiraled out of Garland's control and the host could only listen in awe as Eastman unspooled in his lilting voice: "The Lord is hard to take in his this-way and his that-way-ness." Life's arbitrariness was too much. Eastman returned to Buffalo alone unnoticed and died in a hospital there in 1990. The records cite cardiac arrest.

In 1998, Leach was teaching composition at CalArts and wanted to show her students "Joan d'Arc," but she realized there was no official copy of the piece. A friend of Leach's thought she had it, but the cassette box turned up empty. When Leach reached the man who dubbed the tape, she discovered it was a radio performance and the musicians were credited, including an ex-boyfriend of hers. He then retrieved the tape from storage, but there was no score. Thus began Leach's treasure hunt to find Eastman's pieces and transcribe and preserve them for the future.

The internet is making such unexpected music easier to discover. Leach can email around the world asking about Eastman esoterica and listen to new recordings in the space of hours instead of days or weeks thanks to digital uploads. A new audience is also finding Eastman online, complicating the clean narrative of twentieth-century Minimalism. On YouTube, where the recommendation algorithm in this case might actually help, commenters gush over original recordings and posthumous performances alike. Each new listener is a convert to this messier Minimalism.

During the Eastman festival in 2018, I attended a performance at the Knockdown Center, a sprawling art space in Queens, a factory that had been broken up into an industrial-scale gallery next to a club

that hosted everything from jazz to punk and EDM. From the street, the approaching crowd split evenly between both spaces; Eastman attracted as long a line as the night's concert. His audience was young and hip: composition students, artists, designers, people toting electric-guitar cases—the kind of wide, eclectic gathering he would have wanted but didn't get in his lifetime. The audience sat on folding chairs and then on the floor when those ran out, arranged in a giant square at the center of which were four black gleaming grand pianos arranged facing each other like a severe sculpture.

"Evil Nigger" sounded like a careening robot, the repetition of its staccato musical modules marked off by a memorable cascading hook and one of the musicians shouting a countdown from four. The performers used electronic tablets flashing green and red to follow the piece's structure. The notes accrued like torrents of rain. Later, during the denouement of "Crazy Nigger," about forty-five minutes in, three of the four aligned pianos ceased while one of the musicians pounded a low, ominous note every few seconds. The entire room hung on that single note, a tense silence extending until it sounded again and eventually kicked off a last storm of piano that gradually withdrew, the tide going out and leaving us listeners beached, gasping.

In her essay on the aesthetics of silence, Susan Sontag observed that every avant-garde style eventually becomes acceptable to its audience and is integrated into the cultural tastes of the moment in turn. Successors in the art of silence must be more extreme still, withdrawing and luring us along with them, bringing us further from our expectations of art and our ideas of ourselves. Eastman presents another horizon to pursue. There is nothing lulling or boring about his music. You can't hide from it or use it as a shelter from the rest of the world. It demands our attention.

4. Shadow

IN THE DAYS before I left New York for Tokyo in midwinter all I could think about was the movie *Lost in Translation*. Sofia Coppola's soft, slow art house film from 2003 gave impressionable fifteen-year-old me my earliest image of the city as well as an inkling of what it might mean to be a worldly adult, for better or worse. At that age I had barely traveled outside of the northeastern United States; I found the DVD on the indie shelf at my local Blockbuster.

The movie planted itself in my brain permanently as an aesthetic landmark. Its story, cinematography, and soundtrack combined into an airy, ethereal wash that defined a certain vision of cultural success, the lifestyle of the hypermobile celebrity who disdained Hollywood's usual spotlit tackiness. *Lost in Translation*'s characters were expatriates of the mind, citizens of nowhere: Bill Murray's star actor, dissatisfied even while selling out, talking about converting to a Japanese diet while lounging in the hotel tub; Scarlett Johansson's drifting ingenue, taking up traditional flower arranging and listening to self-help audiobooks; Giovanni Ribisi's clueless photographer, too wrapped up in his job behind the camera to actually notice anything in front of him.

Lost in Translation was a world of blank spaces. There was the glamorous vacuum of an international hotel (the modernist Park Hyatt

Tokyo, to be exact), the capsule of the taxi window that Johansson gazes out from on her way through the city, and the booth in the restaurant where neither she nor Murray understands the menu. In fact, I was reminded when I rewatched it, the movie doesn't actually show much of Tokyo at all, save some luminous B-roll of parks and temples. Coppola was more concerned with the bubble that forms around people displaced from their usual context and seeking any semblance of familiarity than she was with the details of local Japanese life. As a teenager, I didn't understand the elision and took the movie's atmosphere as documentation of an authentic Tokyo. But it was an American fantasy.

You could call it "minimalist," in a way. The movie certainly makes absence pleasing and seductive. There isn't much in the way of dialogue or plot. Instead it rests on a now-standardized style: an ambient soundtrack, transparent glass, soft colors, an atmosphere of floating detachment, and emphasis on self-cultivation, not material accumulation. Maybe that hazy looseness, the image of people letting go of and then finding themselves, was what I found so attractive. I wasn't alone—*Lost in Translation*'s images have become memes. The Park Hyatt Tokyo bar where Johansson and Murray meet is now even more of a tourist destination because of its filmic aura. Selfie-takers role-play Johansson in the windows of the hotel's rooms, looking out over the rippling blanket of Tokyo without participating in it.

I don't think it's a coincidence that the film was a surprise hit in the years after 9/11. It was another crisis moment for the United States and the West at large, the attacks a shock to Americans who didn't know we were a target precisely for our excesses and exercises of power. *Lost in Translation* was about characters who didn't put much stock in their American identity. The diaphanous backdrop of Coppola's

Tokyo presented an alternative to the militarized, nationalistic United States of 2003.

Minimalism as it appears in the West is inherently oppositional, posing itself against something, as a departure from a current state—cleanliness against mess, absence against presence, and silence against noise. The targets of popular minimalism are values that are usually seen as Western or American, whether it's a reaction against capitalism's relentless pursuit of industrialized productivity for profit or the promise of consumer materialism, that being able to buy the right things is what makes us happy. As such, minimalism is easily associated with something foreign. In the modern era Japan, as in *Lost in Translation*, has offered a convenient Other for that projection, a culture with what appeared to be a heritage of spare, precious, quiet, sensitive aesthetics readymade for contrast to problematic excess.

Marie Kondo is only the most obvious import; many of minimalism's threads can be traced back to Japanese influences or interpretations (with varying degrees of accuracy) of the culture's ideals. The sliding walls and gridded rice paper windows of Japanese homes were a precedent for Mies van der Rohe's radical geometric glass structures. Judd spent time in Korea and Japan; his library included books on Buddhism, Zen poetry, and not one but two Taoist sex manuals. John Cage and Agnes Martin drew directly from and made clear references to Zen in their work. The British author Beth Kempton turned the Japanese style of *wabi sabi*—appreciating the handmade and rough-hewn—into a self-help metaphor: life as a paint-your-own-ceramics class.

The conflation of Japan and minimalism continues into the present. Unobtrusive Japanese fashion and furniture are everywhere in the United States courtesy of brands like Uniqlo and Muji (a name that

literally translates to "no brand"). Japanese design has become a byword for extremely efficient, thoughtful, and yet reasonably affordable products, combining the old dream of the Bauhaus with twenty-first-century technology: automatic bidets for everyone. The country has gained an international reputation for embracing austerity. It's even the birthplace of the most extreme minimalist dwellings: capsule hotels where guests sleep in human-sized tubes.

Yet this linking of Otherness and austerity is artificial. It might be a convenient way of making a break and dissociating from a previous belief or identity, but there is a history that has been erased or overlooked, on both sides, in favor of a reductive story and the easy lesson of living with less. The reality is that even Japanese minimalism is a joint, modern creation. It emerged from political conflict over the course of World War II, driven in part by violence and exclusion as Japan defined itself against the West and the West confronted an identity crisis of its own after the war.

The conclusion of this break is that minimalism itself is not a homogenous thing. It's the combination of what might at first seem to be opposites, the way light is inextricable from shadow. This union is best addressed by the particular philosophy of Japanese Buddhism and the art and literature that it inspired over two millennia, which is what I traveled to Tokyo to find.

The fourteen-hour flight from New York was its own form of blankness, like a dream of nothing. I woke up and the clock read the same as when I left, but a day had gone by. I passed through the Narita airport in a daze and took an express train into the center of Tokyo that delivered me to a station only a ten-minute walk from the Airbnb I had booked in Shinjuku. The total frictionlessness of the journey, a species of Rem Koolhaas's ambience, made me feel like I had only taken an

extremely long subway ride and was still somehow in Brooklyn, but different: the buildings taller, the streets quieter. The feeling of displacement, or maybe it was the conspicuous lack thereof, was compounded by the fact that I didn't have to interact with anyone to get into the apartment. I just looked up a mailbox code on my phone, took the keys, and opened the front door like I already lived there. I walked into what was essentially a white box: monochrome walls, floor, ceiling, stairs, lofted bed. There was no mark of personality anywhere save a shiny maroon duvet and a single fake plant. It was like no one had ever lived there before me and no one would again when I left.

After days out in Tokyo—wandering past luxury boutiques, losing my way in Byzantine subway stations, fighting jet lag—I returned to the white box at night feeling a bit like Johansson's character, a ghost in the city. The time difference cut me off from the constant online connection I was used to. There weren't as many Twitter or Instagram posts to consume and timing phone calls back home was awkward. The disconnection put me in a more receptive state. I had nothing to do but observe.

In Tokyo everything is perfect, or perfectly optimized to itself. Each individual building is the best shape it can be as that building, both unique and belonging to an overall uniformity of pattern. The subway lines have their own special synthesized theme songs that ring out when the doors open in a station. The scale of the city is huge, but each component part stands out on its own: One shop sold only vintage clothing from Finland, a subgenre I had never considered. A Michelin-starred ramen restaurant made just a few variations on the dish but its broth of clam and fish was as sublime as anything I had ever tasted, with multiple flavors reduced into a single essence like

they were derived from one thing. A café devoted itself to selling coffee beans from around the world, arranged into a graphic gradient by the darkness of the roast. A dumpling restaurant was staffed by two guys at the counter hand-folding each pouch before cooking it gently and slowly on the grill until it was perfectly brown, and then handing it over to the customer (me) like the highest-grade sushi. Judd's "specific" would be a good word to sum it all up: a careful appreciation of the ideal qualities innate to a certain category of thing—food, drink, space, style.

It was taken to extremes. One night I went to a bar in the Omotesando neighborhood with an American friend who was also passing through Tokyo on vacation. It looked warm and welcoming from the yellow light falling onto the sidewalk, though there were no customers at that moment. Once we took seats the lone besuited bartender gave us a long look and asked what we wanted. There were no menus in sight, just an array of bottles on the back wall. After a short discussion with the bartender we each decided on brands of Japanese whiskey. Employing the methodology and bedside manner of a surgeon he chipped off irregular formations of ice from a block, laid them in two glasses, poured the whiskey in, and stirred several dozen times with a look of intense concentration, as if willing the liquor to rise to its potential, a coach silently cheering on a star player.

As we sipped appreciatively the bartender did not clean up or rearrange glasses. There was no rush of customers to serve until a single couple walked in later on. Instead he stared at a spot on the wall near the clock, hands gently clasped, waiting. Minutes ticked by this way, ten then twenty then thirty. My friend and I chatted down to the bottom of our drinks, but the persistent stillness was almost awkward, like we were stuck in a Haruki Murakami novel (another personal teenage

influence) just at the point something mundane and yet life shattering was about to happen. Maybe it was the looming bill: Each pour cost $20. Such intense focus is expensive.

As great as the food and drink were, evidence of the Japanese delight in subtle sensory perception, my real subjects there were people and places. Over the previous year I had been drawn down a rabbit hole of Japanese history, reading everything from thousand-year-old diaries to modernist philosophers and popular twentieth-century novelists like Junichirō Tanizaki, chasing that particular aura of Japanese art with a fervor that I couldn't quite explain. What I enjoyed about it was the contemplative state it induced, the same as Minimalism in visual art and music—was nothing or something happening?

The Buddhism at the root of this aesthetic was about accepting the fact that life is ephemeral, that every material thing will inevitably drift away and all that remains is whatever joy we can take in the midst in this process of emptying. Yet Japanese Buddhism was an import, too, another heterogenous construction of an Indian religion filtered through Korea and China and mixed with Japan's ancient Shintoism, the belief that everything on earth was equally animated by an essential spirit worthy of worship, a celebration of all that exists at once.

Learning more meant going to Kyoto, the capital of Japan from 794 to 1869 and the wellspring of its ancient culture, a city, locals informed me, as snobbish about itself as New York, Paris, or Rome. I left on the fastest bullet train from Tokyo Station, which runs every ten minutes. The landscape blurred into unintelligibility as pristine mechanical voices chimed the coming stops over the intercom and I ate a to-go tray laden with slices of raw fish on white rice so casually perfect that I couldn't imagine its existence anywhere else on the planet.

In Kyoto I rolled my suitcase down dusty alleyways and up to the dark gate of Yumiya Komachi inn, a centuries-old wooden building in Gion. Gion is the oldest part of the city and its historic red-light district, full of low wooden town houses, restaurants, and bars. The inn had once been a home where the daughters of geisha were educated. The neighborhood is also conveniently close to the Buddhist temples that draw hordes of tourists to the city, a combination of sin and piety that centuries of writers have observed and participated in.

It was quieter in the off-season when I visited; instead of cherry blossoms or yellowing autumn leaves there were bare skeletal branches. As I slid open Yumiya's rice paper door and took my shoes off to go inside, downtown Tokyo seemed farther away than Brooklyn.

IN JAPANESE BUDDHISM, nothingness is not an empty vacuum but a presence, the presence of a total field of absence underlying everything, described by the word *mu* (*sunyata* in Sanskrit). The concept is tricky.

You can think about it this way: In the thirteenth century, a Chinese monk the Japanese call Mumon Ekai collected a famous book of koans, called *The Gateless Barrier*, while he was the head of a monastery in Guangdong. Shaggy-haired and shabbily dressed, with a long beard, Ekai was an itinerant monk, given to laboring in the fields. The first koan in his collection, which was also the koan Ekai was given to meditate on as an acolyte and eventually achieved enlightenment through after six years, gives an anecdote about an earlier Zen master:

> A monk asked Joshu, "Has the dog the Buddha nature?"
> Joshu replied, "Mu!"

In this case "mu" might looks like an answer of "no," but it's actually a negation: Everything has Buddha nature, therefore the question itself is wrongheaded. We're meant to meditate on this negation. Mumon wrote of *mu* in his interpretation of the koan, "Do not believe it is the common negative symbol meaning nothing. It is not nothingness, the opposite of existence." Nothingness must instead be "a red-hot iron

ball which you have gulped down and which you try to vomit up, but cannot." It reminds me of bodega coffee that comes out of the metal canteen boiling but you sip anyway. Spitting it up burns your mouth, swallowing it burns your throat, and so instead it stays there, caught in between. Absence can be this seething, roiling thing—not calm at all. It's the same agitation that Cage caused in his silent *4'33"*, an agitation of indeterminacy.

Zen koans are fractures in language. They don't require answers, only attention; they are tools of perception meant to break down dualism, the belief that anything can be separated from anything else. ("Less is more" might be the Western koan of this book.) The oldest Zen poem, as translated by D. T. Suzuki (John Cage's guru), describes the Zen way as "perfect like unto vast space / With nothing wanting, nothing superfluous." Even thinking too much about this unity must be avoided: "The two exist because of the One / But hold not even to this One." Zen would eventually develop complex social hierarchies and rituals, but at its core it is anti-orthodox.

The historical Buddha lived in India and Nepal sometime around the third century B.C.E. He was born a prince, protected from the world's suffering. But once he realized that life sucks as much as it does, he forsook his title in favor of wandering asceticism and meditation. He adopted "The Middle Way"—a path between worldly materialism and intentional self-mortification. Desire, for either extreme, was the cause of suffering. By the first century C.E. Buddhism spread across mainland Asia and its sutras were translated into Chinese. In China it mingled with native Taoism, which dated back to around the birth of the Buddha. In the *Tao Te Ching* the (possibly mythological) sage Lao Tzu advocated the doctrine of non-action: "Less and less is done / Until non-action is achieved. / When nothing is done, nothing is left undone," chapter

forty-eight reads. "The world is ruled by letting things take their course. / It cannot be ruled by interfering."

Chan, or Zen, Buddhism was brought to China in the sixth century by a gruff, bushily bearded Central Asian monk, Bodhidharma, who at first failed to gain acceptance at a Chinese monastery and then spent nine years staring at a cave wall. During the second year he fell asleep; to ensure that it didn't happen again, he sliced his eyelids off. The fallen eyelids hit the ground and became China's first tea plants, convenient for helping monks stay awake during meditation.

The sixth century was also when Buddhism made it onto the island of Japan through Korea, borne across the sea by an official court delegation that arrived with scriptures and illuminated scrolls. It wasn't until the late Heian period, around 1000 C.E., that Zen Buddhism became popular in Japan, but it was key to the development of many things that are now seen as essentially Japanese, like short-form poetry and the tea ceremony. The latter, an exercise in quietly appreciating humble materials and nourishment, was instated by a monk named Eisai, who established early Zen temples and was the first to bring back green tea seeds from a sojourn studying in China. Eisai happened to be buried in Kennin-ji, a temple (*ji* means temple) off the same alley as my Kyoto inn, where there is a stone monument dedicated to him.

Zen involves accepting a lack of control over the many problems in life, which are more or less universal over time and place: when to marry, how to mourn, where to work, what form of wealth to stockpile, when to give it up. We tend to rely on systems in order to help solve them. It could be the Ten Commandments, Tarot cards, focusing on the swirl of tea leaves in a cup, the position of the planets, or communicating with the dead; reading patterns in the clouds or animal entrails, doing whatever will get you the most Instagram likes, cleaning out your

closet, or chasing the cultural fashions of your time, the fluctuations of which are as random as anything else. We look all around ourselves for instructions on how to live only to be confronted with the basic unknowability of the world. And so we turn to some new mode of control, such as minimalism, only to be infected with the suspicion that it, too, is unreal, a map to no territory.

We switch methods without questioning the basic premise that anything matters at all, or that there is an answer or explanation, thus trapping ourselves, Zen says. As Mumon Ekai wrote, "Anyone who explains this or that, yes and no, is himself the man of yes and no." To echo the ending of so many of the monk's analyses: When you understand that, you will understand nothing.

ONE OF EMPRESS Teishi's attending ladies in Heian Japan convinced the teenage monarch to give her the gift of a rare sheaf of paper that had just arrived. The court ran on paper: The women constantly traded messengered fragments of poems and flirtatious notes with similarly aristocratic men like a flurry of modern text messages, fretting over the composition of the sentences and the quality of the paper itself, the energy or serenity of their calligraphy, and how quickly a response might be expected. This was only possible because they lived lives of utter leisure and had nothing better to do than overanalyze the thrust of a few words on an hourly basis—a familiar dilemma.

Particularly for women, who were barred from government and war, the day-to-day routine consisted of a series of decipherable codes made up of literary references, sartorial choices, and season-specific rituals. These were games of taste and interpretation in which one must understand the poetic difference between the full moon on a rainy night and on a snowy one or whether it was preferable for a lover to depart your bed before you wake up, leaving only the scent of his incense-perfumed robes behind, or to stay too long into the morning, fumbling to get dressed because he can't bring himself to leave.

This knowledge was vital currency for debate, entertainment, and seduction. It was justified furthermore by Buddhist karma: Those who

had lived well in past lives were rewarded with beauty in the present. Thus, the beautiful must have been good, and pursuing beauty—in painting, calligraphy, fashion—was akin to a moral code. Style was the governing principal of the Heian period—to a fault.

The sheaf of paper was a weighty gift, and its thirtysomething recipient, Sei Shōnagon, was under particular pressure. The descendant of a family of influential poets, Shōnagon was expected to brighten Empress Teishi's salon with her wit, wielding words rather than great beauty or political power. The paper was a tool to document the milieu for distribution, the way *Vogue* might do a flattering photo shoot of a royal family. After the bustle of a day's amusements Shōnagon returned to the privacy of her own room and pulled out the sheaf of paper, drew a lamp in the darkness near a low lacquered wooden table, and wrote down notes that recounted the court's goings-on: any quip, anecdote, poem, or journey that might provoke some delight or sympathy in the reader.

The resulting volume is called *The Pillow Book*. Like a thousand-year-old blog, it's full of minutiae that become poetic in their ordinariness. Shōnagon dissects the world around her, sorting it into categories of amusing or displeasing, beautiful or ugly, and poetic or banal—paying attention, first and foremost, and appreciating whatever is present. Her writing is sneakily profound. Brief observations like "Summer insects are quite enchanting things. I love the way they'll fly round above a book when you've drawn the lamp up close to look at some tale" are small and specific but they aggregate into an entire worldview.

I read *The Pillow Book* at night in my tatami room at the Kyoto inn, where the only illumination above my futon mattress came from a single rice paper lamp. In the darkness before falling asleep it was

easier to imagine Shōnagon's surroundings, the mansion rooms ancestor to the one I was in, with sliding doors opening to porches overlooking interior gardens nested with the shadows of gnarled trees. Her vision is as forceful as if the text had been written yesterday. Even after I put the book down the world still glittered with Shōnagon's commentary, her voice in my ear instructing me to look closer at the texture of cloth or leaves rustling outside, to seek out the best moments. "In the seventh month, when the heat is dreadful, everything in the building is kept open all through the night, and it's delightful to wake on moonlit nights and lie there looking out," she wrote. "Dark nights too are delightful, and as for the sight of the moon at dawn, words cannot describe the loveliness."

Many of the moments Shōnagon described take place in dimness, either the enclosed spaces blocked by curtains, screens, and sliding doors that Heian women were cloistered in or the darkness of night, in which some deeper privacy and freedom were possible. The dark destabilizes, as at "that point in the cool of the evening when the dusk has begun to blur the shapes of things," she wrote. Away from the light, secret journeys were undertaken: Men might arrive on surprise visits at the edge of a porch, and long conversations could be held until dawn around a lit brazier. Shōnagon even made a list, "things that are better at night," that includes the glow of softened deep purple silk, a large-browed woman with beautiful hair, and the sound of a waterfall. The Pillow Book's lightness of tone belies its intermittent daggers of sarcasm and judgment, intimate reminders that attitudes really haven't changed that much in a millennium: "Everything that cries in the night is wonderful. With the exception, of course, of babies."

For Shōnagon, catching a glimpse of someone's face or a flash of their particularly extravagant costume in the shade of a room at night

through a crack in the door of a carriage or the twitched-away edge of an indoor curtain could be more enticing than a full view. She described how, when she was first put into the empress's service, she could barely stand to look straight-on at the girl's beauty. (Shōnagon knew that her notebook was more or less public, which perhaps pushed her toward a more flattering portrait.) One of the court's principle games was navigating this subtle space between clarity and ambiguity, in which the latter could be both more beautiful and truthful than the former. Heians valued an unresolved quality in which simple answers are less important than being poetically evocative.

The same appreciation can be found in *The Tale of Genji*, by Shōnagon's rival, another courtly woman named Murasaki Shikibu—shikibu found Shōnagon "dreadfully conceited" and thought her writing mundane, as she noted in her respective diary. The two books, written at the same time and, unusually for the historical record, both by women, make for an interesting pair. *The Pillow Book* is a direct line into an individual consciousness, while the sprawling, episodic *Genji*, perhaps the first true novel in history, presents a holistic view of the Heian court from the semi-omniscient perspective of its disembodied narrator.

Where Shōnagon's voice is incisive and personal, Murasaki's Genji is immaculate, the fan-fiction version of a prince. He is so beautiful, so adept at poetry, so charming, and so loyal that not even the ever-expanding harem of women that he tends to ignore, nor his questionable flirtations with his adopted daughter, mars his character. Beauty meant goodness: The reader sees Genji as the epitome of Heian society, though he never becomes emperor himself—another aspect of the novel that avoids a triumphant linear narrative.

In *Genji*, too, glimpses into the shadows offer hidden meaning. When Genji is exiled from court and lands in the coastal home of a

former nobleman who has renounced the world to become a monk, the two pluck instruments together and observe how "depths of leafy shadow here and there surpassed in loveliness spring blossoms or autumn colors." Men keep trying to peek inside closed chambers, though they're often thwarted: "The music that the Commander heard from all these exquisitely elegant ladies made him very eager to see deeper into the shadows within"; "the Intendant was deeply disappointed not to see more clearly into the shadows of the room." And even when the desired target is within view, they still seem to be shrouded, as when Genji observes a woman who is deathly ill: "Her thin arms, as weak as shadows, still had all their pale, slender grace." Sickness itself is presented as an ideal: "She seemed only dearer and more precious, and lovelier as well."

The aesthetic of the obscured and incomplete comes from a Buddhist value, *mono no aware*, which is often translated as the pathos of things. "Aware" is an interjection, a sigh that expresses sympathy or regret, while "mono" refers to objects as they exist in the world. *Mono no aware* is the beauty of transience, the way a falling leaf or sunlight gilding the edge of a rock at the end of the day can incite a sudden gut-punch awareness that life is evanescent.

Even beyond the shortness of life span in the eleventh century, when women could die from mismanaged pregnancy or demonic possession, both of which occur in *Genji*, the Heian period was on a precipice. The court used to send periodic envoys to the more developed kingdoms of China and Korea, but it had consciously cut itself off in the ninth century. Newly dominant Buddhist thought also held that humanity had reached the end of a cycle of history. A kind of apocalypse loomed. "Everything seems to be in a state of decline," as Genji observes. They were right, in a way. Their decadent society was soon

overcome by a tide of warrior monks from the mountains outside of Kyoto, who rebelled against effete Heian obsessions to establish the more straightforwardly austere Kamakura shogunate in 1192.

No wonder that in both *Genji* and *The Pillow Book* everything is fleeting or fleeing, moving between different states of being. Shadows cover paths so that lovers must wait for the moon to rise to make their way home. Formerly grand houses are covered in vines that create cracks in fences, the better to see if a lantern might be lit inside. Notes of music leak out across distances, drawing the listener toward the player though he can't be seen. In scroll and screen paintings of *Genji* made in later centuries, clouds of empty space (blank paper sometimes filled in with lambent gold leaf) envelop the scenes of nobles flirting and fighting in their well-appointed houses. These blanks capture the drifting, autumnal mood with silent eloquence, evoking a luxurious minimalism.

Yet there's a distinct contrast between the writers' melancholic observations of *mono no aware* and the intense, almost consumerist, material culture on display in the books. Shōnagon was as likely to judge her colleagues at court by the quality of robes they wore, the size of their carriages, or the behavior of their servants as their poetry. Murasaki regales readers with stories of extravagant seasonal celebrations in which men put their favorite female dancers on dolled-up display and of contests to see who has gathered the best painting collection (Genji wins, of course). At times the sheer aggregation of stuff gives a whiff of just how stultified the court must have been to require such intricate entertainment; the writer Ian Buruma has described the Heian aristocrats as "mostly bored out of their minds." It wasn't just about noticing how certain birds called at certain times of year, taking simple joy in nature, but deciding which sound was best,

mocking those who didn't know as well as you that of course the cuckoo bird's tune is lovelier than the bush warbler. Taste was the primary status symbol.

When it all became too exhausting to bear, Heian men and women alike constantly threatened to abandon the shallow material world, shave their heads, and join monasteries far away from Kyoto, the way New Yorkers bail on the city. Such renunciation was viewed with equal amounts horror and romance—it was the ultimate capitulation to fleetingness. But it was also kind of like going on a cleanse or giving up the internet: You could always return, touched by the glamour of your asceticism. One had to be ambivalent about civilization and yet care about it desperately at the same time. Even the nobleman-turned-monk that Genji finds while in exile—he might have abandoned his position, but he's still obsessed with marrying his daughter into the imperial family. It doesn't quite work out, but Genji brings her back to court anyway, because he's a nice guy.

A society built on aesthetics alone, especially the similar curatorial mania that minimalism brings today, can be torturous. The Buddhist acceptance of ephemerality didn't necessarily kill desire but made it all the more intense by giving the Heians a taste for ephemerality itself; they pursued the most beautiful evanescence possible. The problem is that taste operates by its own vicious, vacuous logic. Things are arbitrarily in or out; judgments don't seem to have root causes, only shifting whims that must be followed.

Sei Shōnagon was victim to it herself. The empress she served gradually fell from favor and, with the excuse of protecting her pregnancy, was sent away from the court to stay at a country house far too shabby for her status. She died soon after, and Shōnagon either married a minor nobleman or became a nun and ended her life in

poverty—on this the historical record is vague. But her *Pillow Book* doesn't mention any hardship. She confines her wry written voice to the delightful, amusing, and tasteful. The elision was intentional and would have been more than noticeable to her eleventh-century readers. "People have begged me not to leave anything out," she wrote, and yet the conspicuous absences were the point.

JAPAN'S MEIJI PERIOD presented another crisis moment. Commodore Perry had forcibly opened the nation to outside trade in 1853 with American gunships in the Tokyo harbor. The last Tokugawa shogun abdicated in 1868, the year Meiji began, ending the feudal military government. This time there was no possibility of intentional isolation. Rattling trains and electric signs invaded the once dark and quiet night. Wooden buildings grew into skyscrapers with windows made of glass instead of paper. Young people emigrated to study at Western universities and wore collared shirts and top hats—the shock. The nation had to negotiate the West's overwhelming influence, in the process deciding what it meant to be Japanese as well.

One way of confronting such precipitous change was to retreat into an ideal of fundamental Japaneseness, reaching back to history for a sense of stability and continuity. Artists and writers set about envisioning this identity in reaction to, rather than separate from, the Western incursion. A new version of Japaneseness had to be created or curated, one that could adapt to a new global order. As borders opened Japanese influence was expanding abroad as well; one always sees oneself with sharper contrast in the face of an other.

One cross-cultural emissary was Kakuzo Okakura, a heavily mustachioed, glum-looking poet-curator-administrator who dressed

in traditional Chinese robes as easily as Western suits. In 1901 he wrote a manifesto of exceptionalism, *The Ideals of the East*, arguing that "Japan is a museum of Asiatic civilization...the singular genius of the race leads it to dwell on all phases of the ideals of the past." To Okakura, his people were the perfect stewards of their continent because they had already carefully adapted the best parts of the Indian and Chinese civilizations. These same touchstones—Shinto, Buddhism, Zen, Noh theater—could also turn Japan into a "modern power."

The scholar John Clark has described Okakura's ideology in the essay as "aesthetic nationalism": using art and culture as politics, turning aesthetics into a fatalistic tool for inflating the self and excluding outsiders. "Victory from within, or a mighty death without," the 1901 essay ends.

Okakura was pushed out of office by an ill-fated affair (which had aftershocks of its own) and moved to Boston in 1904 to advise the Museum of Fine Arts. There, he befriended the likes of Ezra Pound and the collector Isabella Stewart Gardner, turning them into committed Japanophiles. In 1906 he published *The Book of Tea*, an eloquent English-language introduction to the Japanese sensibility through the lens of the tea ceremony. A century ago Okakura was already decrying American clutter in his book: "To a Japanese, accustomed to simplicity of ornamentation and frequent change of decorative method a Western interior permanently filled with a vast array of pictures, statuary, and bric-a-brac gives the impression of mere vulgar display of riches," he wrote. Instead of sheer material accumulation, the tea ceremony is "a worship of the Imperfect...a tender attempt to accomplish something possible in this impossible thing we know as life."

There's a dilemma in Okakura's double-sided arguments. On one hand he was at pains to defend his own people's claim to a unique art and beauty that belong to them alone; on the other hand he also tried

to communicate these values to a wider, international audience drawn in by his exotic aura, burnishing his reputation as a man of culture, an influencer of global tastes to this day. Was the Japanese sensibility something that should be shared, or should it be kept close at hand, in what seemed to be its purest form? No matter how simple, quiet, or reserved the attitude, this dichotomy of preservation versus expansion drove Japan into the violent heart of the twentieth century, even as the pared-down Japanese aesthetic spread around the world.

Kyoto is a city of facades, especially in Gion, which lies to the southeast of the original Heian imperial palace across the Kamo River. From the street, even if you can read the signs, it's hard to tell what a building holds or what's going on inside because the storefronts of the old merchant town houses are obscured by vertical wooden slats like window shades. Hanging curtains disguise inner entrances and long corridors lead to far-off doors. You can't look through plate glass windows to gauge how popular a restaurant or bar might be; you're lucky to catch a bare glimpse through the slats. Instead you hesitate for a moment before each new possibility, listening for the murmur of many voices or the clatter of plates.

The hiddenness reflects a wider attitude of withdrawal. As the latest inheritors of centuries of discernment—the same connoisseurship captured by Murasaki and Shōnagon—locals take care to preserve the city's cultural microclimate for themselves and whoever might come after. There's a clear dichotomy to the architecture: The facades are aggressively simple, as if designed to repel strangers (thus attracting us), but the inner spaces once accessed are more intimate and welcoming than in metastasized, anonymous Tokyo. It reminded me of the ancient Chinese aesthetic of "blandness," the English translation for *han* in the French philosopher François Julien's essay "In Praise of

Blandness." Blandness means the absence of prominent defining qualities, the value of neutrality in painting, poetry, or comportment. One who gives off nothing of her personality is better than a charmer who blathers. It's about risking inciting boredom by avoiding the blatant or obvious—another precedent for minimalism.

My innkeeper was an exuberant older woman named Rico, who had been renting the old house from its owner for a decade, adding some modernized showers and bathrooms for her guests without disrupting the overall atmosphere of gentle decay. She wasn't from Kyoto but Kyushu, a southern, more Mediterranean part of Japan known for warm, boisterous personalities. It was hard to make friends with any native Kyotoans, she told me over tea from a kettle boiled on top of a cozy gas heater in the small lobby room. There's even a saying: "Here, it takes five years to be invited through the front gate, and then ten to get inside," she said. An invitation for tea and rice is actually a hint that it's time to leave.

During the inn's early days Rico used to get complaints that she didn't rake the leaves in the alleyway fast enough; it turned out that she was raking in the afternoon, while everyone else got it done in the morning. She had to contain her annoyance and play along. "*Sumimasen, sumimasen!*"—Excuse me! Don't mind me! I'm sorry!—she said while madly pantomiming sweeping up. Sure, Kyoto is lovely—the temples, the cherry blossoms, the surrounding hills rusting orange in autumn—but did everyone really have to be so pretentious?

The inn room I picked was the largest, with a small porch overlooking the Japanese-style pocket garden at the back of the house, where sunlight sluiced in around noon after it cleared the abutting homes. The room and the garden formed one permeable space separated by pairs of sliding doors, one layer of rice paper and the second

Plexiglas, to better keep out the cold. In the morning the plants cast silhouettes onto the gridded paper as I looked up from the futon on the floor. (The Japanese language even devotes a word, *komorebi*, to the dappled pattern of light shining through leaves.)

The boxy interior of the space stayed dim. The monochrome texture of the sand-plastered walls made the corners hazy and mysterious. On one side of the room was the tokonoma, a small recessed alcove. The feature emerged in the sixteenth century as a space devoted to art: Flower arrangements go on the raised dais on the floor and a solitary print, painting, or piece of calligraphy hangs on the interior wall—a miniature gallery for contemplation. (During the tea ceremony, important guests sit facing away from the tokonoma so the host doesn't seem to be bragging.) Mine was installed with a long scroll of an ink wash painting of a monk that was hung above a tall porcelain vase with a single pink flower and its branching leaves. There was no HGTV-mandated salon-style art collection or clutch of extraneous souvenirs. Objects in the tokonoma are framed by empty space, their presence intensified by the absence surrounding them like blank paper.

The effect is a kind of beauty by negation. "Were it not for shadows, there would be no beauty," wrote the novelist Junichirō Tanizaki in a 1933 essay, "In Praise of Shadows." He was living in Kyoto at the time and worked from a low desk like the one in my room, gazing out the sliding doors toward the garden. "We find beauty not in the thing itself but in the patterns of shadows, the light and the darkness, that one thing against another creates."

Tanizaki was an eminent tastemaker who wrote short riffs of cultural commentary when he wasn't completing one of his many novels or laboring at a decades-long project to translate *The Tale of Genji* into modern Japanese, a nostalgic attempt at preserving its sense of style. Born to a Tokyo merchant family in 1886, Tanizaki made his name

with noir-influenced short stories by 1909 and became a symbol of the ascendant literati class of early twentieth-century Japan. Erudite, urbane, and frequently salacious, he befriended Western expats, learned to ballroom dance, and wrote fiction about bisexual love quadrangles and young women emulating the starlets seen in newly available Hollywood movies. His literature changed along with the Japanese identity.

Tanizaki also argued, in his own arch way, for Japan's exceptional aesthetics of absence. "In Praise of Shadows"—like *The Pillow Book*, a seemingly random collection of observations that coheres into something profound—begins with Tanizaki trying to a design a house for himself. He wanted it to mingle new, convenient Western technology with his homeland's love of softness and shadow, "striving somehow to make electric wires, gas pipes, and water lines harmonize with the austerity of Japanese rooms," he wrote. Heaters, lightbulbs, and porcelain toilets are useful, the novelist argued, but they're also ugly, anathema to the beauty that comes with worn-in wood and candlelight.

The acceptance of austerity and ambiguity, imperfection as perfection, was a way of being in the world. It went along with a critique of industrialization, early globalization, and the greed of capitalism. "The progressive Westerner is determined always to better his lot," Tanizaki wrote. "His quest for a brighter light never ceases, he spares no pains to eradicate the minutest shadow." (The novelist might have meant this figuratively, but now it's literal: A 2016 study found that more than 99 percent of United States and European populations live under light-polluted skies, which confuse nocturnal animals, increase algae growth, and cause anxiety and melatonin suppression in humans.)

If such creeping light represents greed, then shadow is satisfaction with the existing dimness, the way it muffles sensation and slows perception. Tanizaki advocates appreciating what is there, letting your

eyes adjust to a different wavelength. The novelist's preferences aren't for the clean, denuded room or the glass window-wall but the interiors of old houses; the cloudiness of miso soup in the dark gloss of lacquered dishes; the green lips of a classical Kyoto geisha, whose black-painted teeth he described as "elfin fires"; and the way the single candle flame in a high-ceilinged mansion room illuminates a particular flavor of shadow not found elsewhere: "lofty, intense, monolithic," the resulting darkness "a pregnancy of tiny particles like fine ashes, each particle luminous as a rainbow."

Darkness deserves as much poetry written about it as sunlight. Tanizaki caught himself up in daydreams, wondering where this fugitive realm had disappeared to amid the neon landscape. By capturing all these experiences of shadow, he salvaged a particular way of seeing:

> I have written all this because I have thought that there might still be somewhere, possibly in literature or the arts, where something could be saved. I would call back at least for literature this world of shadows we are losing. In the mansion called literature I would have the eaves deep and the walls dark, I would push back into the shadows the things that come forward too clearly, I would strip away the useless decoration.

Tanizaki was a quiet iconoclast. He reminds us that we are surrounded by particular regimes of taste created by history and politics but we can step outside of them if we so choose in order to enter a different space—his "world of shadows." Over the past century the problems he observed have only worsened; no wonder that Tanizaki's message has resonated so much beyond his own time and place. "In

Praise of Shadows" was first published in the United States in 1977 by a tiny press in Maine called Leete's Island Books, with a cover featuring a stark black-and-white photograph of a gridded rice paper door. Over decades the book has sold more than one hundred thousand copies across a dozen printings, the cover never changing, spreading like a kind of meme dissenting with modernity.

While I was researching in Marfa, I was surprised to come across a vintage copy of *In Praise of Shadows* facing up on the geometric wood shelves of Donald Judd's personal library, where he had placed it in a position of prominence—the same cover that I've collected and given away to friends, posed as an art object. But then I understood: Judd was fascinated by anyone who experienced the world, almost to the point of unreason, through their aesthetic sense. Judd's own work also embraced obscurity and presented the opposite of what viewers expected. As much as visual austerity, this contrarianism drove Minimalism.

I called the founder of Leete's Island Books, Peter Neill, to find out why he picked up such an esoteric text and why it became so popular. Neill had lived for a time in Tokyo, but when he was introduced to Tanizaki's essay by its translator, it permanently changed his perspective. While reading, he told me, "you're essentially clearing your mind, coming into this space between light and dark, between noise and silence, and it is revelatory."

In Praise of Shadows is like a pair of glasses that allows you to see in the dark. You put them on as you turn the scant few-dozen pages, noticing what Tanizaki noticed, taking second glances into corners and closed rooms. The blandness, in the positive Chinese sense, and slight remove of the writing allow room for complicated truths. You can both desire something and know it's not good for you, or mistake clarity for

truth when ambiguity might be more accurate. Above all, the world of shadows is against absolutes—there is no one right way of looking or being.

Lest his appreciation be mistaken for extremism of any kind, Tanizaki also admitted that modernity would march on despite the advice of a novelist, and he mocked his own anachronistic tastes. His lifestyle was never quite as perfect as he depicted it in writing. Restless to experiment with different spaces, he moved between more than thirty houses in his lifetime. His widow, Matsuko Morita, once recalled the story of an architect who consulted with Tanizaki about designing yet another new home. The architect explained that he had read *In Praise of Shadows* and so knew exactly what Tanizaki was looking for. "But no," the novelist replied. "I could never live in a house like that."

THERE WAS ONE person in particular I wanted to see while in Kyoto. "See" might be the wrong word since he's dead—but to visit, retrace, think about.

I first encountered him by chance. At some point in 2017 I realized that I had subconsciously started wearing all-gray clothing: gray jeans, t-shirts, sneakers. I bought gray collared shirts, forgetting that I already owned several that were basically the same. The uniform seemed convenient because I didn't have to choose anything and each shade went with every other, but it was also a reaction to what was happening around me. During the beginnings of the Trump presidency that year, when the shocking victory had given over to the regime's reckless enthusiasm to turn its beliefs into policy, it felt necessary to hide in some way, as any group that didn't fit the administration's image of America was targeted in turn. Gray clothing was camouflage in gray New York, which had already set itself apart from the presidency in law and rhetoric. The color's innate variations meant to me that diversity was possible even under one label.

When I described my choice of uniform a friend sent me an essay from 1930 by a Japanese philosopher whom I had never heard of, called "The Structure of *Iki*." In the essay, the philosopher Shūzō Kuki deconstructs the Japanese idea of *iki*, which is one of those

untranslatable cross-cultural terms, like the Danish *hygge* or the German *schadenfreude*. It describes an urbane, considered stylishness, not dissimilar to the French "chic," an abstract, specific ideal of cool. Kuki's essay presented another example of aesthetics as a way to live, but *iki* prioritized ambivalence and ambiguity in a way that echoed *mono no aware*, the beauty of ephemerality, and related to the situation that I found myself in. Among the things that Kuki described as having the quality of *iki* in the context of fashion were certain types of checked cloth, shades of light blue and, especially, gray. "Colors, to be *iki*, must speak to duality in a subdued manner," he wrote. A key component of the feeling is "resignation" (*akirame* in Japanese), "an attitude of disinterestedness toward fate, free from all attachments, an attitude that has its source in an awareness of fate." For this, "nothing would be more appropriate than gray." Gray, through *iki*, might reflect minimalism's union of opposites as well as its sense of escapism.

Kuki was more of a thinker than a storyteller like Tanizaki. Obscure in the West, he is known for contributing to the evolution of modern Japanese philosophy and cultural identity; he made his home later in life in the academic hotbed at Kyoto University in the 1930s. Kuki's biography followed the looseness and unboundedness that he described in his famous essay on *iki*. Along with his rigorous scholarship, he left behind diaries and poems that exposed a more human side. He was another person trying to figure out how to live without certainty or stability in the world that he was cast into, a world that was entering its own existential emergency at the time.

Being born isn't a decision; it just happens. You emerge from the darkness into whatever place and body fate has decided for you. Kuki was blessed in that regard; maybe it was a surplus of karmic credit that caused him to arrive in Tokyo on February 15, 1888, into a wealthy

family. His father was Ryuichi Kuki, a severe samurai turned baron-diplomat, and his mother, Hatsuko, a beautiful former geisha. But what might have looked like favor at first glance turned out to be more difficult. On a trip back from the United States, where Ryuichi was ambassador, Hatsuko began an affair with Kakuzo Okakura, the writer of *The Book of Tea*, that soon split the family. The young Shūzō Kuki grew up moving between houses, hanging out with the aesthete Okakura at his mother's home, until they, too, split and Hatsuko ended up in an asylum. The young man saw Okakura as his spiritual and artistic father. (Rumor had it this paternity was genetic as well.) The two studied paintings and went hunting together. Once, when they were resting at a mountainside teahouse, the old proprietress remarked that Kuki looked just like his father—Okakura only laughed.

Kuki attended the First Higher School alongside Tanizaki. He wanted to study German law, as did many Japanese aiming to work abroad, but it didn't stick; instead he fell into philosophy and literature, immersing himself in Kant and Nietzsche. At twenty-one, he entered the prestigious Tokyo Imperial University. Philosophy answered questions for him that law failed at, questions that started to plague Kuki, like why was he born in Japan instead of India, Europe, or America? Why did the facts of life seem so arbitrary? He was drawn toward uncertainty like a skier down a mountain slope. In 1911, at the age of twenty-three, he converted to Catholicism at a time when there were only eighty thousand Catholics in Japan and freedom of religion itself was only a few decades old. Kuki took the baptismal name of Franciscus Assisiensis, the ascetic, itinerant saint, anticipating his own wandering.

The religion was a self-chosen identity, setting the young man apart from his homeland. He wore Western suits with aplomb, admiring

the way the tall white shirt collars accentuated his neck, elongated face, and aggressive nose, which he felt looked more European than Asian. Kuki was a precocious patron of old Tokyo's lantern-lit pleasure districts—dark doorways and brothel teahouses beckoned. But Westernization also had its temptations. His international dreams were intensified by new American-style restaurants and movie theaters, where the usherettes brushed their kimono sleeves against aisle seats in the supercharged dark. In 1917 Kuki married Nuiko Nakahashi, his late brother's widow. It was more family duty than love; regardless, marriage didn't hold him back much. If life was so arbitrary then one may as well embrace the contradictions and the possibilities.

Maybe Kuki hoped that he would find instant acceptance in Europe when he first arrived with Nuiko in Marseille in 1922 at the age of thirty-three, nominally on government business as a Ministry of Education attaché. More than worldly success, he was there for the chance to study Western philosophy from close up, seeking answers to his persistent questions of why, why me, why here. He moved from Marseille to Heidelberg to double down on German. Then the couple decamped for Paris in 1924, where Kuki's life snapped into place and he seemed to finally find himself, or a version thereof.

While Nuiko stayed inside their rooms Kuki was out wandering at all hours. Once in a while he felt guilty, remembering his wife's loyalty. Yet the city for him seemed to exist at a deeper level of sensation, beyond the grasp of dry analysis. It was the decade of Fitzgerald and Hemingway and Stein, all the Americans losing themselves in Paris. Kuki was lost there, too. He observed the blue sky over the Arc de Triomphe, yellowing chestnut trees in the serpentine streets, tulips in the Bois de Boulogne, and pigeons in the Parc Monceau. He spent an entire autumn day in silence, just looking around, head bent down

in the rain—a Japanese flaneur in the mold of his contemporary Walter Benjamin, who was also in Paris beginning in 1926, spelunking in the shopping arcades and taking notes.

Kuki wrote short melancholic poems memorializing his glimpses of the city, which he submitted to journals back in Japan under the alias S. K., separating the poems' embarrassing sincerity from his government job, which didn't amount to much. Reading them, you can feel close to his bemusement.

The Parisians were exotic for the young man even as he was to them. He packed his schedule with operas, burlesques, dances, and dinners. There was no need to be abstemious. Unlike the painters in their garrets, he was always set for money. His family wealth flowed to endless bottles of wine, cartons of cigarettes, restaurant bills, theater tickets, new suits, and gifts for his new friends, French women. He praised the beauty of Yvonne, Denise, Louise, Henriette, Rina, and Yvette in his poems, then ranked them in a list of dates at the back of his diary.

During his travels, Kuki forms a kind of circuit connection between modernizing Eastern and Western cultures in flux. There's a place where a spark leaps from one side to the other, uniting both at least for a moment into a new syncretic whole that neither side can claim as belonging solely to them.

This leap happened in unexpected places. Le Sphinx was the first upscale brothel on the Left Bank, opened by an American madame with international mafiosi as investors. Egyptian-themed, with murals by the Dutch Fauvist painter Kees van Dongen, it was more of a bohemian club, with a "quiet atmosphere of a delicate, amiable and exquisite participation, reigned in a diffused pink light," as a local later described. (It certainly sounds reminiscent of *iki*.) Simone de Beauvoir considered Le Sphinx tacky but sincere. Henry Miller and André

Salmon frequented it. So did Kuki. He made no excuses for his escapades—in a poem, he bragged that the blood of Don Juan ran in his veins.

The difference between poetry and philosophy is that poetry creates and improvises while philosophy deconstructs, makes static. Kuki had to find space somewhere between the two. At times he got tired of his carousing and hit the dusty books, heart aching, taking refuge back in Kant and the world of "gray abstraction," as he wrote in a poem. He took classes at the Sorbonne with students much younger than he. When words like "universal" and "objective" began to swim in front of his eyes, he hit the streets again. During his European sojourn Kuki was in that graceful state of being lonely but not unhappy, besieged sometimes by homesickness, at other times by the sensation that here was where he truly belonged. Years passed. "This is a life / That misses its way," Kuki wrote. He described himself as "one who pursues an invisible shadow."

What was this "invisible shadow" that he chased? The wannabe bohemian had everything he needed. In his notebook he left behind an entire ode to the seafood restaurant Prunier, musing on its salmon roe sandwich and sea urchin. Maybe the shadow was his way of being: treading lightly, never settling for too long into a single sense of self, always looking into corners that others ignore—a minimalist existence. He was like a novelist who never wrote a novel, the protagonist of his own floating fiction. When I look at the few extant black-and-white photos of Kuki, he gives nothing away except a knowing glance and the arch hint of a *Mona Lisa* smile, a suggestion of amusement and the sense that he understood more than I ever will. Kuki was evasive; his philosophy ultimately became evasiveness itself.

Kuki focused his studies on phenomenology, the analysis of consciousness and perception, following the German philosopher

Edmund Husserl and his disciples, like Martin Heidegger. Phenomenology was also what the Minimalists later played with, focusing on perception in its own right. It aligned with Kuki's core philosophical question of "contingency," which he defined as "the possibility of becoming on the part of what is not"—going from nothing to something. Contingency might be fate or it might be nihilism: Life's arbitrariness is either meaningful or meaningless. While in Paris Kuki also took weekly French lessons from an activist and student named Jean-Paul Sartre, the future existentialist who in 1943 summed up his own thinking, influenced in a glancing way by Kuki: "Nothingness haunts being." Maybe this nothingness is the "invisible shadow" that Kuki chased, attracted to its darkness: *mu*, the universal beginning and end.

In 1927, when he was thirty-nine years old, Kuki left again for Germany, where he studied phenomenology with Husserl at the University of Freiburg. At Husserl's home, he met Heidegger and made a lasting impression on the philosopher, introducing him to some aspects of Eastern thought. Heidegger had just published *Being and Time*: "Everyone is the other, and no one is himself." He had not yet joined the burgeoning Nazi party, a decision that would permanently cast doubt on his lifetime of work.

It was when Kuki returned to Paris in the latter half of 1928 that he started work on "The Structure of *Iki*," explaining his own culture in the language of the other, Japanese aesthetics refracted through rigorous Western theory, mingling the electric Parisian street of Sartre with Tanizaki's dim Tokyo teahouses. But that December he left Europe for Japan via a detour to the United States.

Kuki's odyssey had lasted eight years. He never returned, but memories of Paris remained: He was a lanky silhouette pacing the cobblestone banks of the Seine as a clock rang two in the morning. There were ball gowns of infinite colors like the night sky blooming

into dawn. He remembered emerging onto the street out of the swirl of another dance club and being struck by a precipitous detachment. He didn't know how to belong, here or there, West or East, intoxicated by both at once. Standing on a corner, he brought an Abdulla brand cigarette to his lips, contemplating the rose petal on the tip, and exhaled in the warmth of the dark. The smoke floated in still air over the all-night café lamps and through the beams of streetlights. It dissipated during its ascent, joining the gray blanket over the city.

There is something and then nothing again. One must know one's fate and then forget about it in order to keep living.

*How **do you** find a way to live the life that you are born with and stake out a space for yourself in the tumultuous present?* The question seems to occupy every human attempt to seek out a new way of seeing the world or being in it. There's a process of reconciling the arbitrariness of chance or fate—the environment you find yourself in, whether industrializing Tokyo, upstate New York, or rural Texas—with the day-to-day, step-by-step decisions that mark the exercising of our will as we move from the people we are now to the people we are becoming, like walking unsteadily along a balance beam.

One act of will is to erase everything that's already around you, washing it clean white and starting over again so that the only things left are those that you choose, which is the standard practice of minimalism. This is a simple way to build a sense of self: You are what you include. An object, person, or idea is either in or out of your worldview. But favoring control leaves no room for surprises. A more difficult, perhaps more deeply satisfying method is to embrace contingency and randomness, accepting that life is a compromise between what exists and what you want, and beauty is found not by imposition but through an absence of control. You capitulate to particular moments as they pass.

This was also what Shūzō Kuki pursued in Paris. He followed the trail of his sensibility through the universities, restaurants, and dance

clubs until he arrived back at himself, realizing that what defined his philosophy was that Japanese ideal of *iki*. The nostalgic Kuki traced *iki* back to eighteenth-century Tokyo. It was a city dweller's blasé: at turns flirtatious and melancholic; passionate yet noncommittal; easy come, easy go. Like Tanizaki and his "world of shadows," Kuki felt that *iki* was being lost amid Japan's modernization and took it upon himself to recapture it.

In 1929 he moved to Kyoto to become a lecturer at Kyoto Imperial University, following the recommendation of his mentor Kitarō Nishida, a professor already at work synthesizing Japanese and Western thought through a phenomenological approach. Nishida would later be seen as the most prominent Japanese philosopher of the twentieth century—the leader of the Kyoto School. Kuki and Nishida often took walks together along a canal in northeast Kyoto, where the density of the city fades into lush hills. It's now named the Philosopher's Walk because of Nishida's daily meditative strolls there.

I went to wander it one bright afternoon. The canal appeared suddenly out of a jumble of blocks of low houses and a few convenience stores. The stone blocks of its banks angle steeply down to a shallow stream where shoals of fish here and there float still in the passing current. Later in the spring the canal would be canopied by hundreds of cherry trees in rosy bloom, but in the winter the trees were skeletal, thin dark slashes against the blue sky. Tourists like me passed by on the way to scattered temples, but it was otherwise quiet, a perfect spot for contemplating life's ephemerality.

Kuki published "The Structure of *Iki*" in 1930, when he was forty-two. In its fifty pages he attempted to dissect a fleeting thing, literally diagramming *iki*, pinning it down like a rare butterfly. Kuki tried to put into universal language something that was incredibly personal to him.

The paradox is part of the essay's charm. His writing remains elegant but in reading it you can feel the urge to communicate almost beyond the reach of words in a series of sentences that evoke more than define. *Iki*'s existence "depends on maintaining possibility as a possibility," he wrote. "*Iki* lives in the future, holding the past in its arms... *Iki* shelters a dark negation concealed within its sensual affirmation." With all the poetic abstraction, you'd think he wasn't just writing about philosophy.

Maybe it was about sex. Kuki wrote that true *iki* is contained in the coquettish and unconsummated, coming "as near as possible, and at the same time making certain that nearness stops short of actual touch." It's suffused with a certain longing, the desire for something unreachable, like absence itself, that always withdraws from direct view.

Kuki reels off examples of *iki* expressed in the world, summoning it on the page. Thin, sheer fabric is *iki*; so is a woman just after bathing; slight smiles; willow trees and slow, steady rain; a cultivated urbanity; informal hairstyles; a beckoning hand that is bent slightly; vertical stripes (as opposed to horizontal); bare feet, especially in winter, implying a hint of self-sacrifice; subdued lighting from paper lanterns; the dance of attraction and distance, pleasure and pain, between lovers. *Iki* is positional, dependent on dynamic relationships and the union of opposites, dwelling in ambiguous spaces without closing down avenues of meaning: "a trace of seductive and ingenuous tears behind a charming lighthearted smile."

Despite his worldliness, Kuki believed that *iki* could only be understood by the Japanese. He fervently argued that it was core to "the being of our people," who must "remain steadfast, true to the passionate eros of our idealistic and unrealistic culture"—against Westernization,

stretching back to the somewhat absurd Heian courtliness a millennium before. But here I want to go against Kuki's argument. *Iki* is another facet of the longing for less that's shared widely across places and eras. Kuki's essay came more than a century after the poet John Keats's 1817 description of what he called "negative capability," which bears some relation to *iki*'s eternal irresolution and minimalism's hope for direct sensory experience, without judgment. It's a state in which "man is capable of being in uncertainties, Mysteries, doubts, without any irritable reaching after fact & reason," Keats wrote. "The sense of Beauty overcomes every other consideration, or rather obliterates all consideration."

Kuki described one version, but we all have examples of things that trigger a sense of the world passing by or a tenuous, voluptuous existence between states. Imagine what gives you a sense of ambivalent beauty, a pleasure inseparable from a hint of danger or unbridgeable distance. My personal list might include the low hum of a bow drawn across cello strings, which always somehow reminds me of the hands moving on a clockface; the sallow, aged colors of certain mid-century American abstract paintings; the period of leaves changing colors in New England, where I grew up, when the red has turned to rich yellow but some leaves are already desiccated in the onset of cold; and the feeling of submerging in a body of water to swim, floating between the warm air and liquid darkness. And, of course, the varying shades of gray-on-gray that I took to wearing.

Are these things, in fact, *iki*? Maybe not, but I can still keep them as part of my own code and adopt the idea into a personal minimalism. *Iki* is important because it provides a space of reconciliation. Its sense of beauty is not about decluttering or cleanliness, absence as a vacuum driven to create more pressurized emptiness, but instead about arriving

at a resting point, an acceptance of uncertainty. It's dangerous to assume any such value belongs to one people or is limited to a single orthodox definition. Such a restriction negates the very qualities of openness, ephemerality, and tension that define *iki*.

Kuki was promoted to associate professor at Kyoto Imperial University, lecturing on European philosophy and literature. Instead of Paris or Tokyo he had Kyoto's Gion, praised again in his poems, with its intimate architecture and obscured wooden facades lit by rice paper lanterns that beckoned him inside sake bars and geisha houses. Today the Gion alleys are still dotted at sunset with dressed-up geisha and *maiko*, Kyoto geisha-in-training, making their way to appointments, but most of the people dressed in kimonos and sandals are tourists renting outfits and role-playing in the nostalgic surroundings, taking copious selfies—probably not the kind of revival Kuki was hoping for.

The cosmopolitan Europe Kuki dreamed of grew more violent as he hid in his books and worked on essays. In 1936, a Jewish student of Husserl and Heidegger named Karl Löwith wrote Kuki a letter requesting a position in Japan in order to escape Nazi Germany; he found Löwith a temporary post at Tohoku University. Under nationalist ideas of racial superiority, Japan invaded Chinese Manchuria and installed a puppet government. In 1937 the Japanese military perpetrated the Nanjing Massacre, which resulted in the hundreds of thousands of Chinese dead; two years later Kuki still played his role as a public intellectual and toured the area.

Ambiguity only goes so far in the face of such absolutes. Violent nationalism, after all, makes use of the same connection between aesthetics and ethnicity that Okakura proposed and Kuki drew out in "The Structure of *Iki*": One people must preserve one orthodox way of

being in the world that excludes all others for the sake of purity. Art—or taste—becoming politics is disastrous. "The logical outcome of fascism is an aestheticizing of political life," Walter Benjamin, a German Jew, wrote in 1936. "All efforts to aestheticize politics culminate in one point. That one point is war." Benjamin was still in Paris at the time but soon fled to Spain and committed suicide in preemptive fear of being captured and handed over to the Nazis.

In 1940 Japan allied with Hitler, and the Nazis occupied Kuki's beloved Paris. Despite his desire for "possibility as a possibility," he never took a public stand against what was happening, save his favor to Löwith. Kuki's inaction and brief association with Heidegger has tainted his scholarship in academic eyes ever since, though it's tempting to think he was just too bemused to notice, trying to preserve something beautiful from the past for the future. But it's true, too, that the minimalist attitude is susceptible to corruption. The desire that everything be just right, matched with everything else around it in a unified whole, leads easily to intolerance.

Regardless, Kuki was not able to work much longer. In spring of 1941, struck with stomach pain and tides of nausea, he was hospitalized for peritonitis, an infection of the tissue covering the abdominal organs. On April 29, he wrote a poem to a friend thanking him for a sickbed gift of potted azaleas. Kuki observed the flowers at their peak, "Dimly blooming / A thin red," both living and decaying. On May 6, still in the hospital, he died at the age of fifty-three.

Kuki's gravestone is in a cemetery along a pathway from Honen-in temple in Kyoto, established in 1680, off the middle of the Philosopher's Walk. Swaddled in trees just at the edge of the city before the forested hills take over, Honen-in is one of Kyoto's less-famous temples. I walked alone in silence through the high moss-covered wooden gate, which frames a geometric slice of the trees like

a camera lens, feeling like I was a character in a *Legend of Zelda* video game on the lookout for monsters. When I climbed the stone stairs from the path mine was the only presence breaking the cemetery's misty stillness.

I first spotted Junichirō Tanizaki's monument in a prominent place at the top of the hillside. The novelist died in 1965 when he was seventy-nine, fully aware of his fame and able to shape his legacy to the point that he designed his gravestones—two of them. A pair of organic-looking rocks emerged from the grass, each carved with a single character, "tranquility," on the left, and on the right, "family." Someone had placed a can of plum wine and a white sake cup against one stone, which I thought the gregarious Tanizaki would have appreciated; it matched the slightly florid quality of his memorial, affected in its naturalness.

I couldn't find any English-language information online or off about where Kuki might be. He had none of Tanizaki's celebrity, but then he didn't seem to want it. Again he was hidden. The weather was getting colder as the afternoon withdrew. In the distance a gong sounded from Honen-in, signaling the temple gate was closing for the night. The cemetery was crowded with hundreds of gravestones on several terraces, but I stayed toward the older section hoping to catch a glimpse of his name. (Kuki was always amused that his family name had the same characters as "nine devils." The image felt more sinister given the hillside's general gloom.) The endeavor was pointless, I suddenly thought; it would be better to let him be. To chase too hard would contradict Kuki's ethos.

But after pacing down to the second row from the back, around the middle of the upper terrace, I ran into the grave by surprise, a severe stack of mottled gray-and-pink rectangular blocks like most of the others in the cemetery. The only thing that set it apart was the vertical

calligraphy of his name, forceful and energetic, contrasting the stolid stone. Running down the side was a carved scrawl of handwriting: Nishida had translated and calligraphed a poem by Goethe, one last elision of East and West, for Kuki's epitaph. The chosen lines from "Wanderer's Nightsong" reflect in one haiku-like image the placid nothingness that everything emerges from and returns to:

> Mountaintops appear in the distance
> No wind makes the treetops sway, no bird sings
> Wait a moment; in the end, you too will be resting

I stood in front of the grave for a long time while the sun came and went, illuminating the surface of the stone and then leaving it in shade. I felt a kind of vertigo, like the ground was tipping at an angle and I might fall off or fall through to the other side of the Earth, back home. In that moment Kuki's life became real for me in a way that it hadn't been before, despite my trip through all his poems, diaries, and difficult essays. Those had been words printed in books; here was the last vestige of the actual person, and his inevitable end that the grave represented.

I found myself speaking aloud, almost without thinking. What I said into the air was something like this: I admired the work that Kuki had left behind. I admired his commitment to beauty, where he found it, whether in the structures of philosophy or the humble swatch of fabric on the limb of someone beloved, a material more romantic for being mundane and at the edge of notice. Time wears away at all these man-made symbols until their roots are exposed and it becomes clear that they are the same—emanations of a fundamental spirit, no matter highbrow or low, abstract or literal. Kuki collected a particular feeling,

minor yet precious, and pressed it between pages like a spring flower so that I could access it almost a century later and feel moved by it. By chance it had reached me as it would reach future readers, translated into other languages, analyzed, imprinted in our collective cultural heritage, belonging to no one in particular but available to anyone who looked for it. The transmission may never be perfect but such beauty can only be found within incompleteness, the gaps that remain.

I wondered if I would ever return to that cemetery in Kyoto and how different the world might be the next time, except for that one stone marker like an axis around which everything spins. When I left, the tears running down my face turned sharp in the cold.

HISTORY KEEPS MOVING, driven by conflict: "One wave throughout the world, one wave since Troy rolls its haunch towards us," wrote the French diplomat and poet Alexis Leger, who spent five years in China in the 1910s. (The line has stuck with me thanks to another existential artist, the German Anselm Kiefer, who referenced it in the name of a sculpture.) Japan's ultranationalist government plowed into World War II using the ideas of philosophers like Shūzō Kuki and Kitarō Nishida as a justification for violence on a massive scale. The Kyoto School's work to taxonomize the uniqueness of Japanese identity gave cover to the militaristic doctrine that Japan must become the central power of Asia and defend its "idealistic and unrealistic culture," as Kuki put it, by force.

Existential minimalism was a way of reacting to the anxiety of Western influence and Japan's vulnerability. Attempts at philosophical unification like Kuki's meant little in the face of World War II and its aftermath. In 1942 some of Nishida's pupils participated in a seminal symposium called the "Conference for the Reintegration of Culture: Overcoming Modernity." The aggressive title encompassed its goal: The philosophers sought an alternative to the West's imperialist, industrialized ideology. But in its sense of manifest destiny, Japan became imperialist itself, invading neighboring nations and imposing its will over the Asian geopolitical sphere. Nishida didn't participate in the wave of

nationalism directly, yet some of his statements are unmistakably supportive: "[Japan's] Imperial House is the beginning and the end of the world, as the absolute present that embraces the past and the future." Zen's universal nothingness was warped into an apocalyptic cult. In August of 1945, four years after Kuki's death, the United States dropped two nuclear bombs, and in September Japan surrendered (Kyoto escaped the devastation because Secretary of War Henry Stimson, who had visited the city, argued for its cultural importance). As part of the nation's reconstruction, the United States military worked to dismantle the spirit of exceptionalism. On January 1, 1946, came the Humanity Declaration, when Emperor Hirohito disavowed his divinity and became just another person.

Death is what makes art meaningful, according to the Kyoto School philosopher Keiji Nishitani. Nishitani was a younger disciple of Nishida and fell on the side of hypernationalism. Like Kuki he had traveled abroad to study, working under Martin Heidegger in the 1930s, and in the "Overcoming Modernity" symposium he praised Japan's "moral energy" (a euphemism for military violence). After the war, Nishitani was banned from taking public office and he eventually retreated from ground-level politics, confining his work to the abstractions of religion and art, which he felt had more potential to be truly universal.

In 1953 Nishitani wrote an essay on ikebana, the Japanese art of flower arranging. The arranger selects a very few seasonal blooms or branches, cuts them, and places them in a handmade ceramic vase or bowl so that the plants extend upward and outward like energetic strokes of calligraphy, framed within the blank space of the tokonoma, like the one in my inn room. Intentionally austere and reticent, ikebana is the opposite of the effusive Western bouquet's profusion of contrasting colors.

In his essay Nishitani linked ikebana to Europe's postwar wave of popular existentialism, championed by Jean-Paul Sartre, Kuki's French teacher. Existentialism put existence before essence, championing the individual's ability to create herself through action and experience instead of slotting in to predetermined social roles. "Man first of all exists, encounters himself, surges up in the world—and defines himself afterwards," Sartre wrote. To do is to be. Nishitani thought this also aligned with ikebana's ephemerality: "The essential beauty lies precisely in its being transitory and timely."

In the midst of existence, most living things deny time. They grow and reproduce in order to fight the inevitable. Life strives to be permanent, though it cannot be. Even the slow natural decay of a flower in the ground is a consequence of this struggle to survive as long as possible. When the ikebana practitioner cuts the flower at its stem, she stops this process, freezing it in a moment in which there is "no arising or perishing," Nishitani wrote, at least for three or four days within the vase. The flower is "poised in death…It becomes a temporary manifestation of eternity that has emerged in time." The philosopher argued that this ephemeral timelessness amounts to a kind of transcendence. Only by cutting can the plant be transformed into art: "The flowers are simply there, in their correctness"—defining themselves alone, moment to moment.

There are two forms of art, according to Nishitani. The Western form strives toward permanence, as in the stone cathedral built to last thousands of years or the royal portrait commissioned to communicate ostentatious wealth and power to future generations. Yet in trying to deny its inherent temporariness, this form ends up becoming artificial or inauthentic. The cathedral crumbles into ruins and the portrait tatters; in the end, Nishitani claimed, these monuments can only prove

the impossibility of achieving permanence. The Japanese form of art accesses eternity by embracing time. "Instead of trying to deny time while in the midst of it, ikebana moves along in time without the slightest gap," Nishitani wrote. In 2017 there was a wave of interest in ikebana from magazines like *T* and *New York*. The flower arrangements popped up in hotels and Blue Bottle coffee shops, becoming an element of the overall minimalist decorating scheme, perhaps pursuing this brief sense of timelessness.

Instead of assigning the value of temporariness only to the Japanese, as Kuki did with *iki*, Nishitani observed how it is shared across cultures, particularly after industrialization. "This idea which had lain dormant for so long is gradually grasping the hearts and minds of Europeans," he wrote. He found ikebana's aesthetic of ephemerality in the essays of Montaigne and Nietzsche and the poems of Rainer Maria Rilke, as well as in the existentialists. He would have found it later in Minimalist visual art and music, too. In the 1950s, after the cataclysm of the war, maybe the concepts of permanence and accumulation had been finally bankrupted. The bombing campaigns on all sides demonstrated that humanity would willingly destroy anything it built. There was an international turn toward Japan's negative aesthetic, an appreciation of absence and disappearance because absence was so prevalent in the ruined buildings and shattered lives.

Nishitani wrote that each flower in ikebana appears as if it emerged from nothingness. Nothingness undergirded everything—humans, animals, objects all brought together by one long shadow that rests "in the depths of existence." The shadow of nothingness combines being and nonbeing, collapsing the binary between them. It is space in which all possibilities are simultaneous and "points directly to a most intimate encounter with everything that exists," Nishitani wrote in 1961. "A

most intimate encounter with everything that exists" is also a good way to describe Minimalism circa 1964, with its aim for objects that are complete within themselves. Donald Judd's Marfa boxes are like so many ikebana flowers, timeless and yet experienced within time.

The desire to find the essence of things, to confront existence unmediated, made sense for the postwar desolation. The wreckage was beyond morality, beyond winning or losing sides. Western writers sought out the nonbinary space of absence, too. Shadow was a convenient metaphor—as Tanizaki noticed in *In Praise of Shadows*, it represented everything that Western progress plowed over or ignored. "Speaks true, who speaks shadows," wrote the Romanian poet Paul Celan, whose poems took on the impossibility of expression in the wake of the Holocaust. Within the futility of existence one still had to find a way forward, as in Samuel Beckett's existentialist 1953 novel *Watt*, which he wrote while on the run during the war: "For what is this shadow of the going in which we come, this shadow of the coming in which we go, this shadow of the coming and the going in which we wait, if not the shadow of purpose?"

"I thought the most beautiful thing in the world must be shadow," Sylvia Plath wrote in her 1963 novel *The Bell Jar*. The narrator gives a litany of "the million moving shapes and cul-de-sacs of shadow" that creep under everything, like Nishitani's nothingness. "There was shadow in bureau drawers and closets and suitcases, and shadow under houses and trees and stones, and shadow at the back of people's eyes and smiles, and shadow, miles and miles and miles of it, on the night side of the earth."

There's a darkness and danger to the idea of absence in this list and for these writers, as well as for figures like Shūzō Kuki or Julius Eastman, that's totally missing from the bland facade of popular

minimalism today. It's not about consuming the right things or throwing out the wrong; it's about challenging your deepest beliefs in an attempt to engage with things as they are, to not shy away from reality or its lack of answers. To believe or commit too strongly to one particular way of seeing or being is to miss out on all the other possibilities and to allow yourself to be defined too much by one thing. I thought back to Sonrisa Andersen, who had used minimalist self-help to solve her own consumerist identity crisis, but then left that behind, too, when she found she no longer needed it. It seemed like the most minimalist response possible.

After the war a new wave of foreign artists began visiting Japan. Among them were members of the Beat movement, who were already exposed to Japanese culture from living in San Francisco. Kenneth Rexroth, one of the predecessors of the Beats, set about translating Chinese and Japanese poetry. In the '70s he rented an ancient Kyoto farmhouse with a tea room—"Kyoto was unbombed & full of temples etc and old houses," as he described in a letter to the poet Morgan Gibson. Gary Snyder, known as the Thoreau of the Beats, made an intense study of Zen and in 1956 traveled to Kyoto to join a temple. A 1958 volume of the *Chicago Review* (covered with an ink-wash painting of a single tree branch) focused solely on Zen, with essays from Snyder, Jack Kerouac, and Alan Watts. Allen Ginsberg had a life-changing epiphany on the high-speed train between Tokyo and Kyoto in 1963 so strong that it made him abstain from drugs in favor of meditation.

Zen provided an alternative to America's postwar drive into suburbanization, consumerism, and the nuclear family—the seemingly solid pillars that identity and success were supposed to be built on, which also feel less dependable than ever today. By 1979 Rexroth described

the U.S. as a "bankrupt police state" and wrote that he couldn't imagine anyone going back there who had moved to Japan. (Though in other letters he also complained about Japanese conservatism.) Was the adoption of Zen cultural appropriation—the theft of a heritage that didn't belong to Americans? If so, minimalism could fall under the same critique. The answer is more complicated. Though its roots were in ancient history, the Japanese aesthetic of absence grew over the course of the twentieth century not in a vacuum but as a response to Western imperialism and the expansionary, globalizing pressures of capitalism and industrialization. In reaction to the general alienation and the extreme changes that were happening, it showed an alternative, the possibility of a life built on the careful appreciation of life's minor details and ephemerality over permanence.

No wonder that in the twenty-first century, when so many feel modernity has failed the West—that our civilization has come close to destroying itself and our lifestyles appear gaudy and pointless—absence is appealing once more. Embracing it reflects the need for a new way of thinking as well as consuming, one that makes a virtue of incompleteness and irresolution.

Minimalism is a communal invention and the blank slate that it offers an illusion, especially given its history. It is popular around the world, I think, because it reacts against a condition that is now everywhere: a state of social crisis mixed with a terminal dissatisfaction with the material culture around us that seems to have delivered us to this point, though the fault is our own. When I see the austere kitchens and bare shelves and elegant cement walls, the dim vague colors and the skeletal furniture, the monochrome devices, the white t-shirts, the empty walls, the wide-open windows looking out onto nothing in particular—when I see minimalism as a meme on Instagram, as a

self-help book commandment, and as an encouragement to get rid of as much as possible in the name of imminently buying more—I see both an anxiety of nothingness and a desire to capitulate to it, like the French phrase for the subconscious flash of desire to jump off a ledge, *l'appel du vide*, the call of the void.

The popular minimalist aesthetic is more a symptom of that anxiety, having less as a way of feeling a little more stable in precarious times, than a solution to it. The art, music, architecture, and philosophy that I've described, however, isn't concerned with perfect cleanliness or a specific style. It's about seeking unmediated experiences, giving up control instead of imposing it, paying attention to what's around you without barricading yourself, and accepting ambiguity, understanding that opposites can be part of the same whole. This deeper form of minimalism can't be reduced to a hashtag or sold on a t-shirt. It offers no answers, let alone step-by-step guides, and it comes with risks. But it suggests another way of living that we can carry on into the future beyond the length of a trend.

THOUGH I WAS supposed to return to Tokyo before my flight home, I decided to stay longer in Kyoto. The bullet train could get me back to Tokyo and then the express train to the airport in one early morning more dependably than I could usually count on getting from Brooklyn to JFK. I didn't need any more skyscrapers blaring neon or ten-story department stores selling only stationery. I had exhausted any desire for mass-market Uniqlo minimalism. Besides, a new hotel designed entirely by Muji wasn't taking reservations yet.

Kyoto's human scale was more appealing. I wanted to stay in my quiet, comfortably dim room at the inn and have green tea and rice crackers with Rico. Despite crosshatching the city on bus and foot along highways and up mountains on a Pokémon-esque quest to catch the personality of each different temple in the city, there were also a few I had missed and still wanted to see.

The most recognizable icon of Japanese minimalism to Western eyes is the rock garden. Properly called a "dry-landscape" garden, the expanse of gravel embedded with a few larger standing rocks and patches of moss at first seems emblematic of everything minimalism stands for. Things that are expected are absent: No grass, trees, or bright flowers intrude on the zone of the garden, which isn't meant to be walked through except by monks who rake the gravel daily as meditative exercise. The visual field that the garden creates is flat and

monochrome. From a distance the fine-grained texture makes it appear even more blank than an empty wall, like a white-gray hole in the world. At first glance, the rock garden looks breathtakingly abstract—without any references to natural forms—as if it had ejected every fallible thing and become immaculate, accomplishing the dream of a perfectly controlled space.

Rico had told me that her favorite rock garden was the one at the temple closest to the inn, Kennin-ji. I went one morning when it was raining and the streets were quiet, less choked with tourists. The largest temple rock gardens are usually installed in front of a veranda jutting from the *hojo*, the abbott's residence. Beyond pleasant decoration, they are tools for meditation and sacred symbols with roots in Shintoism, which also venerates individual stones. At Kennin-ji, the veranda is surrounded on three sides by gravel as if it were a dock jutting into water. Rain came down in a steady curtain, dripping from the curved wooden eaves, sinking into the field of gravel like it was falling into the ocean, returning to where it came from. Long waving lines in the gravel, equally spaced and made by a single rake, receded into the distance. The scene struck me like a sedative—here, an end had been reached. There was nothing more that could complete the stones and the rain.

In the 1957 fourth issue of *Evergreen Review*, Grove Press's countercultural magazine, an artist named Will Petersen wrote an essay called "Stone Garden," analyzing the garden at Kyoto's Ryoan-ji, now perhaps the single most famous in the world, and explaining its appearance to American readers. (Philip Johnson later made a pilgrimage to Ryoan-ji and John Cage created musical compositions based on its layout.) Petersen was introduced to Asia after he was drafted into the U.S. Army, sent first to Korea and then to Japan, where he fell in love with calligraphy and Noh theater. He knew that he wasn't the first to

discover Japanese aesthetics. Art Nouveau had already taken inspiration from Japan's curvilinear decoration and Postimpressionism the colors and lines of its woodblock prints. "Each age sees what it is prepared to discover," he wrote in an apt summary of aesthetic theory that applies to minimalism as well. In the postwar mid-century, what he took away was the starkness of the rock gardens: "For us, Japanese art means simplicity, black and white."

I visited the site on a sunny afternoon. Ryoan-ji is famous because its sixteenth-century rock garden is so simple, reduced to the very essentials of an essential form. Its classical nickname is the "Garden of Emptiness," *mutei*—the same *mu* that the philosophers used. Fifteen stones are arranged asymmetrically across a rectangular field of linear raked gravel twenty-five meters long by ten meters wide. The stones are neither remarkable nor mundane. They're positioned in several clutches of odd numbers. Smaller stones, some only just emerging from the gravel like low islands, surround larger stones with carpets of moss. There's no one focal point but a kind of visual hum across the field that holds the stretches of emptiness and moments of presence in balanced tension. The stones are all pushed back from the edge of the veranda, leaving a patch of uninterrupted gravel in front of them and making them appear even more distant, like the visitor is looking out from a beach over a coastal horizon and seeing islands in the distance. Yet this metaphorically massive landscape is contained within the space of the temple's modest clay walls.

Ryoan-ji's other perceptual trick is that no matter where a visitor stands on the veranda only fourteen of the fifteen stones are visible at any one time, because they block or occlude one another as you move. Petersen described it as a "visual koan." The only way to see them all at once would be to float above the garden or stand up higher than any Japanese monk from centuries past would have been able to.

"Emptiness, expressed as vacant space in visual art, silence in music, time and spatial ellipses in poetry or literature, or non-movement in dance, requires aesthetic form for its creation and comprehension," Petersen wrote. "Form is arranged in vacant space in such a way that we perceive emptiness as form, and form as emptiness" (echoing the Heart Sutra). In other words, the garden shows that absence and presence are inextricable from each other, intermingling in the same way that life is contiguous with death.

Yet the initial impression of simplicity, of a blank void, that rock gardens give is not quite right because it's anachronistically modern, as the scholar Alan Weiss has written. The rock garden emerged in Japan in the eighth century, when there was no inkling of minimalism as we know it today. In fact rather than pure abstract form there's a careful symbolism to the stones. They refer outward to the world and back through history. The raked gravel is a substitute for the water features of ancient Chinese gardens, from which Japan's evolved. The ridges of the raked lines suggest shifting currents and waves without the need for actual plumbing.

Some stones are supposed to be mountains, mythical mountains of Buddhism or specific geographical landmarks. Others represent waterfalls because they're tall and have mineral strips running down their faces. Some sets suggest the heads of a tiger and her cubs navigating a river. Another famous stone in Kyoto is a boat floating down a stream of gravel, so chosen because it looks—literally—like a boat. The important thing is that the meaning of the rock garden isn't fixed. It isn't confined to just transcendent emptiness or the three-dimensional equivalent of a landscape painting; it can be both at once, shifting between absence and presence. The Heian period's *Sakuteiki*, or *Book of Gardening*, instructed that designers must lay out their compositions only "according to the will or desire of stones."

The rock garden is both less and more profound than it seems. It does not offer a solution to the chaos of the world via cleanliness and control, nor is it the end point of some non-Western cultural track. Instead, it's a tool for awareness, a destabilizing provocation that everything is not as it seems, that what you see is not always what you get. It is minimalism as a continuous challenge.

On the afternoon I was there, the veranda was crowded with schoolchildren who counted the stones aloud in Japanese and Chinese, stopping with a gasp at fourteen because they couldn't find the last one, though they knew it was there. Apprehending the whole requires a process of movement, taking note of the spaces between the stones as much as the stones themselves. What you see depends on your perspective. Looking at the garden, you are three figures at once: yourself, sitting on the deck in human-scale surroundings, a tiny wanderer exploring the crags and wrinkles at the focal point of your gaze, and an omniscient viewer looking over the vista of an entire vast world. This act of perception is what is beautiful, the fact that we are capable of experiencing what is in front of us at so many different levels. As Donald Judd wrote in his Marfa diary, "It simply exists."

Older rock gardens are mysterious. Their designers are often anonymous or otherwise unknown to us, so they lack a sense of individual authorship. In the sixteenth century the stones were installed by laborers in a caste at the bottom of the social hierarchy, so only monks and nobles got credit. Some gardens have also shifted from their original layouts, thanks to the erosions of time or disasters natural and human—Ryoan-ji endured at least one fire and reconstruction in the eighteenth century, making it hard to refer to any pure original, the way we might look at the Mona Lisa. The plants bloom and fade, the walls change color, the stones weather; it both changes and remains the same.

Despite the site's iconic status, I never felt a ceremonial air around Ryoan-ji. Lest you think the trick of the layout, the impossibility of seeing all fifteen stones, is meant to inspire a sudden ineffable miracle, there's a scale model of the garden in the temple near the gift shop. You can see where each stone rests, touch them, and rake the sand yourself if you'd like. Visitors are invited to consume the garden as a landmark. It wants to be mundane.

Even though it was winter the veranda was packed and loud, making it even more of a spectacle than a space for contemplation. Group tours came through with lecturers explaining the site's history. Visitors waved their smartphones around to get the best shot and took selfies with the stones in the background. Better-equipped photographers crouched in one corner with tripods and elaborate lenses extended toward the gravel, even though the garden steadfastly refused to be contained in a single image. Despite the bustle the guard on duty was paying close enough attention to tell me to stop sketching the stones in my notebook, which apparently wasn't allowed—only photographs. Maybe because there are official paintings available for purchase at the counter, cash only.

This all could have felt annoying and inauthentic, the contamination of what was supposed to be an experience of some kind of sacred emptiness, perfect minimalism. But in that moment, what I saw was dramatic simplicity side by side with unruly life. There was a peacefulness to the garden, as if it had accepted every one of its visitors' interpretations and was content simply to persist. I felt a kind of joy at how the aesthetics of absence could be found at the heart of life's drama rather than separated from it, raucous instead of quiet, warm instead of cold, with nary a white wall in sight. The stones looked as if they would be there forever as a reminder.

Afterword: Looking Again

The Longing for Less came out in mid-January of 2020. It was a new decade and a climactic American election loomed, but at the time of publication the date didn't mean anything in particular. We didn't yet know what that year's biggest story would be. We didn't know that the world would suddenly feel so small and humanity so fragile, falling under the grip of a single virus. Just after my book tour ended and I landed back home in Washington, D.C., everything shut down. Streets were silent in the weeks when it still felt frightening to merely step outside. After many years treating apartments as not much more than convenient sleeping quarters, I was stuck inside, surrounded by my physical possessions.

It felt darkly ironic: this book is about the attitude that possessions don't matter as much as experiences and perceptions. Followers of the minimalist lifestyle felt that consumerism had become excessive, a distraction from happiness rather than a path to it. Under the influence of Marie Kondo, they divested themselves of excess *stuff*—that curse word—to live lighter and freer lives. But in that spring's pandemic lockdown, stuff was all we had. Quarantine kicked off a manic shopping spree that formed a bizarre parallel to the fear of sickness. Even the most devout minimalists had a reason to fill their homes up again. I found myself buying a TV of my own for the first time in my life and

celebrating when I managed to land a pull-up bar from Amazon—a hot commodity, since gyms were closed. For years, so many digital start-ups in the "sharing economy" had promised that you could have access to things you didn't own; those claims were quickly dismantled as sharing itself seemed dangerous. It became harder to live with less.

For a time, at least, the pandemic overhauled our material priorities. Consumerist urges were slaked with upscale takeout meals and luxury sweatpants. Meanwhile, the immaterial satisfactions of social life could only be found online. Yet oversaturation in the virtual world drove me and many others out into physical space, in whatever way we could safely use it. I was all but forced to appreciate the environment around me. I got to know every square foot of my neighborhood parks and had time to take up drawing again by rendering those local landscapes. Minimalist artists like Agnes Martin and Donald Judd would have approved: when you look at the mundane or seemingly uninteresting in a new way, you can always find something beautiful. Architecture and urbanism came alive for me. Before, I was never much interested in gardening, but then watching spring flowers unfurl in pots on our small balcony became fascinating. I tracked the blooms on our hibiscus tree. I marveled at the way the park lawn filled with picnic blankets like a sprawling patchwork quilt, as small, scattered groups, careful to stay apart, drank wine together. The scene hummed like a busy street would have. Every dynamic thing felt like a miracle.

John Cage taught me something for that time, too: to listen and perceive every sound around me as meaningful, worthy of attention. If I hadn't, the constant absence of stimulus might have felt like being immersed in a sensory deprivation tank every day. In D.C., the initial silence, filled with the suddenly loud chirping of birds, gave way to ambulance sirens and then constant helicopter drones during the tide

of Black Lives Matter protests and Trumpian political unrest around the Capitol. If the debut of *4'33"* was about paying attention to the sounds of nature in upstate New York, the pandemic version suggested that all sound is political. The auditory landscape was as pointed as a conceptual art installation: nothingness interrupted by intensity.

Perhaps writing this book prepared me to concentrate so much on my own senses. That was the outcome I wanted for the reader, too: seeing the world slightly differently, through a new lens. Each thinker and artist in the book offers their own visionary interpretation of reality. The element of artistic minimalism that I have come to appreciate most is its openness. Its philosophy doesn't tell you *what* to see or which conclusions to come to. It only offers a *way* to see. That is why the popular orthodox minimalist style of empty rooms, white walls, and angular furniture is so stultifying. It doesn't lead to new experience; it builds a buffer keeping out sensations.

Over the past few years, sped along by quarantine, that buffering has become less appealing. Since we couldn't have randomness and chaos and surprise, we craved more of it. The minimalist obsession of the mid to late 2010s—with all those generic Everlane outfits, monochrome sneakers, and abstract Instagram color blobs—has lately turned toward maximalism. Clashing colors, patterns, and textures are more desirable. The collage aesthetic is more popular than minimalism's austere uniformity. Excess is cool, insofar as it can be found or afforded. From an era of Soylent meal-replacement products we entered a postpandemic fad for martinis, steak, and french fries. White-walled postindustrial restaurant interiors were out, in favor of traditional clubby rooms of leather banquettes and vintage art. When scarcity is a voluntary aesthetic choice it can feel fresh and interesting; when it is forced, of course, it's no fun.

Cultural fashions change, and they will keep changing. No aesthetic is forever more correct or in better taste than another. While writing *The Longing for Less* I imagined a pendulum swinging between less and more, austerity and excess. What I find most fascinating is the persistence of these two inextricable values. The appeal of a stripped-down nineteenth-century Shaker chair does not render obsolete the frescoes of sumptuous feasts adorning a classical Roman villa. What remains is the importance of understanding your own preferences, cultivating an awareness of what is in front of you and how it got there.

In retrospect, the minimalist wave may have been a function of the millennial generation's coming of age, alongside the rise of all-encompassing digital platforms like Facebook, Instagram, and TikTok during the 2010s. Generic minimalist style provided a kind of code of conduct just at the moment when millennials aging into their midtwenties and early thirties (and escaping the aftermath of the Great Recession) needed a way to fit into the adult world of commuting to office jobs and furnishing leased city apartments. Buy the right chair, the right lamp, the right cashmere sweater, and you'll only ever need one of them—useful for staying within young adult budgets. The ambient judgment of Instagram likes will affirm your tastefulness. In that context, minimalist design wasn't a route to personal taste so much as a defense mechanism, a bland bulwark against instability.

At its worst and most misunderstood, minimalism breeds conformity. Minimalist art is not meant to look the same everywhere. None of its early practitioners were so prescriptive; everyone in this book is a seeker of their own way of living. It is their specificity that sticks with me: Julius Eastman's persistence in his radical art and life; Kuki Shuzo's resignation to the beauty of ephemerality; Cage's ever-restless creativity and willingness to jettison any marker of tradition. The deepest principle of

minimalism may be that we have to shed our preconceptions, question our tastes, and look again at the overlooked. We have to work to understand what we see as beautiful. That labor is a way of drawing closer to the world, not cocooning yourself. Writing is a way of doing that, too: focusing to excess on a single subject is an act both minimalist and maximalist.

I continue to think of this book as something like one of Judd's installations in Marfa: a series of containers, all similar but different in content, set against each other in conversation and in contrast. Four chapters, each with eight parts. By repeating form, the arrangement can better highlight differences and create a rhythm that carries through the experience. One beauty of minimalism is that it emphasizes form and causes us to notice absences as much as presences. Books have to partake of absence, too: they always leave things out. This book is my personal version of minimalism. Many others could and should be written, since the ascetic attitude is a fundamental part of human psychology as well as the task of living.

It seems appropriate for this infinite loop to land back on the book's title, the first thing the reader encounters. It was a struggle to figure out. For a while, we called the book *Lessness*, a made-up word for the quality of austerity and reduction that all of its subjects share. But that felt limiting and abstract. Amid a long thread of emails, my agent and friend Caroline Eisenmann came up with *The Longing for Less*. It encapsulates that intense desire for minimalism, the persistent idea that by throwing things out—by starting over, by going back to emptiness—we can find a better path and make ourselves happy. But the title also hints at how we never reach that state of perfect emptiness. It is always a temptation in the distance.

—Kyle Chayka
January 2024

Acknowledgments

Thanks to:

My agent, Caroline Eisenmann, without whom this book wouldn't exist and I would be missing a great friend.

My Bloomsbury editor, Ben Hyman, for taking this project from its beginnings to its final shape and constantly pushing for its openness.

Jess Bidgood for her love, support, and collaboration in home decor.

Nozlee Samadzadeh and Jarrett Moran for many conversations on and around these subjects. Tatiana Berg, Gregory Gentert, and Orit Gat for art commiseration.

The article editors I've worked with and their respective publications, including Julia Rubin, William Staley, Laura Marsh, and Michael Zelenko, whose editing fed into this book.

The entire staff at Bloomsbury, especially Morgan Jones, Jenna Dutton, Barbara Darko, Nicole Jarvis, Sara Mercurio, and Katerina Boni.

Tree Abraham, Elizabeth Van Itallie, Mia Kwon, and Patti Ratchford for the brilliant design of the outside and inside of the book, which reflects its ideas just as much as my writing does.

Flavin and Rainer Judd and the staff of the Judd Foundation, including Andrea Walsh and Caitlin Murray.

Authors like Eula Biss, Kate Briggs, and Gregor Hens, whose work allowed me to imagine what nonfiction could be in both form and content.

Kristi Soucie of New Milford High School, as well as the staff of the Aldrich Contemporary Art Museum, for nurturing my interest in art.

My grandmother Mary DeSalvio, who taught me to play games with words.

The internet of media and people that has given me access to so much culture and dialogue, filling the usual lonely silence of writing.

And finally, a few of the reliable Brooklyn cafes in which I wrote much of this book: Charter Coffeehouse, Variety, and El Beit.

Photo Credits

x Eames House interior, 1952. © Eames Office LLC (eames office.com).

54 Donald Judd, *15 untitled works in concrete*, 1980–84. Permanent collection, the Chinati Foundation, Marfa, Texas. Photo by Douglas Tuck, courtesy of the Chinati Foundation. Donald Judd Art © 2019 Judd Foundation / Artists Rights Society (ARS), New York.

112 The woods around Maverick concert hall, where *4'33"* debuted, photo by author.

166 Inside a room at Yumiya Komachi in Kyoto, photo by author.

228–29 The rock garden at Ryoan-ji in Kyoto, photo by author.

Notes

Chapter 1: Reduction

Quotes that are not cited to a book or article are generally from my personal interviews for this book, as with Sonrisa Andersen, the Minimalists, and Chuck Burton in this chapter. Nancy Princenthal's poignant biography of Agnes Martin was key for writing about the artist.

17 **"a good flow of life…"** Stobaeus 11:77. Quoted in *The Cambridge Companion to Life and Death*. Edited by Steven Luper. Cambridge: Cambridge University Press, 2014.

17 **"the thirst of desire…"** Cicero. *On the Orator: Book 3. On Fate. Stoic Paradoxes. Divisions of Oratory*. Translated by H. Rackham. Loeb Classical Library 349. Cambridge, MA: Harvard University Press, 1942.

18 **"Our life should observe…"** Seneca. "Letter 5: On the Philosopher's Mean." In *Letters from a Stoic*. Translated by Robin Campbell. New York: Penguin Books, 1969.

19 **"That which is really beautiful…"** Marcus Aurelius. *The Meditations*, 4:20. Translated by George Long. Accessed October 2019, http://classics.mit.edu/Antoninus/meditations.html.

19 **"detested those in the Order…"** Cameron, M. L., and Thomas of Celano, active 1257. "The First Life of St. Francis of Assisi." In *The Inquiring Pilgrim's Guide to Assisi*. Translated by A. G. Ferrers Howell.

London: Methuen, 1926. Accessed October 2019, http://www.indiana .edu/~dmdhist/francis.htm.

20 **"to front only the essential facts…"** Thoreau, Henry David. *Walden; And, Resistance to Civil Government: Authoritative Texts, Thoreau's Journal, Reviews, and Essays in Criticism.* New York: Norton, 1992.

20 **"narcissistic, fanatical about self-control…"** Schulz, Kathryn. "Pond Scum." *New Yorker,* October 19, 2015.

23 **"vast quantities of paper and ink…"** Gregg, Richard. "The Value of Voluntary Simplicity." *Visva-Bharati Quarterly* (August 1936).

24 **"That's the whole meaning of life…"** Carlin, George, in *Comic Relief.* HBO. March 29, 1986.

25 **"returning to the simple life…"** Elgin, Duane. *Voluntary Simplicity: Toward a Way of Life That Is Outwardly Simple, Inwardly Rich.* 1981. Reprint, New York: Quill, 1993. (Additional information from interviews with Elgin.)

27 **"choosing to buy and earn less…"** Goldberg, Carey. "Choosing the Joys of a Simplified Life." *New York Times,* September 21, 1995.

28 **"The less you are…"** Marx, Karl. "Human Requirements and Division of Labour Under the Rule of Private Property." In *Economic & Philosophic Manuscripts of 1844.* Progress Publishers: Moscow, 1959. Accessed October 2019, https://www.marxists.org/archive /marx/works/1844/manuscripts/needs.htm.

30 **"KonMari Method"** Kondo, Marie. *The Life-Changing Magic of Tidying Up.* New York: Ten Speed Press, 2014.

32 **"I don't need to own all this stuff…"** Becker, Joshua. *The More of Less.* New York: WaterBrook, 2016.

32 **"he's just a regular guy…"** Sasaki, Fumio. *Goodbye, Things.* New York: W. W. Norton, 2017.

33 **"What are you trying to distract..."** Davies, Alison, ed. *The Little Book of Tidiness*. London: Quadrille, 2018.

33 **"perfectly imperfect"** Kempton, Beth. *Wabi-Sabi*. New York: Harper Design, 2018.

36 **"impeccable without having reference..."** Trow, George W. S. "Eclectic, Reminiscent, Amused, Fickle, Perverse." *New Yorker*, May 22, 1978.

38 **the Instagram account...** John Pawson's Instagram account, https://www.instagram.com/johnpawson/, c. 2018.

38 **"Minimal living has always..."** Pawson, John. *Minimum*. London: Phaidon Press, 2006.

40 **In a famous photograph...** Steve Jobs photograph included in Walker, Diana. *The Bigger Picture*. New York: National Geographic, 2007.

43 **"the second body"** Hildyard, Daisy. *The Second Body*. London: Fitzcarraldo, 2018.

44 **"way-it-should-be-ness"** "The 'Way-it-should-be-ness' of the Eames Radio: Interview with Eames Demetrios." *Vitra Magazine*, May 12, 2018. https://www.vitra.com/en-us/magazine/details/the-way-it-should-be -ness-of-the-eames-radio.

46 **"unselfconscious"** "Eames House." Eames Foundation website, accessed June 5, 2019. https://eamesfoundation.org/house/eames -house/.

48 **Agnes Martin biography** Princenthal, Nancy. *Agnes Martin: Her Life and Art*. New York: Thames & Hudson, 2015.

52 **"that which takes us by surprise..."** Schwarz, Dieter, ed. *Writings / Schriften*. Winterthur, Switzerland: Kunstmuseum Winterthür / Edition Cantz, 1991.

Chapter 2: Emptiness

Large portions of this chapter are drawn from my direct observation of the sites and objects being described. The biographical material on Philip Johnson was confirmed by Mark Lamster's comprehensive Johnson biography, which was published during the process of producing this book, and supplemented by the Johnson papers at the Museum of Modern Art. The Judd Foundation in New York City and Marfa, Texas, allowed me generous access to Donald Judd's spaces and archives. Judd's letters, papers, and interviews are cited; otherwise, his own writing and criticism can be found in the collections published by the Foundation and David Zwirner Books.

58 **Philip Johnson background** Lamster, Mark. *The Man in the Glass House*. New York: Little, Brown, 2018.

61 **"Comfort is not..."** Richardson, John H. "What I've Learned: Philip Johnson." *Esquire*, February 1, 1999. https://classic.esquire.com/article/1999/2/1/philip-johnson-what-ive-learned.

62 **"ruthless elegance"** Mason, Christopher. "Behind the Glass Wall." *New York Times*, June 7, 2007.

62 **"Snugness and prestige..."** Meyer, Hannes. "The New World" (1926). In *Buildings, Projects, and Writings*. Translated by D. Q. Stephenson. Teufen, Switzerland: Arthur Niggli Ltd., 1965.

63 **"it appeals to a morality..."** Lynes, Russell. *The Tastemakers*. New York: Harper & Brothers, 1954.

66 **"All that glows sees"** Bachelard, Gaston. *The Poetics of Space*. New York: Orion Press, 1964.

67 **"To live in a glass house..."** Benjamin, Walter. "Surrealism: The Last Snapshot of the European Intelligentsia" (1929). In *Walter Benjamin: Selected Writings*, vol. 2, *1927–1934*. Cambridge, MA: Harvard University Press, 1999.

67 **"Glass is, in general ..."** Benjamin, Walter. "Experience and Poverty."
In *Walter Benjamin.*

70 **"I have a lot of complaints"** Judd, Donald. *Donald Judd Writings.*
Edited by Flavin Judd and Caitlin Murray. New York: Judd Foundation /
David Zwirner Books, 2016.

71 **Richard Bellamy, an iconoclastic, improvisational dealer** Richard
Bellamy information and quotes from Stein, Judith E. *Eye of the
Sixties.* New York: Farrar, Straus and Giroux, 2016.

72 **"indifferent to formal analysis and metaphor"** Meyer, James.
Minimalism: Art and Polemics in the Sixties. New Haven, CT: Yale
University Press, 2004.

72 **"useless objects"** and various reviews and primary sources in this
chapter from Battcock, Gregory, ed. *Minimal Art: A Critical Anthology.*
Berkeley: University of California Press, 1995.

72 **"I had to close the gallery ..."** Bellamy, Miles, ed. *Serious Bidness: The
Letters of Richard Bellamy.* Brooklyn: Near Fine Press / Spoonbill
Books, 2016.

73 **whom Judd dismissed during a gossipy interview** Lucy R. Lippard
papers, 1930s–2010, bulk 1960s–1990, Archives of American
Art, Smithsonian Institution, Washington, D.C. (Copy held in Judd
Foundation archives.)

76 **the European Commission decided to tax** Kennedy, Maev. "Call
That Art? No, Dan Flavin's Work Is Just Simple Light Fittings, Say EU
Experts." *Guardian,* December 20, 2010. https://www.theguardian
.com/artanddesign/2010/dec/20/art-dan-flavin-light-eu.

77 **"aura ... age of mechanical reproduction"** Benjamin, Walter. "The
Work of Art in the Age of Mechanical Reproduction." 1936. Reprinted
as *The Work of Art in the Age of Mechanical Reproduction.* Penguin
Great Ideas. London: Penguin Books, 2008.

78 **SoHo and loft information** Zukin, Sharon. *Loft Living: Culture and Capital in Urban Change.* New Brunswick, NJ: Rutgers University Press, 1989.

80 **"I spent a great deal of time placing..."** Judd, Donald. "101 Spring Street." 1989. Reprinted in *Places Journal*, May 2011. Accessed June 5, 2019, https://placesjournal.org/article/101-spring-street/.

82 **"Minimalism in the 1960s..."** Author interview with Miguel de Baca, 2016.

84 **"The word kills art..."** Johnson, Philip. "Style and the International Style." Speech presented at Barnard College, April 30, 1955. Philip Johnson Papers, I.30c. The Museum of Modern Art Archives, New York.

85 **Earth Room** Author interview with Bill Dilworth, 2017.

88 **"offers an intensity of experience..."** Dyer, Geoff. *White Sands: Experiences from the Outside World.* New York: Pantheon, 2016.

92 **"one's own house suddenly seems cluttered..."** Malcolm, Janet. "A Girl of the Zeitgeist." *New Yorker*, October 12, 1986.

92 **"The great thing about this space..."** Slesin, Suzanne. "Eating in the Kitchen." *New York Magazine*, May 16, 1977.

93 **"SoHo has a style all its own..."** Panel audio recording in Hood, Mallory. "SoHo Galleries in 1977." Guggenheim.org Blog, March 24, 2011. https://www.guggenheim.org/blogs/findings/soho-galleries -in-1977.

93 **"The new god..."** O'Doherty, Brian. *Inside the White Cube*: The Ideology of the Gallery Space. 1976. Expanded edition, Berkeley: University of California Press, 2000.

97 **a sheet of blurry Polaroids...** Polaroids found in Judd Foundation archives in Marfa, TX.

107 **"If we install it..."** Author interview with Flavin Judd, 2018.

108 **"a phenomenon whereby cultural investment…"** Moore, Rowan. "The Bilbao Effect: How Frank Gehry's Guggenheim Started a Global Craze." *Guardian*, October 1, 2017. https://www.theguardian.com /artanddesign/2017/oct/01/bilbao-effect-frank-gehry-guggenheim -global-craze.

108 **Ben Lerner's 2014 novel…** Lerner, Ben. *10:04*. New York: Farrar, Straus and Giroux. 2014.

Chapter 3: Silence

Sensory deprivation narrative and information comes from my reporting, including interviews with Graham Talley of Float Tank Solutions and James and Steven Ramsay of Superior Float Tanks. Kyle Gann's writing made John Cage accessible both biographically and artistically. Conversations and emails with Mary Jane Leach were key to representing Julius Eastman and her process in recovering Eastman's work. Where not officially released, Eastman's performances are accessible on YouTube and Vimeo.

115 **"digital minimalism"** Newport, Cal. *Digital Minimalism*. New York: Portfolio, 2019.

116 **Soulex** Author interview with Dariush and Pedramin Vaziri, 2018.

122 **"impossible without silence…"** Merton, Thomas. *The Silent Life*. New York: Farrar, Straus and Giroux, 1956.

122 **"This prison gives me a sense of freedom"** Park, Minwoo, and Yijin Kim. "South Koreans Lock Themselves Up to Escape Prison of Daily Life." Reuters, November 23, 2018. https://www.reuters.com/article /us-southkorea-prisonstay/south-koreans-lock-themselves-up-to -escape-prison-of-daily-life-idUSKCN1NS0JB.

123 **Etymology of silence** Online Etymology Dictionary. Accessed 2018, https://www.etymonline.com/word/silence; and Lewis, Charlton Thomas. *A New Latin Dictionary*. New York: American Book Company, 1907.

124 **"Everyone who knows how to remain silent…"** Kierkegaard, journal 1842–43, cited in Emmanuel, Steven M., William McDonald, and Jon Stewart, eds. *Kierkegaard's Concepts*. Farnham, UK: Ashgate Publishing, 2015.

124 **"still, small voice"** 1 Kings 19:12, cited in Holliday, Marsha D. "Silent Worship and Quaker Values." Friends General Conference, 2000. Accessed June 5, 2019, https://www.fgcquaker.org/resources/silent-worship-and-quaker-values.

124 **"The fear, even dread, caused by silence…" and other background on silence** Corbin, Alain. *A History of Silence*. London: Polity, 2018.

124 **"In an overpopulated world…"** Sontag, Susan. *Styles of Radical Will*. New York: Farrar, Straus and Giroux, 1969.

126 **"What we cannot speak about…"** Wittgenstein, Ludwig. *Tractatus Logico-Philosophicus*. London: Kegan Paul, 1922.

127 **"In order to play this motif 840 times…" and other background on Satie** Ross, Alex. "Satie Vexations." *New York Times*, May 20, 1993.

129 **"There is no school of Satie…" and other Satie quotes** Zukofsky, Paul. "Satie Notes," June 2011. *Musical Observations, Inc.* Accessed June 5, 2019, http://www.musicalobservations.com/publications/satie.html.

129–30 **"Go on talking! Walk about! Don't listen!"** cited in Milhaud, Darins. "'Musique d'ameublement' and Catalogue Music," in Schwartz, Elliott, and Barney Childs, eds. *Contemporary Composers on Contemporary Music*. New York: Hachette, 2009.

135 **"almost inaudibly" and Brian Eno background and quotes** Eno, Brian. Liner notes to: *Discreet Music*. EG, 1975; and Eno, Brian. Liner notes to: *Music for Airports*. Polydor Records, 1978.

136 **"The central idea was about music..."** Sherburne, Philip. "A Conversation with Brian Eno About Ambient Music." *Pitchfork.* February 16, 2017. https://pitchfork.com/features/interview/10023 -a-conversation-with-brian-eno-about-ambient-music/.

137 **The veteran rock critic...** Christgau, Robert. *Music for Airports* capsule review. In "Christgau's Consumer Guide." *Village Voice,* July 2, 1979. Accessed June 5, 2019, https://www.robertchristgau .com/get_album.php?id=447.

138 **"people are always, and never, at home..."** Augé, Marc. *Non-Places.* London: Verso, 1992.

138 **"equally exciting—or unexciting..."** Koolhaas, Rem. "The Generic City." In D.M.A., Rem Koolhaas, and Bruce Mau. *S,M,L,XL.* New York: Monacelli Press, 1997.

142 **"organization of sound" and other John Cage quotes** Cage, John. *Silence.* Middletown, CT: Wesleyan University Press, 1961.

143 **"No idea / No intention..."** Genauer, Emily. "Art and Artists: Musings on Miscellany." *New York Herald Tribune,* December 27, 1953.

145 **"There is no such thing..."** Gann, Kyle. *No Such Thing as Silence.* New Haven, CT: Yale University Press, 2011.

153 **"Conversation strives toward silence..."** Felman, Shoshana. "Benjamin's Silence." *Critical Inquiry* 25, no. 2 (Winter 1999).

154 **Background on the beginnings of Minimalist music** Strickland, Edward. *Minimalism: Origins.* Bloomington: Indiana University Press, 2000.

154 **"Time is my medium"** Licht, Alan. "A Conversation with La Monte Young, Marian Zazeela and Jung Hee Choi." *Red Bull Music Academy Daily,* July 9, 2018. https://daily.redbullmusicacademy.com/2018/07 /la-monte-young-zazeela-choi-conversation.

155 **"At least there was some excitement..."** Schonberg, Harold. "Music: A Concert Fuss." *New York Times*, January 20, 1973.

156 **"pop-middlebrow"** von Rhein, John. "Philip Glass, Winner of 2016 Tribune Literary Award, Reflects on a Life Well Composed." *Chicago Tribune*, October 26, 2016.

157 **Biographical information on Julius Eastman** Levine Packer, Renée, and Mary Jane Leach, eds. *Gay Guerrilla: Julius Eastman and His Music*. Rochester: University of Rochester Press, 2015.

161 **"I never thought of Julius as sticking out..."** Author interview with Mary Jane Leach, 2019.

163 **"I'm in the bar and I might write..."** and other late Julius Eastman quotes and information: Garland, David. *Spinning on Air* (podcast), episode 2. Accessed June 5, 2019, https://spinningonair.org/episode -2-julius-eastman/.

Chapter 4: Shadow

Ivan Morris's evocative writing and translation was key to describing Japan's Heian period. The books that I cite are the translations of the texts I used. I am grateful to Michael F. Marra and Hiroshi Nara's work editing, translating, and writing on Shūzō Kuki, which gave me access to Kuki in the first place as a non-Japanese speaker. Encountering Junichirō Tanizaki's In Praise of Shadows *many years ago at the bookstore Spoonbill & Sugartown in Brooklyn, which keeps it permanently stocked, is truly one of the reasons this chapter exists. The owner of that store, Miles Bellamy, also happens to be the son of Donald Judd's first dealer, Richard Bellamy.*

176 **a famous book of koans...** Aitken, Robert. *The Gateless Barrier*. New York: North Point Press, 1991.

177 **"perfect like unto vast space..."** Suzuki, Daisetz Teitaro. *Essays in Zen Buddhism*. New York: Grove Press, 1961.

177 **"Less and less is done..."** *The Complete Tao Te Ching.* Translated by Gia-Fu Feng and Jane English. New York: Vintage Books, 1989.

181 **The resulting volume...** *The Pillow Book of Sei Shōnagon.* Translated by Ivan Morris. New York: Columbia University Press, 1991.

183 **"dreadfully conceited"** Keene, Donald. *Seeds in the Heart: Japanese Literature from Earliest Times to the Late Sixteenth Century.* New York: Columbia University Press, 1999.

184 **"depths of leafy shadow..."** Shikibu, Murasaki. *The Tale of Genji.* Translated by Royall Tyler. New York: Penguin Classics, 2002.

185 **"mostly bored out of their minds"** Buruma, Ian. "The Sensualist." *New Yorker,* July 20, 2015.

189 **"Japan is a museum of Asiatic civilization..."** Okakura, Kakuzo. *The Ideals of the East.* New York: E. P. Dutton, 1904.

189 **In 1906 he published...** Kakuzo, Okakura. *The Book of Tea.* New York: Duffield, 1906.

190 **"blandness"** Julien, François. *In Praise of Blandness.* Translated by Paula M. Varsano. Brooklyn: Zone Books, 2004.

192 **"Were it not for shadows..."** Tanizaki, Junichirō. *In Praise of Shadows.* Translated by Thomas J. Harper and Edward G. Seideasticker. Sedgwick, ME: Leete's Island Books, 1977.

193 **99 percent of United States...** and light pollution facts: Falchi, Fabio, et al. "The New World Atlas of Artificial Night Sky Brightness." *Science Advances* 2, no. 6 (June 10, 2016).

195 **I called the founder...** Author interview with Peter Neill, 2017.

197 **"The Structure of *Iki*"** quotes and information from Nara, Hiroshi, ed. *The Structure of Detachment.* Honolulu: University of Hawaii Press, 2005.

201 **"quiet atmosphere of a delicate..."** Crespelle, Jean-Paul. *La vie quotidienne à Montparnasse à la grande époque, 1905–1930.* New York: Hachette, 1976.

203 **"Nothingness haunts being..."** Sartre, Jean-Paul. *Being and Nothingness.* New York: Philosophical Library, 1956.

203 **In 1927, when he...** Further Shūzō Kuki: Pincus, Leslie. "In a Labyrinth of Western Desire: Kuki Shūzō and the Discovery of Japanese Being." *Boundary 2* 18, no. 3 (Autumn 1991).

203 **"Everyone is the other, and no one is himself"** Heidegger, Martin. *Being and Time.* New York: State University of New York Press, 1996.

205 **This was also what Shūzō Kuki pursued...** Shūzō Kuki in Paris information, poetry, diary entries, and essays: Marra, Michael F., ed. *Kuki Shūzō: A Philosopher's Poetry and Poetics.* Honolulu: University of Hawaii Press, 2004.

209 **Shūzō Kuki and Karl Löwith**: Takada, Yasunari. "Shūzō Kuki: or, A Sense of Being In-Between." In *Transcendental Descent: Essays in Literature and Philosophy.* Tokyo: University of Tokyo Center for Philosophy, 2007.

210 **"The logical outcome of fascism..."** Benjamin, Walter. "The Work of Art in the Age of Mechanical Reproduction," 1936.

214 **Leger and Kiefer**: "Anselm Kiefer: Sculpture and Paintings from the Hall Collection." Accessed June 5, 2019, http://www.hallartfoundation.org/exhibition/anselm-kiefer_1/information.

214 **"Overcoming Modernity" and Nishida** Dallmayr, Fred Reinhard. *Border Crossings: Toward a Comparative Political Theory.* Lanham, MD: Lexington Books, 1999.

215 **In 1953 Nishitani wrote...** Nishitani, Keiji. "The Japanese Art of Arranged Flowers." *Chanoyu Quarterly* 60 (1989). First published in June 1953 issue of *Rakumi.*

216 **"Man first of all exists, encounters himself..."** Sartre, Jean-Paul. "Existentialism Is a Humanism." Lecture, 1946. Published in

Kaufman, Walter, ed. *Existentialism from Dostoyevsky to Sartre.* New York: Meridian Publishing, 1989.

218 **"Speaks true, who speaks shadows"** Celan, Paul. "Speak, You Too." In *Paul Celan: Selections.* Berkeley: University of California Press, 2005.

218 **"For what is this shadow…"** Beckett, Samuel. *Watt.* Paris: Olympia Press, 1953.

218 **"I thought the most beautiful thing…"** Plath, Sylvia. *The Bell Jar.* New York: Heinemann, 1953.

219 **"Kyoto was unbombed…"** Gibson, Morgan. *Revolutionary Rexroth: Poet of East-West Wisdom.* Hamden, CT: Shoe String Press, 1986. Accessed June 5, 2019, http://www.thing.net/~grist/ld/rexroth/rex-08c.htm.

224 **"Each age sees what it is prepared to discover"** Petersen, Will. "Stone Garden." *Evergreen Review* 1, no. 4 (1957).

225 **"according to the will or desire of stones"** Nonaka, Natsumi. "The Japanese Garden: The Art of Setting Stones." *Sitelines* 4, no. 1 (Fall 2008).

Index

Note: Page numbers in italics refer to images.